WE ARE FRIENDS WITH YOU

RIZZOLI
NEW YORK

New York Paris London Milan

First published in the United States of America
by Rizzoli International Publications, Inc.
300 Park Avenue South, New York, NY 10010
www.rizzoliusa.com

WE ARE FRIENDSWITHYOU

Copyright © 2014 FriendsWithYou. Copyright texts © 2014
Peter Doroshenko, Alejandro Jodorowsky, and Pharrell Williams

FOR RIZZOLI INTERNATIONAL PUBLICATIONS
Editor: Ian Luna
Editorial Coordination: Monica A. Davis & Kayleigh Jankowski
Editorial Management: Lynn Scrabis
Production: Susan Lynch & Kaija Markoe

Publisher: Charles Miers

FOR FRIENDSWITHYOU
Editorial Director: Emma Reeves
Editor: Maxwell Williams

Book Design: Roxane Zargham

Printed in China

2014 2015 2016 2017 / 10 9 8 7 6 5 4 3 2 1
Library of Congress Control Number: 2013956663
ISBN 978-0-8478-4237-7

AN INTRO-DUCTION BY PETER DORO-SHENKO

Similar to professors appropriating knowledge, FriendsWithYou is always on the lookout for whatever pushes the limits of the everyday. FriendsWithYou's artwork is the product of a refined mix of deliberations. Producing enlightened situations, they offer only that which is already embedded in our memory, like a reference point of what is lost or a temporal experience of an eternal recurrence. FriendsWithYou's works arise from unique observations of issues concerning the individual, the social, and the spiritual.

Outwardly minimalist in style, their works have more to do with actions, creating active pieces that often—but not always—last for a limited amount of time.

FriendsWithYou (Samuel Borkson and Arturo Sandoval III) has been working for more than 10 years on a coherent oeuvre closely related to a hybrid minimalistic trend. Their brightly colored spaces, forms, and simple volumes can be viewed as some respite within Minimal Art. In FriendsWithYou's work, the creative background does not overpower: for them, in addition to a neutral, singular design language, beauty is equally important. In their quest to narrow their design language, color and shapes continue to play leading roles. FriendsWithYou bears testimony to that same endeavor to distill a design, which is scarcely possible to directly "encapsulate" mentally. The characteristics of FriendsWithYou's work are examined in and against the framework of Minimal Art as it came into vogue in mid-sixties America. Their work brings up Minimalists such as Donald Judd and Carl Andre or even Post-Minimalists like John McCracken. At the same time their unique position and the individuality of their work are examined in the context of children's toys, including Play-Doh, Silly Putty, Colorforms, Slinky, Gumby and Pokey, and Twister.

Minimal Art emerged in early 1960s America. In contrast to the predominant Abstract Expressionism of the time, the artists wished emphatically to distance themselves from any form of composition and expression. The Minimalists did not want to produce works of art wherein the observer could lose himself in the painted surface. The new generation took a stance of uncooperativeness with regard to the idea that the content must exclusively be positioned within the work so that the observer's subjectivity or corporeality is, as it were, eliminated. Jackson Pollock's drippings, for example, or Mark Rothko's color fields flirted with the "flatness" of the painter's canvas and evoked an illusory space. The Minimalists wanted to put an end to these so-called suggestions and to the so-called external significance, which the observer is able to project into the work. Their aim was to distill the work of art to its pure essence. In their opinion, this essence exists not so much in the work itself but in the confrontation between work, observer, and the surroundings. By making the work as simple as possible, they attempted to focus attention on the observer's perception and the work's relationship to the exhibition area. This resulted in volumes executed in materials such as plywood, Plexiglas, or metal. The materials used by the Minimalists were relatively "new." In the 1950s and 1960s, the United States was in a period of industrialization, and since increasingly more materials and products were being produced in factories in a constant stream, new materials—like the metal tiles or bricks used by Carl Andre or Dan Flavin's neon lights—were more accessible to the general public.

A work of art was no longer considered to be a unique creation reflecting the artist's personal expression. Minimalists strove to make the work as impersonal and neutral as possible. Addressing the viewer in a direct experience was pivotal. This resulted in radical, challenging works, which can be seen as a kind of tabula rasa, both in terms of contemporary painting and sculpture. The aim was to return to a so-called pure state. To ensure that the meaning was attached to the relationship between the work and its surrounding space and in order to remove any distance, the geometric works were erected directly on the floor of the exhibition area. The sculptures were not mounted on plinths, framed or clearly delineated. Through their simplicity they acquired an object character, but they equally displayed commonality with architectural forms. Because these forms were situated directly within the space, one can speak of the works as being tied to a particular area. In this the viewer's

perception completes the work so that it becomes anchored in the "here and now."

Some Minimalists strongly emphasized the theoretical fundamentals of the artistic trend. They repeatedly referred to the French phenomenologist Maurice Merleau-Ponty, whose book *La Phénomenologie de la Perception* (1945) was not translated into English until 1962. According to Merleau-Ponty, we can never know a three-dimensional work completely because our eyes can never see all the sides of an item at the same time. By looking at an object successively from several sides, we suppose that we know how the item is constructed. In this respect, the French philosopher differentiates between "seeing" and "knowing," a division which had formerly been literally cited in Cubism. From our previous experiences our brain automatically accumulates various impressions to form a coherent image. This enables shapes to be recognized. The simpler the shape, the more quickly we can switch to that "recognition" and are able to name the shape. This "filling-in," which we mentally inject into a totality of impressions, is called the "gestalt." The gestalt is a known constant, a mental definition, which after a while comes into existence. When a gestalt is known as a shape it is clearly present as a unit. By keeping the volume as simple as possible, the Minimalists want, on the one hand, to attain an almost immediate "recognition" of the gestalt of a geometric shape or formation. On the other hand, they want the observer to take time to test out this gestalt against his/her changing experiences whilst moving through the space.

The time that the viewer spends with the work is important to FriendsWithYou. The volumes acquire a meaning only through the observer's experience. FriendsWithYou also stress that their works "appear," that the gestalt can immediately be understood. The neutral shape appears and simply says, *here I am*. Only after this does moving around the space and testing one's own experiences become important. What sets *FriendsWithYou* apart from their contemporaries is the fact that they give personal input to the aspect of "time." For them, time is not considered a linear item but something without a beginning or an end. They want to underline the fact that all things are essentially in the mind:

energy and pure thought. Their works, which are connected with the man-made world, are a kind of world prototype. They are concerned with how humanity might be formed; the shapes offer possibilities for the future.

Working for the past decade with paintings, sculpture, large-scale experiential installations, public playgrounds, published works, and live performances, FriendsWithYou's works have no indication of a place. Many of their works address personal and complex issues. They always present an element of intrigue or suspense in their works, but they do not resolve the atmosphere of physical tension. That lack of resolution entices the viewer to long for another scene from these strange narratives, but unlike a series of movie stills, the next image never appears.

In terms of the works presented and their subsequent positioning in space, FriendsWithYou's work involves a kind of mise-en-scène in which the position and attitude of the viewer are paramount. Just as Takashi Murakami's short videos are often seen as slick and intentionally provocative, FriendsWithYou's work can be seen as simple or easy. The use of these adjectives points to those characteristics that allow the separate works to expand, to become more complex, to push the viewer beyond an initial stance of taking things for granted.

Like a film director, FriendsWithYou composes its works carefully to create a compelling narrative. At first glance, the works seem to be decisive moments in a larger narrative, captured and frozen, but the surrounding story remains exclusive to the viewer. By fabricating and staging their own reality in a single work, FriendsWithYou takes complete control, contrasting banal situations and a subliminal world of conflict.

The human measurements of the minimalistic works distinguish them from earlier paintings and sculptures. Various artists argue that when the volumes become too small, they appear too much like objects. But, if they become too large, they acquire a sense of architecture. By seeking out a size that matches that of a person, it becomes easier to appeal to the corporeality of the observer. Because of their measurements, it is clear that the works

belong to the human-made world. Even though the shapes first appear as gestalt, FriendsWithYou nevertheless emphasizes that they ultimately want an arising of a new consciousness.

In the form in which they appear, the artworks are minimal and of simple geometric shape. The content that FriendsWithYou ascribes to the works reveals subtle distinctions compared with what is generally assumed about minimalistic volumes. By paring down the volumes, FriendsWithYou aims not only to neutralize them, but to bring them back to a kind of archetypal form, a form that preceded the various ways in which they now appear. It would not, however, be true to say that FriendsWithYou avoids more complex shapes. Variations on geometric shapes are possible for them when they stem from the logic of the shape itself. Even when the volumes possess a number of facets, they still remain as FriendsWithYou's singular forms, which have absorbed those variations. According to them, their works of art must be regarded as variations or resonances of the mental original.

In that respect, FriendsWithYou's underlying vision clearly has a spiritual side. They want to underscore that in essence all things are of the mind, energy, and pure thoughts. Their work is connected to the human-made world; the shapes are made by people. They are like prototypes of humanity that suggest how the world might be shaped as possibilities for the future.

For FriendsWithYou, shape variations do not conflict in the slightest with their aspirations for unity. They regard them as attempts to inject enlightenment into the sculptural forms, like representations of individual characters within DNA. The shapes are given a specific character: some are long and elegant, others more block-shaped or ambiguous. These variations are an attempt to "animate" the shapes, to allow them to comment on the world. Through these more complex shapes, they wish specifically to approach the singularity, so accentuated by Minimal Art. They do this precisely by allowing a work, no matter how complex, to nevertheless become a unitary object. With these more complex geometric sculptures, an optical game comes into play such that, from certain viewpoints, some facets disappear and re-appear. In realizing this kind of work the artists

studied natural crystalline shapes, wanting to transpose the logic from these faceted, angular shapes into the creation of more complicated shapes.

FriendsWithYou sculptures are able to both diminish and generate movement simultaneously. Their colorful sensory aesthetic makes them one of the most enduring figures in the hybrid minimalistic movement. The objects activate their surroundings and trigger experiences. At the same time, FriendsWithYou sees the work as prototypes within a broader world view in which they witness a more idealistic attitude than most of their contemporaries: "We chose minimalism as a means to best communicate our greater message. By redesigning spirituality through a primary system of shared religious symbols represented by primary colors and shapes that most clearly speak to the subconscious of all humans, our goal is to create emotional and spiritual connection and transcendence for all people that experience our work. This universal accessibility is one of the main ingredients to tapping into the rainbow of human culture by celebrating the primary symbols and language we all share. In a world with so many messages consistently targeting our brains, we feel the power and beauty in the idea of reductive ideas that act as a spiritual oasis. We feel peace is food for the heart."

Through the process of reflection, the art works almost become anonymous. Though the artists' egos remain in the background, FriendsWithYou expects the viewer to actively look at the works. One cannot fight against the ego and win, just as you cannot fight against darkness. They ask viewers to be part of the light and mentally participate with them. The works are aesthetically appealing, while at the same time they teach us something about the idiosyncrasies of the medium.

It is hardly surprising that both artists and critics link their work to a reality with the rise of a new consciousness. With their work, FriendsWithYou aims to give us an aperture onto a reality behind the physical world, changing or extending our idea of it. One can say that FriendsWithYou continues their purpose of reaching maximum inner transformation through simplicity.

Still from "Cloudy"

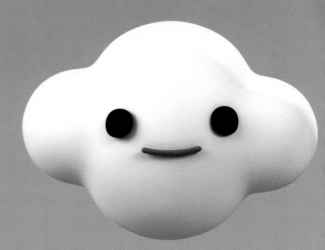

ANIMISM

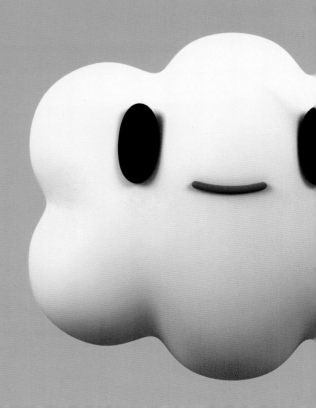

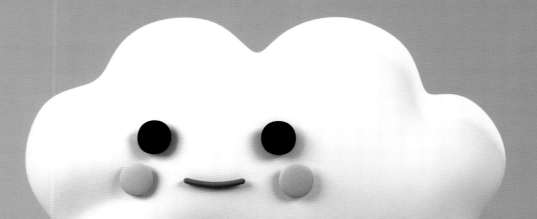

Anthropologists believe that certain Aboriginal Australian tribes developed belief systems approximately 60,000 years ago, and some of those beliefs were considered the precursors to animism. Dr. Graham Harvey, in his book *Animism: Respecting the Living World*, describes animists as "people who recognize that the world is full of persons, only some of whom are human."[1] That is to say, there are spiritual aspects to everything, including animals, plants, and even inorganic objects such as rocks. FriendsWithYou embrace this practice, and take it one step further, by "exposing" the inanimate object as a spirit, giving it human facial features, and bringing that spirit into the living world.

In various world religions, animism is a central theme in the iconography and artwork. Shinto shrines and sculptures incorporate animals who take on human characteristics and expressions, while modern Japanese film director Hayao Miyazaki refers to wind and earth spirits, both concepts of the Shinto animism of abstract natural forces. FriendsWithYou have created characters out of clouds and mountains that speak to their connection to animism. Their characters are not just simple spirits, but they are cognizant beings, able to fulfill roles in allegorical narratives.

It is impossible to ignore the influence of Walt Disney on modern animism. Through his characters, the world accepts the anthropomorphism of everything from mice to mops. FriendsWithYou, as is their customary practice, take elements of religious animism and modern examples like Disney, throw it all into their creative blender, and rearrange it for a contemporary art audience. Their characters and sculptures take on the role of animism's spirit animals, while maintaining a positivist approach.

[1] Harvey, Graham. *Animism: Respecting the Living World*. New York: Columbia University Press, 2005. Print.

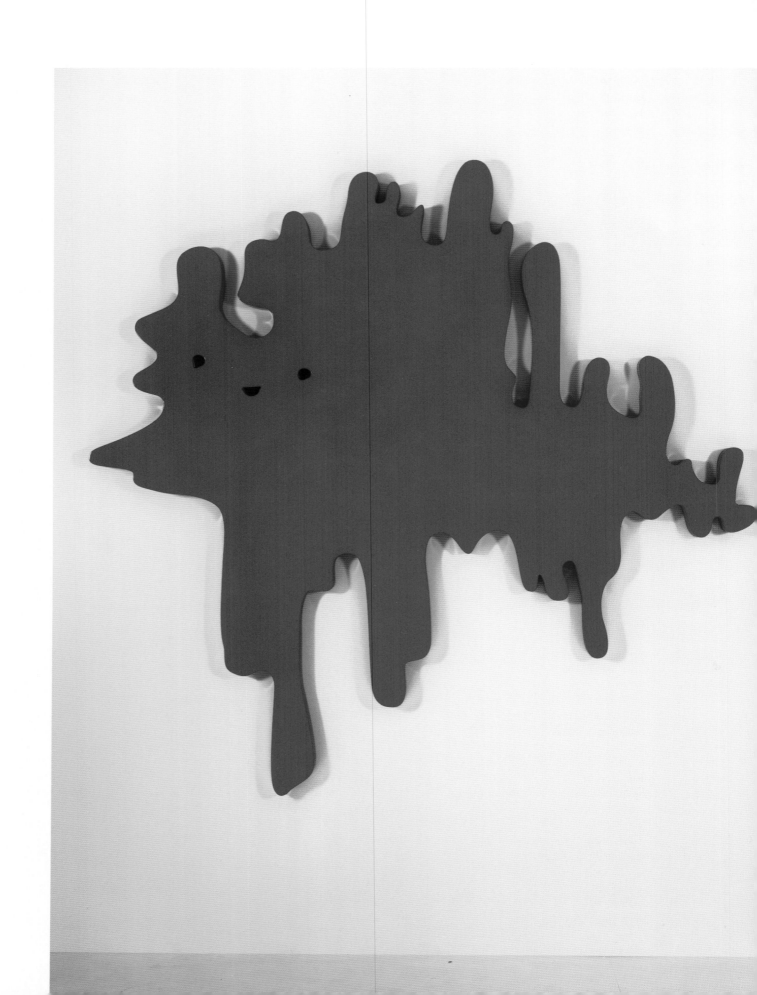

MAXWELL WILLIAMS Animism is an extremely important theme in your work. There is a lot of debate about what animism is, historically. What does animism mean to you?

SAMUEL BORKSON We understand it one way, and we put it in our work in another way—these are two different things. How animism relates to our work, which I think is more specific, is the idea of bringing a soul to anything, or bringing life to anything. We started in our practice with putting ideas to certain emotions, playing with this figurative aspect to these emotions, and then putting it under this umbrella of the FriendsWithYou language. We've explored animism in a very open way that allows for vastly different interpretations. Taking sacred symbols and simplified ideas and giving life to them with this figurative presence was how we were able to approach all of these different ideas. The basis of FriendsWithYou is that all of these elements are here in your favor or disfavor. These 'spirits' that we've created are here to be friends with you and to aid you if you so choose to recognize them.

ARTURO SANDOVAL III It's also in line with the gesture of making art. When you make something, you are birthing something new. At the beginning of FriendsWithYou, we were making products—objects that were not even made by us—but they still embodied this idea. It made the object real. We didn't want to just make 'things.' We wanted to make entities. I understand it more now, what animism really is defined as, and what we are doing with it, but we were using a naïve approach to those things. We simply believed that without our breath and without our shadow, that we are just lumps of atoms. We were lucky, to some extent, just doing these things for the fun of it, really empowering these objects with a very wholesome animation. Now I understand that what makes animism is the concept of spirit. You can't have animism without the preconception of the spirit. It's the idea that we see ourselves in our shadows, or that we see ourselves in our dreams as perceived mirrored images of our own self but a different kind of embodiment. The ghost, the phantom, the spirit—the anima. Animism is a gestural implementation of the idea of the spirit. What really enticed us was that we could make these abstract things be alive.

MW How does animism fit into the characters that you're making in a literal sense?

AS The spirit is the thing and animism is the verb, like how it manifests itself. In primitive culture, it was tiered. Animism, as it pertains to humans, was the highest tier. Next was the animal level. Then it went down to the flora level. The last tier was inanimate objects. We found that to be interesting to us, because we were making products. These products were objects, and we wanted them to have those characteristics.

MW A big part of animism is seeing yourself or the human spirit within an object. Can you tell me about how you utilize human characteristics to signify animism?

SB We are all looking for that, almost unknowingly. You look at a shadow, and you think it is a human. That's what makes art really beautiful, too, is the constant figuration of these abstract and non-abstract things. We've done that forever as humans. What converges when people are looking at our work is: us making a vessel with an abstract idea of humanity, and the viewer taking that mirror and reflecting their own idea upon the vessel.

AS It's really that. It's a mistake that is so universal, that we see our spirits embodied into all those things.

MW Sometimes you look at a tree, and the tree looks like a person, or a cloud will look like an animal. Are you taking those projections one step further, and giving them actual spiritual characteristics?

AS When you project yourself into an object, to some degree, it's wholesome and very naïve and pure.

MW There are two sides to the animism in your work. There is some non-traditional animism—things that aren't so clear when you look at them that they contain souls—and other works that are a little bit easier to read as animism, which is say like "The Cloud" or the "Rainbow Valley," with the baby mountain named Peeko. I think a lot of people, when they think of animism, they think of the anthropomorphic rendering of preexisting elements, like the mountain spirit or the cloud spirit. But there's this other side to your work that is more assertive and godlike in that you're actually configuring characters out of the aether. For instance, your character Malfi is an abstract being. He is something that you guys conjured up on your own. There is a lot of that in Takashi Murakami's work. The characters are semi-humanistic or semi-animalistic, but they don't actually have roots in reality. Nobody's going to put it in the uncanny valley. How do you see the godliness in your work?

SB It's about showing that our Earth and our space around us—the things that we don't see—are much bigger than us; that god is this big connection. To create those things is almost to dwarf us as

Sonic Goo, 2011.
MDF, automotive paint.
87 x 84 inches.

One of the painted portraits of spirits, "Sonic Goo" is a tonal essence, representing the fluidity of life. His form recalls that of certain mud gods in Japanese mythology, adding a sonic quality—a *gloop*—to an undefined shape. "Sonic Goo" tells the viewer that shapes are not real, that geometry is relaxed, and that figurations are simply metaphysical constructs.

Now I understand that what makes animism is the concept of spirit. You can't have animism without the preconception of the spirit.

It's the idea that we see ourselves in our shadows, or that we see ourselves in our dreams as perceived mirrored images of our own self but a different kind of embodiment.

The ghost, the phantom, the spirit— the anima.

humans—to evoke our subservience to greater powers. That's also why we made these monolithic, godlike worlds. This looming monolith is powerful and stoic, and the power of a god is something that we all can relate to. What is our own power? What is this power that we can give to things so that our audience can now gain power and help us manifest these things? If god is invented by a man, then we're the creators as much as every other man has been through time. It's the Joseph Campbell school of mythology coming together; we're just the purveyors of that concept—the idea that if we make all of this stuff up, we are all the gods. Every human has that power. If we can dream there are bigger things than us out there, then maybe that lets us understand our world better.

AS We try to think of the idea of a god without any functionality to it. It becomes just the idea. I think it's a byproduct of the age, and how we've come to think of things—no one really cares anymore about the truth or the real hard definitions of it. It is more about gesturally how it manifests itself. We make the image completely in a void in our little studio by ourselves on a computer, and then somehow it becomes this thing. Then it becomes an idea that we get to talk about, and talk about it from that standpoint of a metaphysical challenge, where it doesn't even matter what the definition is, or what we meant to say about it.

SB Tury and I both take a step when we believe that an art piece is ready. It's a charged piece. It's ready for the world. We create this together.

AS What I'm trying to emphasize is that it's just an idea that gets manifested as a character. The characterization and anthropomorphism part of it, it's only a vessel. It's only a medium towards the means. The *idea* of the symbol is what unifies; the idea is what transcends the symbolism. That's why we try to use neutral symbolism to make those characterizations. When you are in the neutral zone, then you are closer to the idea and further away from the character. 'Character' is a charged word that comes with a persona. Most of the god characters that we've come to know were characters that came from a personal projection of our own existence. The real power of this comes from the creation that happens when we share everything, like when we both perceive it. That's what an idea is: our sensory perception of something becomes the idea to some extent. When you make art, you are making those birthing points.

MW You're saying that there is a pre-character concept in the creation of the character, but then they become characters with their backstories?

AS We infuse a lot of our characters with backstories. When we talk about the Malfi and Rainbow King, we're talking about the characters themselves. Because it's charged, and that character comes pre-installed with a concept.

SB We create characters with certain archetypes, and it's almost like our own Jesus story or our Mickey Mouse story. They end up being Malfi and Rainbow King, but then we also have these pieces that explode through the visual. Some pieces take on the meaning you project onto them. What we're driving at is you gaining power over a concept or an idea.

MW Hayao Miyazaki has been referenced as an influence, and you've talked about a trip to Japan as a formative experience. What attracted you to Miyazaki's animism?

SB I found Miyazaki before we did FriendsWithYou. We were already creating figures from our emotions, which is animism at its core, but we didn't realize it yet. The first time I saw *My Neighbor Totoro*, it changed everything in my life. Miyazaki had made an accessible version of animism that was wholesome and Disney-esque, but with these very powerful lessons and morals. We didn't want to make artwork that was cold; we wanted it to be a warm hug. Like Miyazaki, our style and message are warm and powerful even in the most ominous moments. It shows dark and evil as something that is subjective and changing. I think that was an important message he was delivering. He explored the metaphysical state of explaining animism, and that influenced us a ton. His multitude of spirits was infinite, allowing his dream world to expand in his viewers' minds. He hinted at magical instances, which is what we try to do. He inspired us to make simple, minimal objects that allow people to expand the story based on this metaphysical interjection of real life.

AS He projects all the archetypes into entities that are found in nature, like trees, the wind, mountains, plants. He was animating traits of nature, and really working with a mythology that's a little bit more naïve and nature-driven, as opposed to the Western philosophy that moved away from nature myths.

MW Did you see yourself fitting into a larger discussion with art and animism?

SB We tend to gravitate towards other artworks that have animistic qualities, maybe in the same way all humans are drawn to human forms.

AS People have a general disposition toward animating objects and animating ideas and projecting the spirit into the thing. That stems from a fantastical play that we like to do amongst ourselves, where we're referring to things as animated. Artists aren't the only ones that do that. To this day, when you hurt your foot on a rock, you get upset at it. It's ingrained in our nature. Why animism is so important in our practice is because we aren't afraid of making those assumptions, and that naiveté was pure and void of the cynicism of modern, science-driven philosophy. It's childlike, but it's also inherent in our psyche. We were playing around with having those ideas manifest without taking the childlike quality out of it.

MW Are you within the work? Does your persona carry on with the piece when someone else takes it into their home?

SB It has its own spirit, but it also has mine and Tury's spirit. It is a continuation of us. I feel that people do feel us through our work. The emotions that we're conveying through those things are real and they emanate from those objects, since we're consciously and subconsciously building those things into the design of those pieces.

AS We're not self-referential, though. We don't say, 'Oh, I made this painting and it has a chunk of my psyche in it.' That happens to an extent with our work, but it's not so personal. It's devoid of our own experience in the general context of what those emotions are. That's why people can access our work, because it's not a personal story, it's a universal story. It is our work, and it is our personal thing, but these are universal emotions.

SB Even when we do the dual self-portraits—the 'Buddy Chubb' character—we are inside of that piece, but it's also the inside of everyone, the generic, non-specific part of yourself that allows the character to be accessible to a wider range of people that aren't me and Tury.

Spirit Guide, 2011.
MDF, lacquer paint.
55 inches diameter.

"Spirit Guide" is a sculptural painting of an
amorphic shape with 10 eyes. The eyes are
kinetic, each painted half red and half blue
so that they shift from side to side, changing
colors as they look out into the gallery.

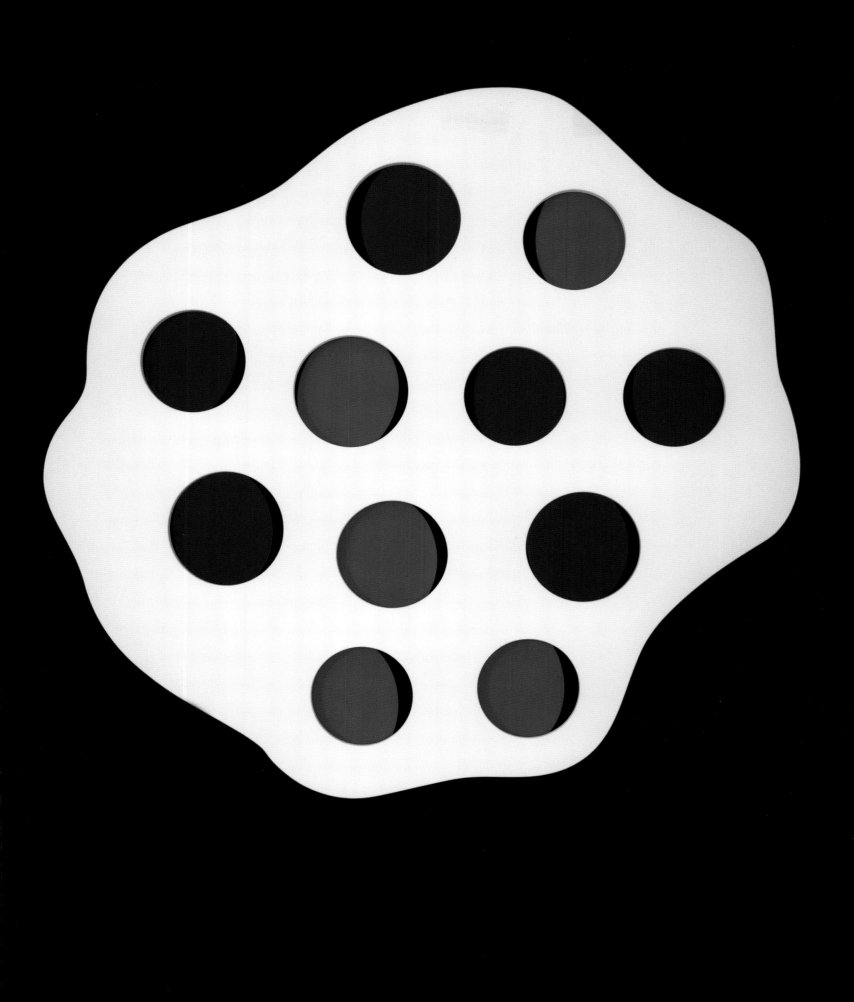

I See You, 2011.
MDF, lacquer paint, mechanical parts.
18 inches diameter.

Deconstructing the ubiquitous art deco Kit-Cat
Klock to its shifty-eyes, "I See You" becomes a
watcher, on the lookout. In the FriendsWithYou
universe, "I See You," a kinetic sculptural
painting, has the capability to see spirits,
keeping his eyes peeled as the watchman.

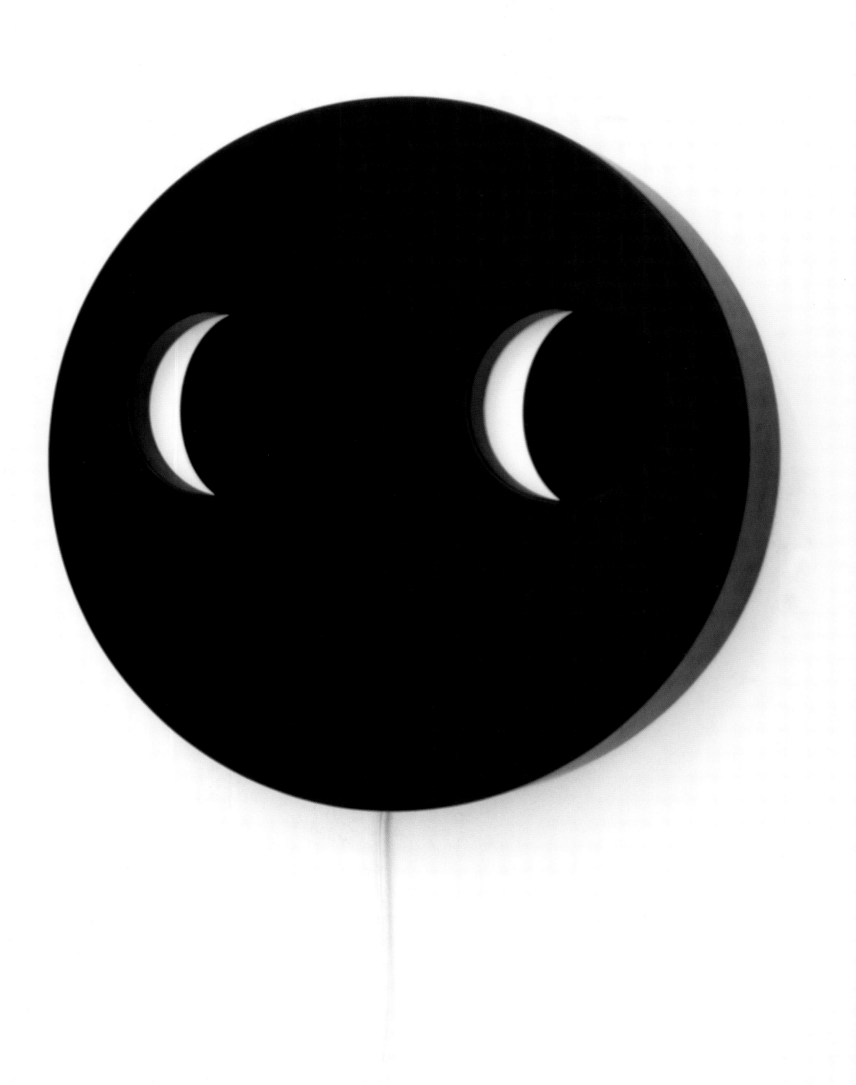

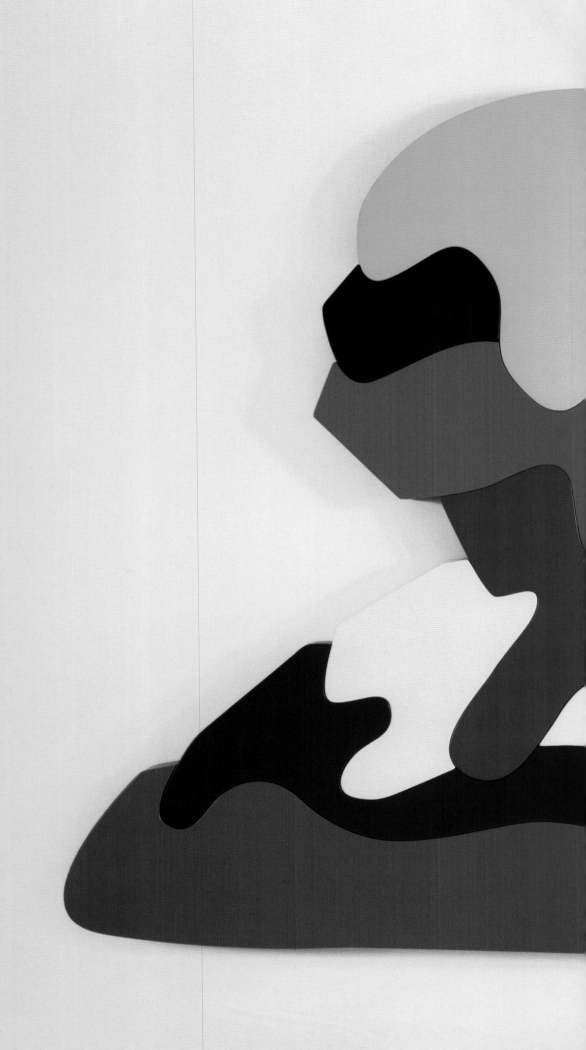

I Melt For You, 2011.
MDF, lacquer paint.
40 x 60 inches.

"I Melt For You" is a gestural painting, an animistic interpretation of the idea of melting. There is a freedom to the melting character, the straight edges and lines of the canvas juxtaposing with the ugly amorphousness of melting. "I Melt For You" remains one of the most abstract manifestations in the Friends-WithYou universe.

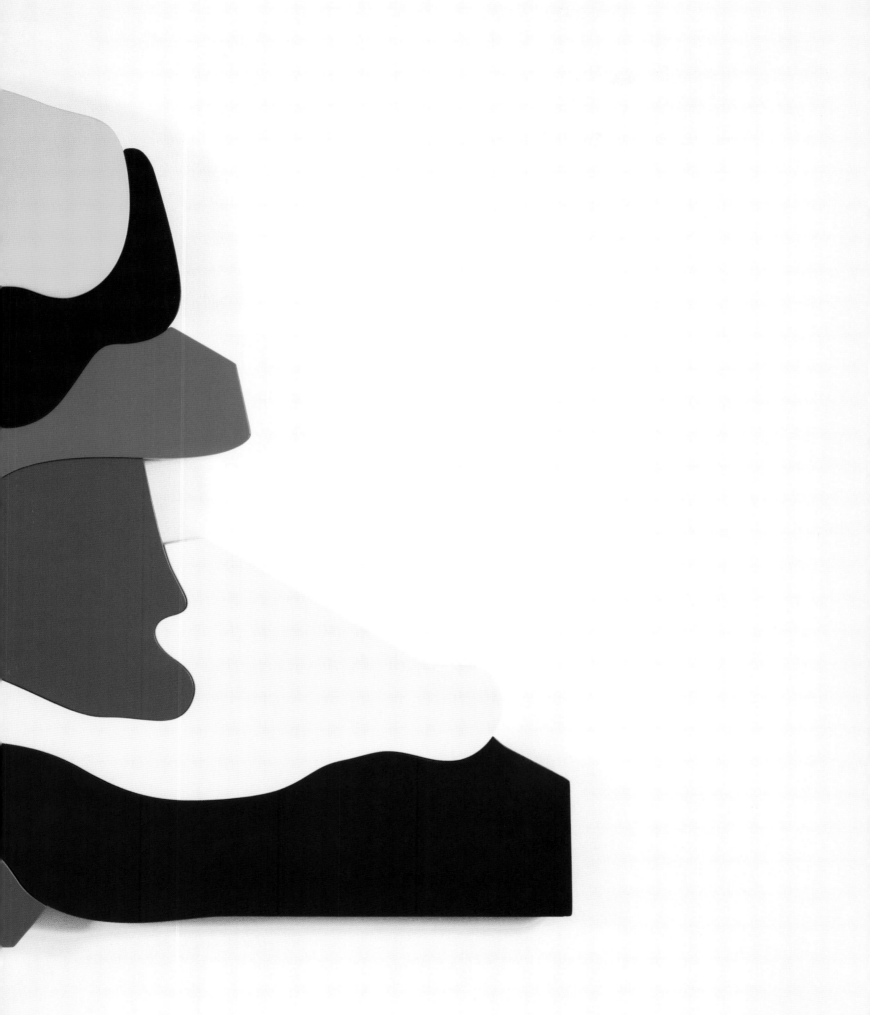

The Sacred Covering, 2011.

MDF, lacquer paint.

48 x 30 inches.

"The Sacred Covering" signifies the personification of a deeply religious sentiment. The imagery of the piece amalgamates iconography from various religions. The figure is meant to draw the viewer into a reflection on intense personal religious thought—the same feeling as walking into a house of worship or entering a meditative state might bring. The character is veiled, indicating a sacred mental mask that compels the viewer to consider "belief," and what it means to be healed. The void of the character's face and body is the boundary where the viewer must access to induce a self-transcendental moment.

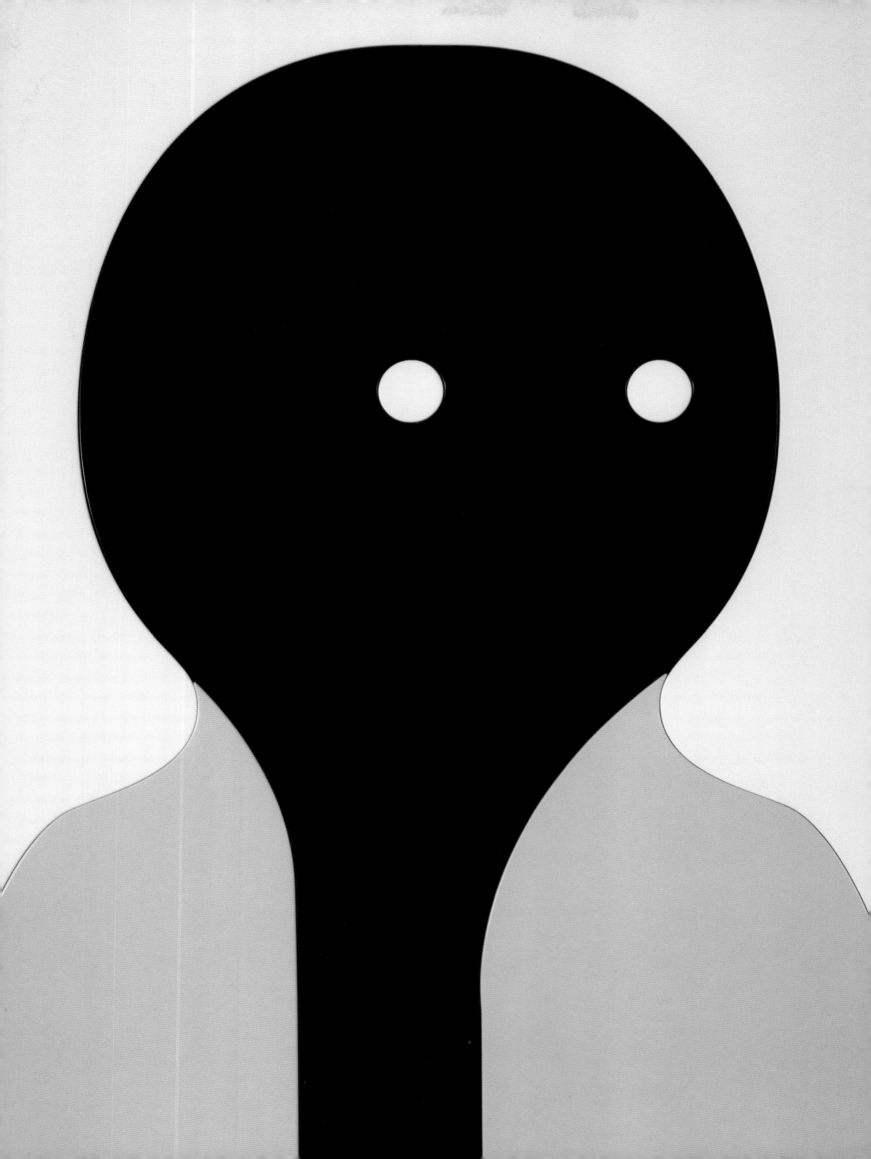

Infinity Pond, 2011.
MDF, automotive paint.
58 x 84 inches.

"Infinity Pond" is an abstracted, amorphous
puddle that emerges from the ground. He has
a highly reflective veneer, creating a mirror,
not unlike actually looking in a reflecting pool
of water. Too look into "Infinity Pond" is to
look into yourself. The story goes that "Infinity
Pond" was originally two triangles, and that
he is separating—despite the separation,
he remains a peaceful body of water.

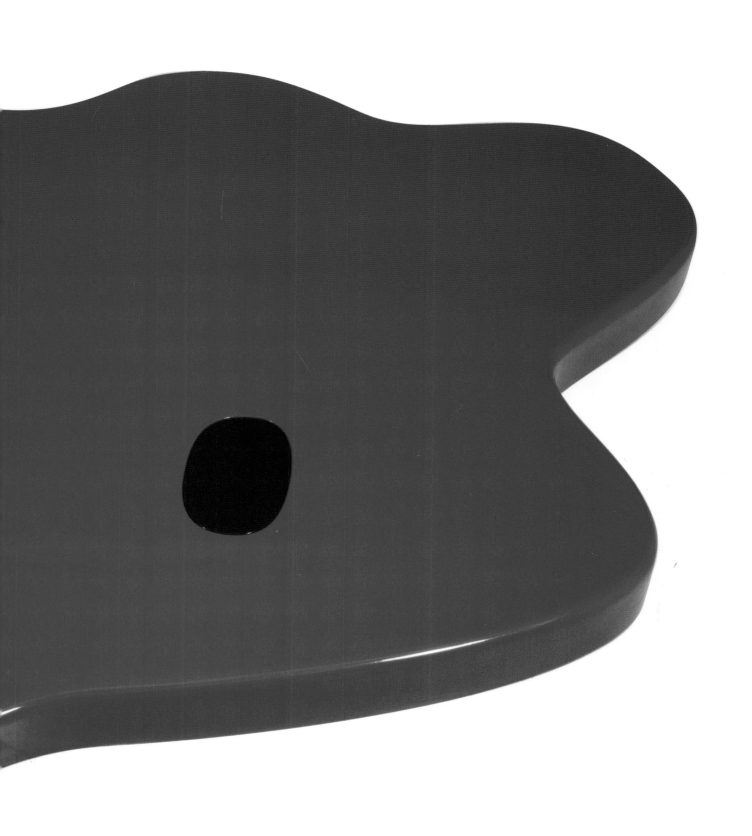

Round & Round, 2011.
MDF, lacquer paint, mechanical parts.
48 x 32 inches.

"Round & Round" is a kinetic painting made up
of two entities spinning around each other. It's
the story of the FriendsWithYou process—the
artist duo spinning emotional ideas around
each other to keep the project going. There is
a strong Buddhist color symbolism in the blue
and yellow (harmony) of the piece, giving it a
non-Western spin.

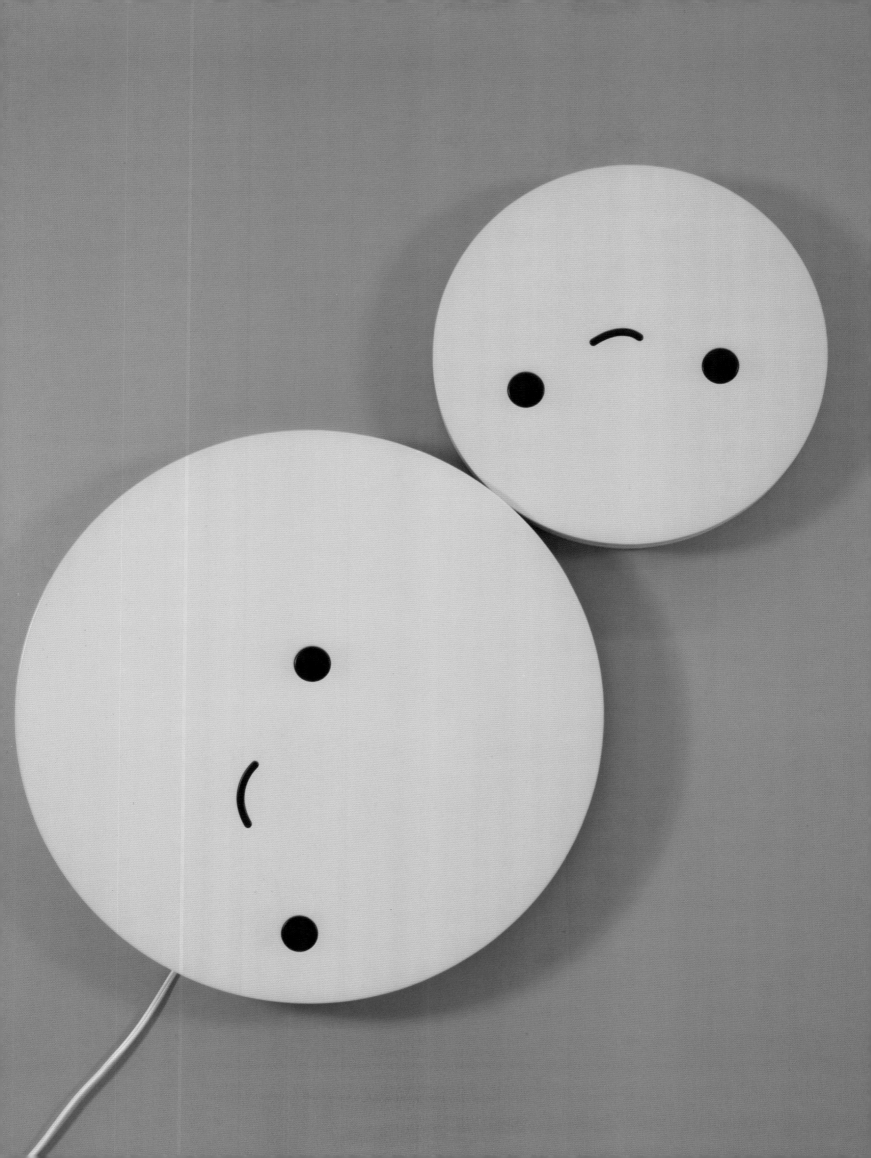

The Shadow of Death, 2011.
MDF, lacquer paint.
24 x 36 inches.

"The Shadow of Death" sticks his tongue out mockingly. He is a demon that looms, but he is also meant to give the viewer power over death. His amorphous shape and off center, multiple eyes imbue him with a mysterious, almost sickly look, as if "The Shadow of Death" might be awaiting death himself.

What converges when people are looking at our work is: us making a vessel with an abstract idea of humanity, and the viewer taking that mirror and reflecting their own idea upon the vessel.

Power, 2011.
MDF, lacquer paint.
40 x 40 inches.

"Power" is the madman of the FriendsWithYou
universe, a lightning god with reversed eyes
to give him a powerful glare. The use of a
vivid blue and red imbues "Power" with the
yin and yang of the color wheel, and his
gestural judders give him a commanding
electricity-like presence. Opposing on the
color wheel, blues and reds are often utilized
as black-and-white by FriendsWithYou.

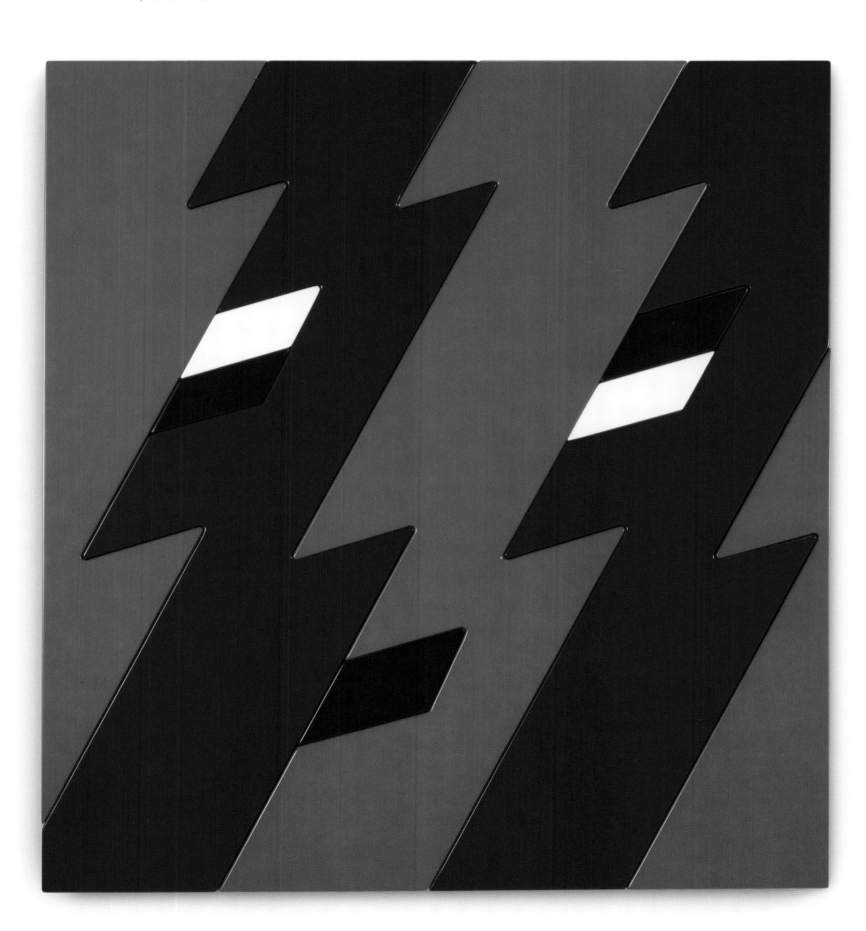

Power, 2011.
MDF, lacquer paint.
40 x 40 inches.

Cloudy, 2012.
Animated short film.
6 minutes 10 seconds.

"Cloudy" is an animated short video with
a running time of 6 minutes 10 seconds.
Anthropomorphic clouds float through the
sky, singing a childlike tune, while raindrops
operate a cloud factory, and lead an
orchestra of joyful characters through a jaunty
song. Based on the idea that everything—
whether it is sentient or not—has a role and a
purpose in the world, "Cloudy" premiered on
Pharrell Williams' culture portal i am OTHER.

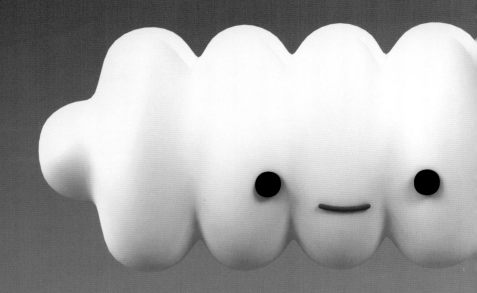

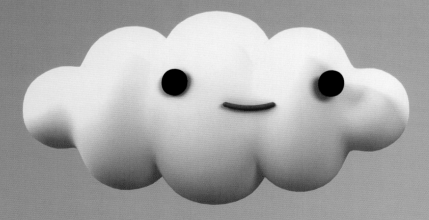

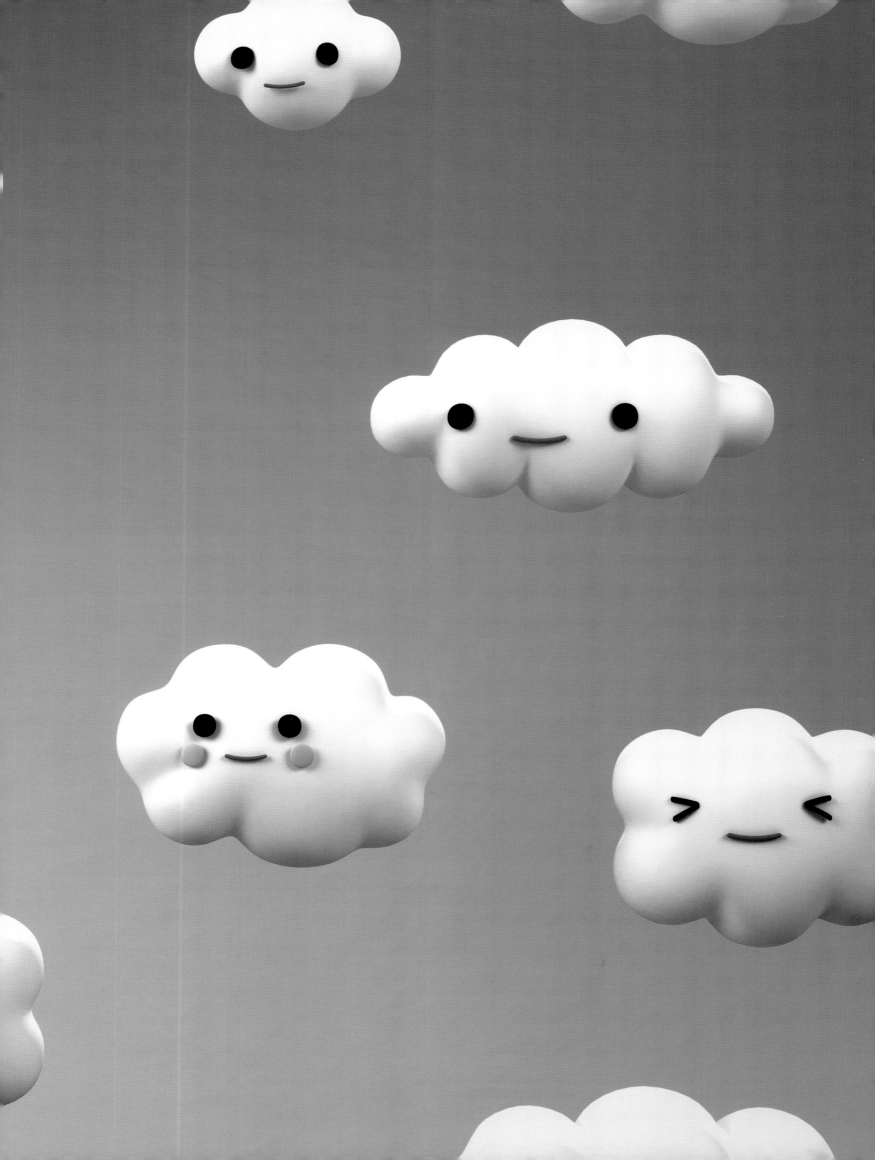

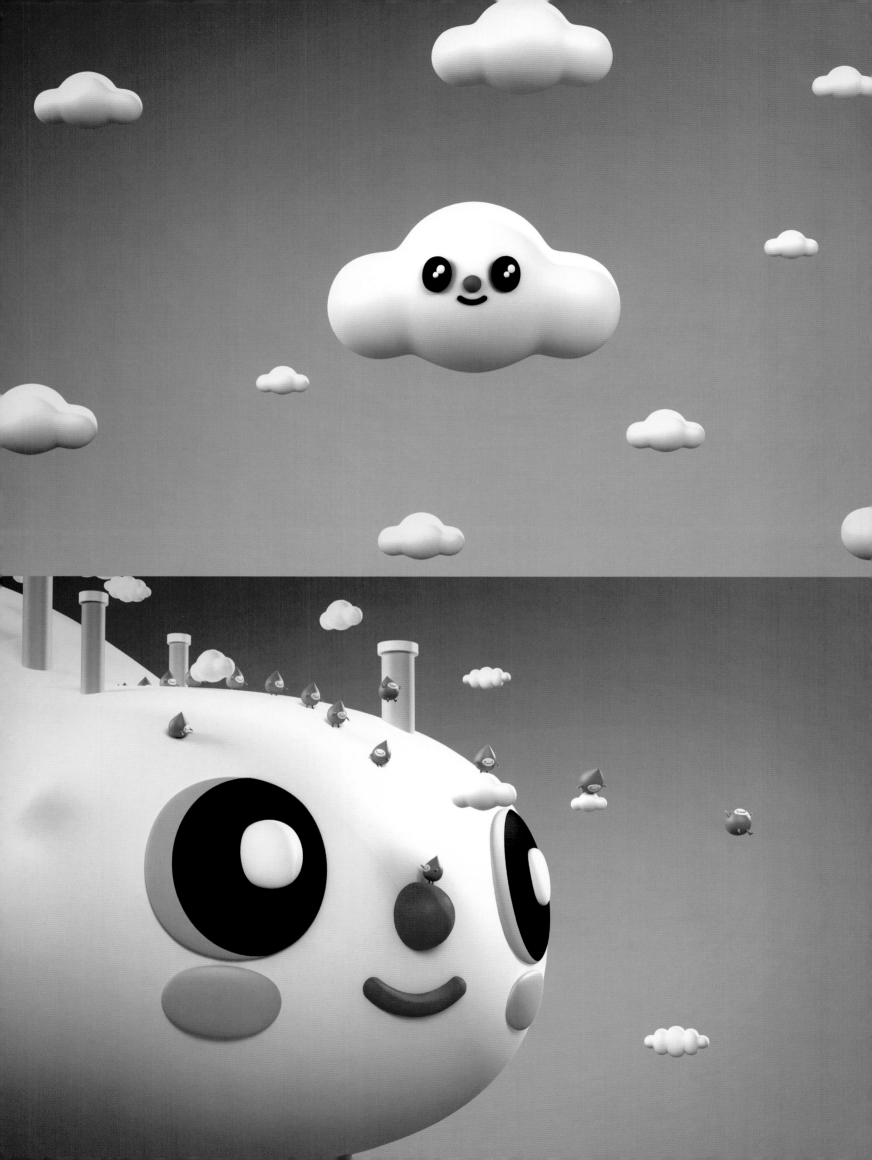

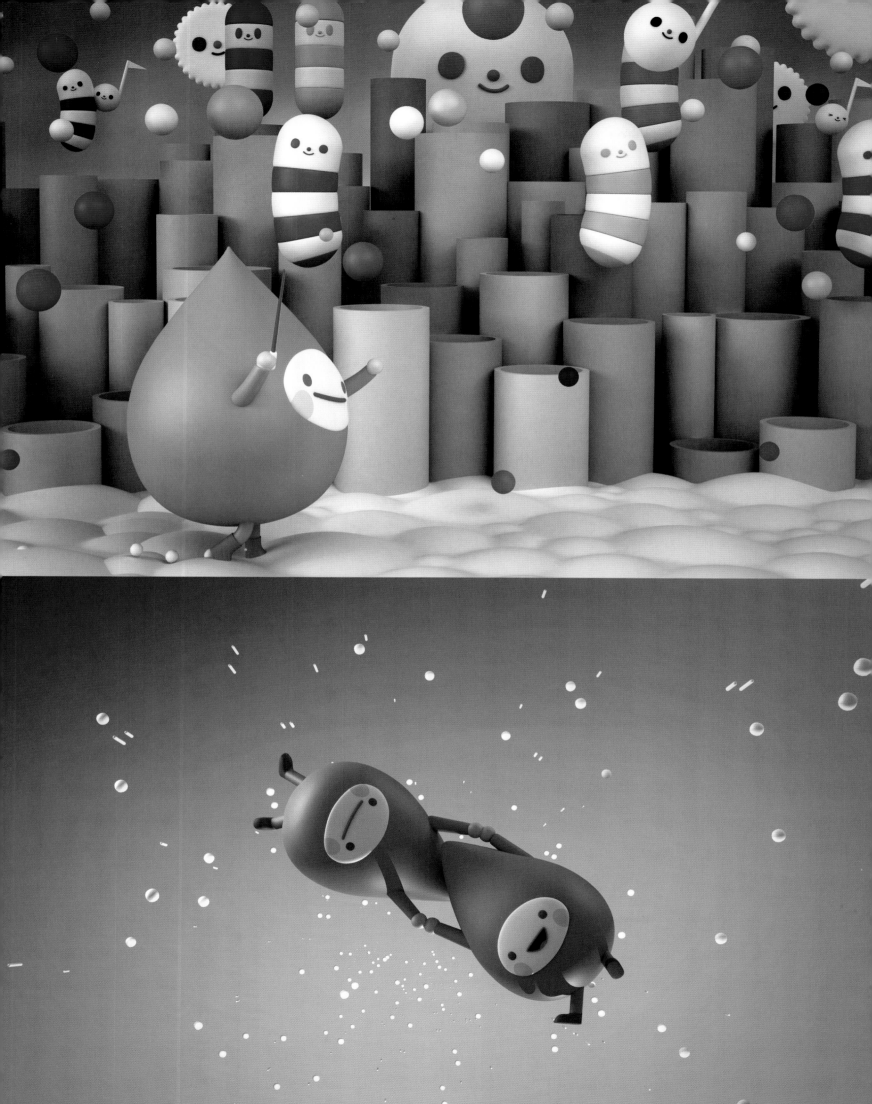

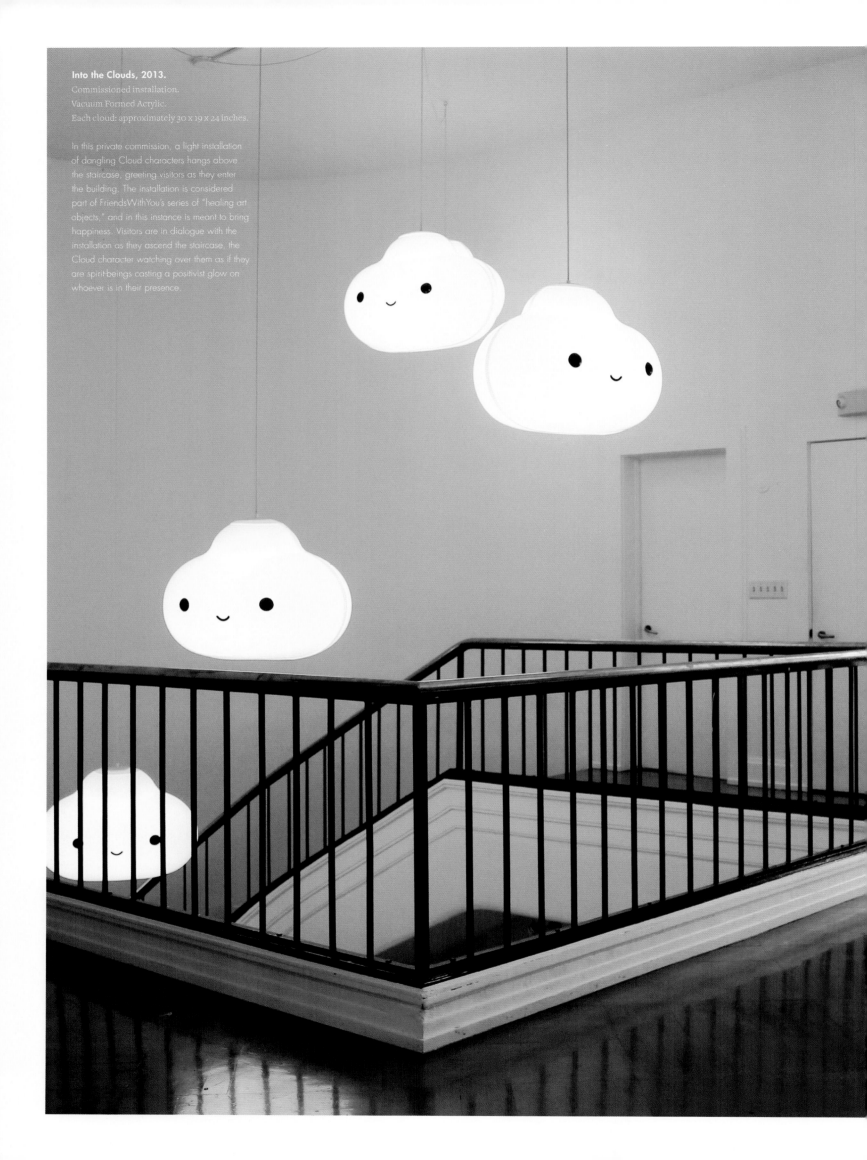

Into the Clouds, 2013.
Commissioned installation.
Vacuum Formed Acrylic.
Each cloud: approximately 30 x 19 x 24 inches.

In this private commission, a light installation of dangling Cloud characters hangs above the staircase, greeting visitors as they enter the building. The installation is considered part of FriendsWithYou's series of "healing art objects," and in this instance is meant to bring happiness. Visitors are in dialogue with the installation as they ascend the staircase, the Cloud character watching over them as if they are spirit-beings casting a positivist glow on whoever is in their presence.

The Cloud has been a Minimalist character within FriendsWithYou's work since the beginning of their practice in 2002, a clean-lined, beautiful white shape with a pleasingly firm smile and wide black eyes. Starting with early totems and plush art objects, and later explored in various incarnations through video and sculpture, The Cloud is a key symbol in the FriendsWithYou arsenal. The serene nature of The Cloud is designed to evoke a pure form of animism meant to instill a relaxed or cheerful state within the viewer. The Cloud bears similarities to certain Zuni talismans, tribal representations of spirits that the Zuni believed traveled in the skies. In 2012, The Cloud starred in *Cloudy*, FriendsWithYou's first foray into computer generated filmmaking, an animated short that sees The Cloud in a surrealist symphony in the sky, joined by raindrop friends.

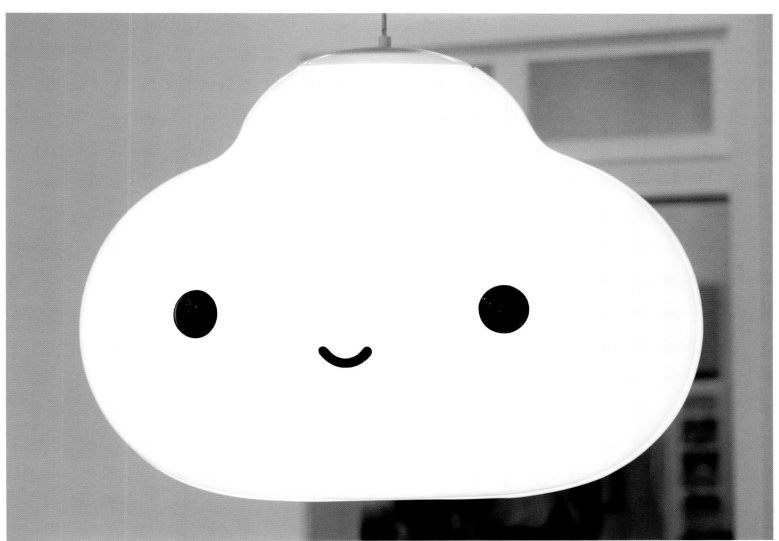

Aqui Uzumaki, 2004.
Mix Media. Installation.

In collaboration with Mumbleboy and Gaga
Inc., FriendsWithYou created "Aqui Uzumaki,"
a tornado-shaped cluster of plush toys, each
with snap buttons on them to form an animistic
storm of connectivity. The use of plush toys
in clusters brings to mind the dance between
naïve and calculation explored in Mike
Kelley's stuffed animal works.

We didn't want to make artwork that was cold; we wanted it to be a warm hug. Like Miyazaki, our style and message are warm and powerful even in the most ominous moments.

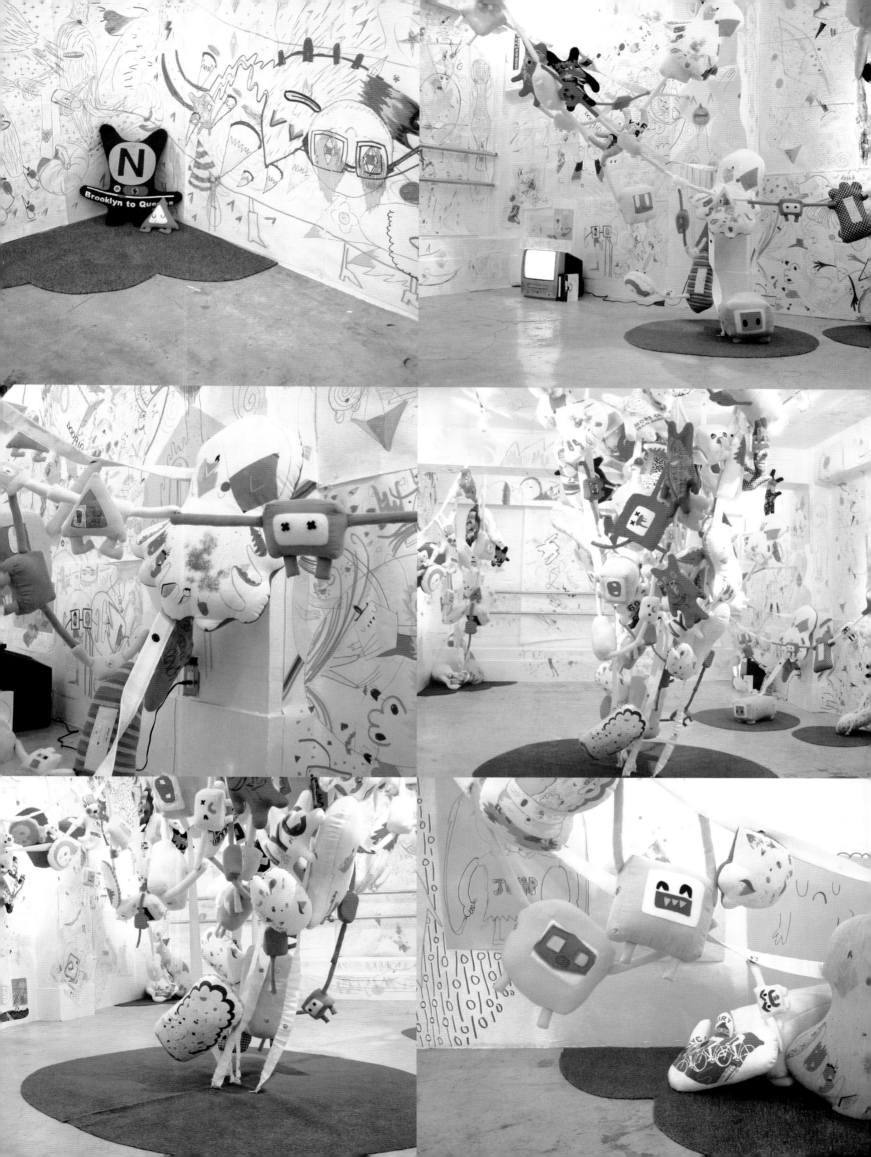

Building Blocks, 2010.

This page:
"Happy Thought"
Cel-vinyl on wood panel.
60 x 48 inches.

Following pages:
"Thinking of You"
Cel-vinyl on wood panel.
48 x 36 inches.

"Magic & Lucky"
Diptych.
Cel-vinyl on wood panel.
48 x 54 inches each.

"Happy House"
Cel-vinyl on wood panel.
48 x 36 inches.

"Building Blocks" is a collection of paintings originally shown at Art Basel Miami Beach in 2010. The paintings are spirit portraits; the abstraction of human visage allows viewers to project their own emotions. In this manner, the portraits become vacillating reflections, reliant and transformed via audience interaction. This exchange, echoed by the artists' experiential sculptural installations, delivers these paintings from flat to dimensional, aesthetics to conceptual. Presented alongside this series of paintings, the artist exhibited select sculptural pieces, meant to illustrate the progression between their installation and the "portraiture."

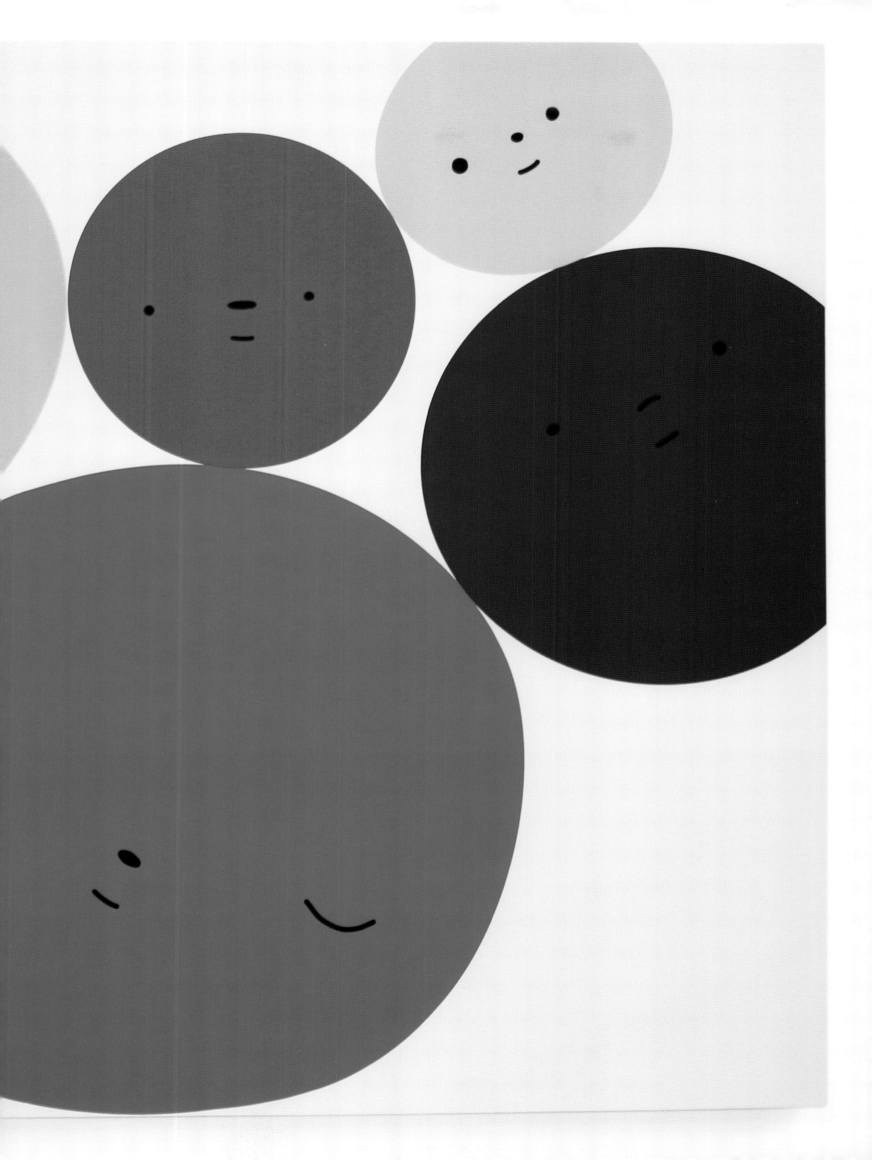

Albino Fox, 2005.
Mix media. Four room installation.

FriendsWithYou were commissioned to
design four hotel rooms and an installation
involving a car in Copenhagen, Denmark.
Each of the rooms is narrative, exploring
the different realms of existence as filtered
through FriendsWithYou's minds. The décor
of the rooms fits each of the four stories.
The vehicle became the "Albino Fox," an
animistic deity, whose ritualistic nature gave
the car a unique spiritual identity.

Why animism is so important in our practice is because we aren't afraid of making those assumptions, and that naiveté was pure and void of the cynicism of modern, science-driven philosophy. It's childlike, but it's also inherent in our psyche.

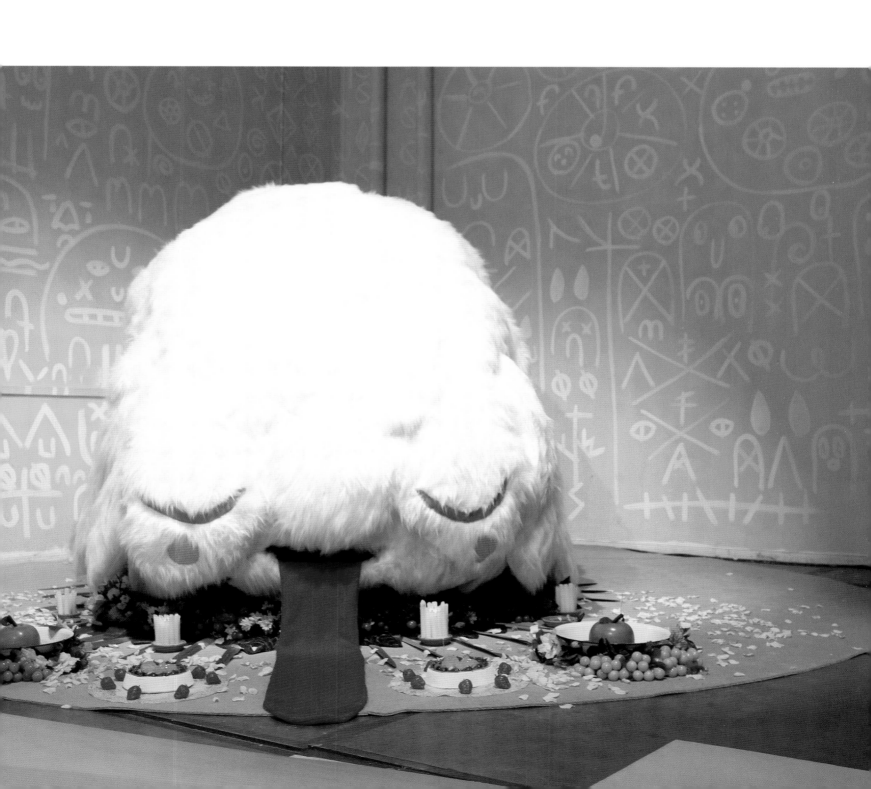

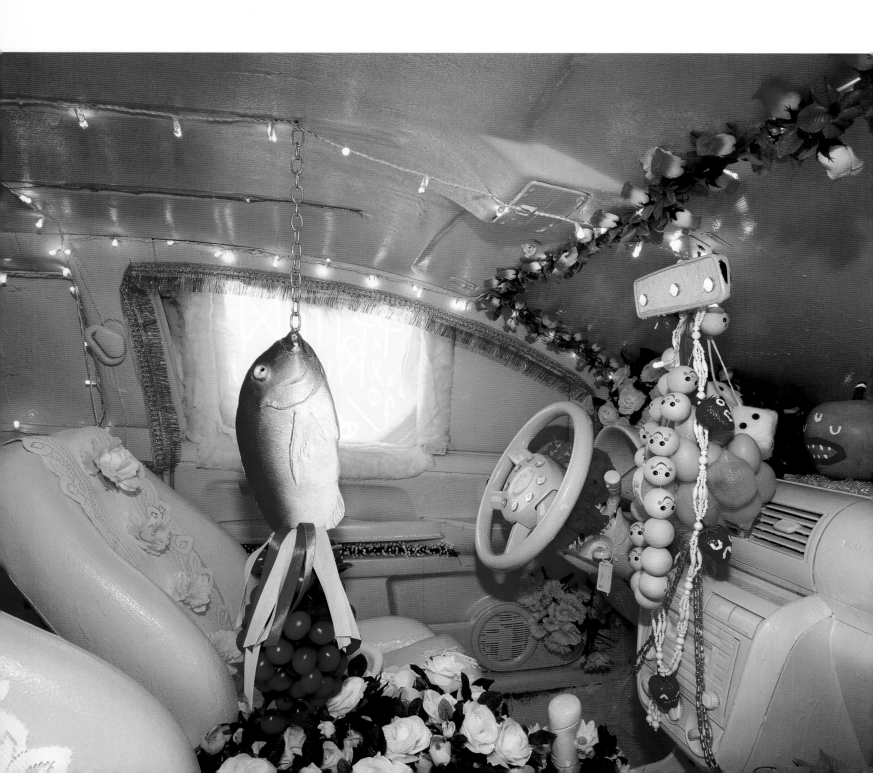

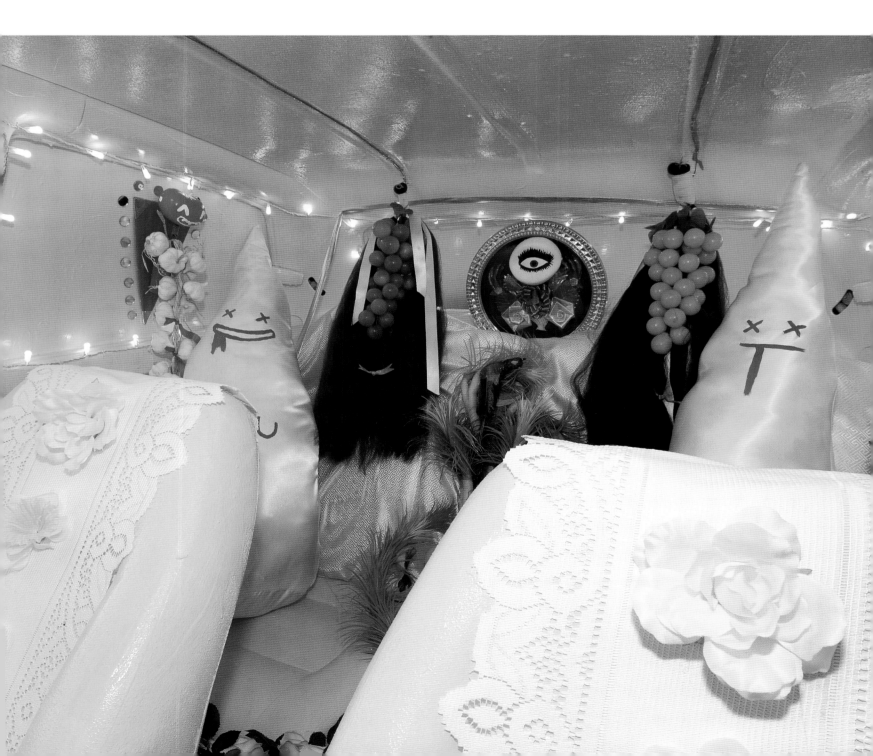

Rainbow Valley, 2006.
Mixed media. Indoor playground installation.

"Rainbow Valley" is a permanent public
artwork at the Aventura Mall in Miami,
Florida. A functional playground for chil-
dren's recreation, "Rainbow Valley" is also
a narrative work, telling the story of a baby
mountain named Peeko who is separated
from his family, and who embarks on a
journey to find other small mountains to play
with, coming across The Cloud on the way.
The playground has smiling mushrooms, rain-
bow bridges, slides, a control center, and
crawl-in mountains in bright colors. But most
importantly it contemporizes and elucidates
the sociologically intriguing idea of animism's
influence on spaces for children.

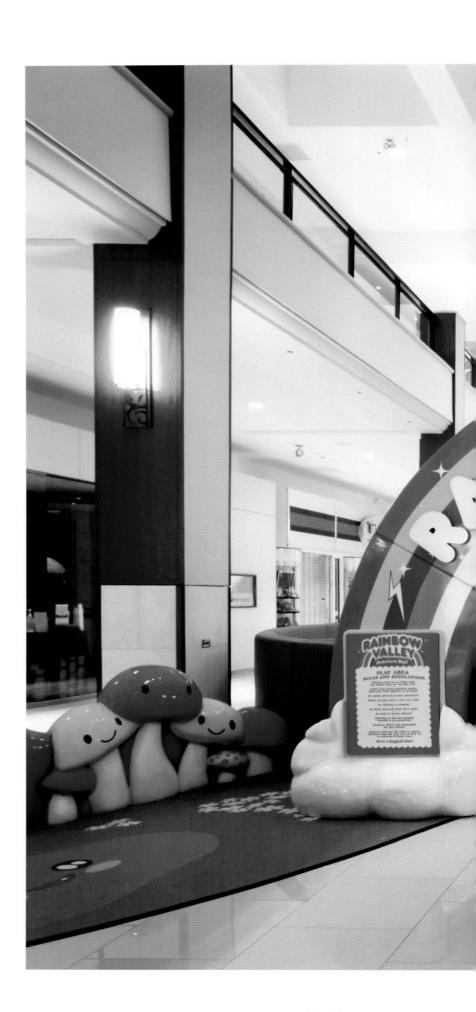

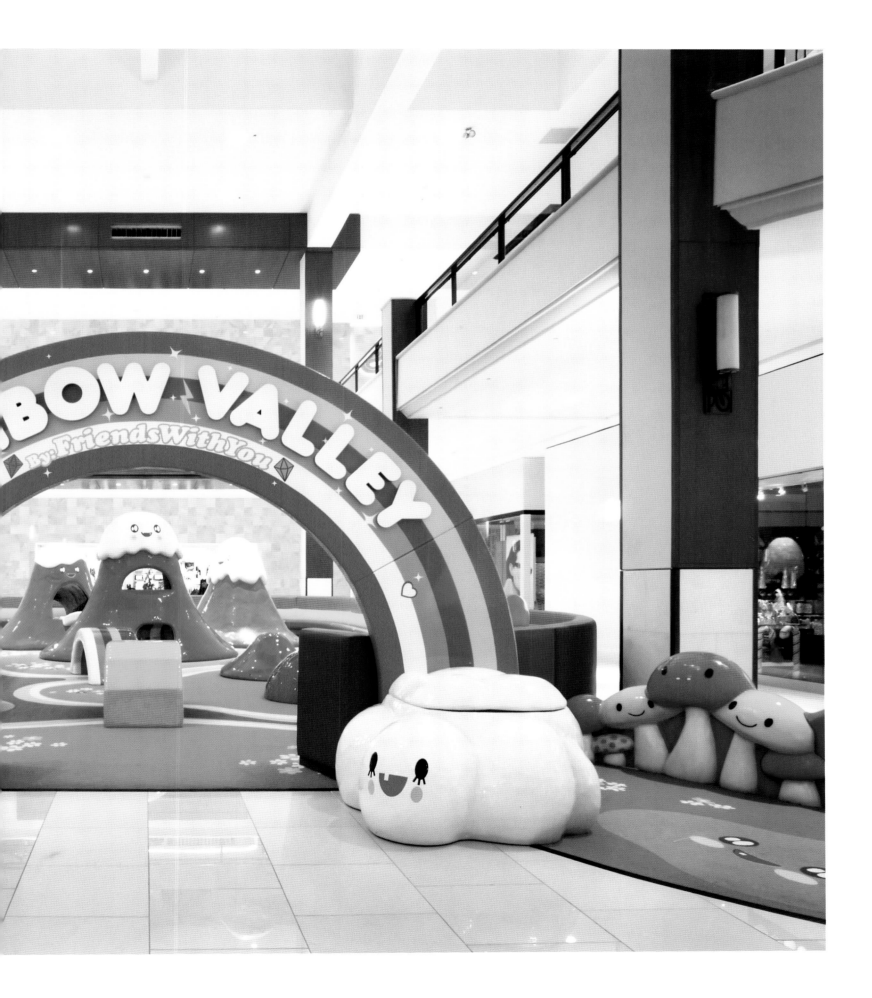

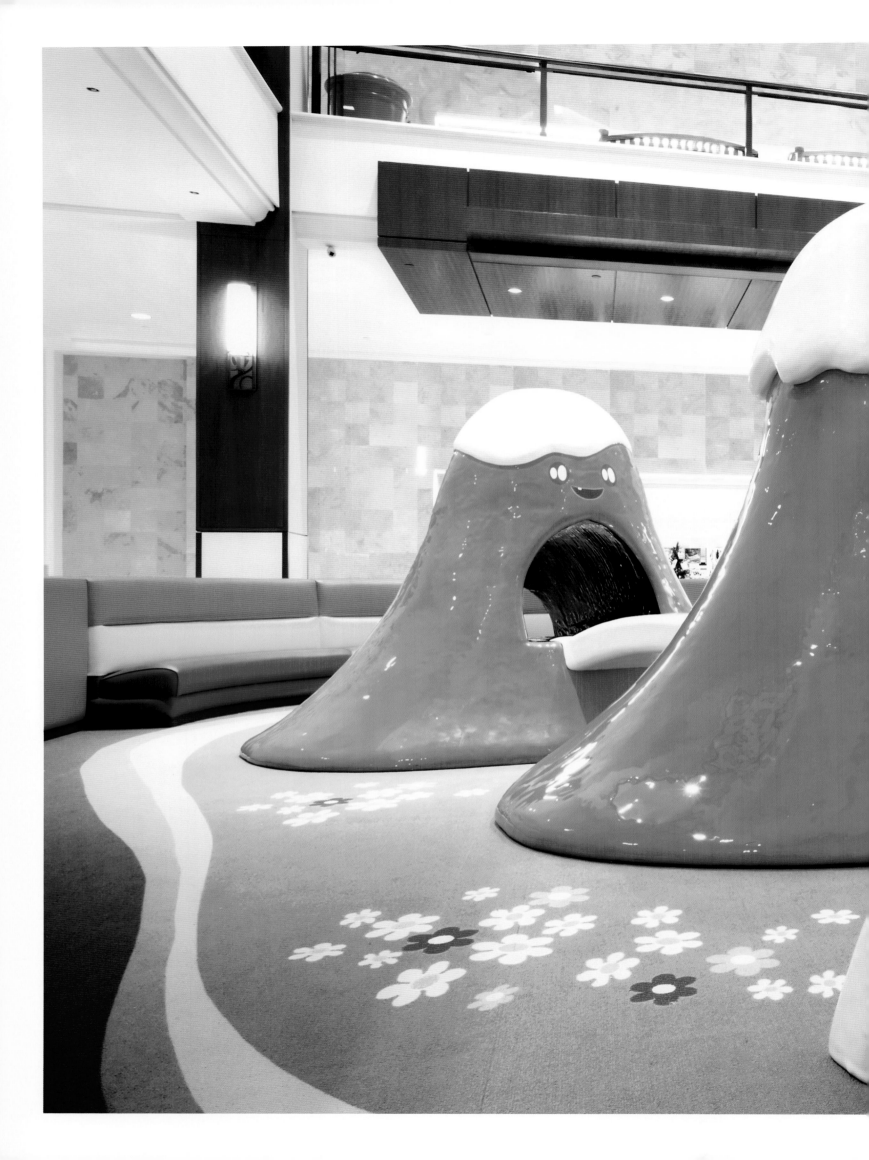

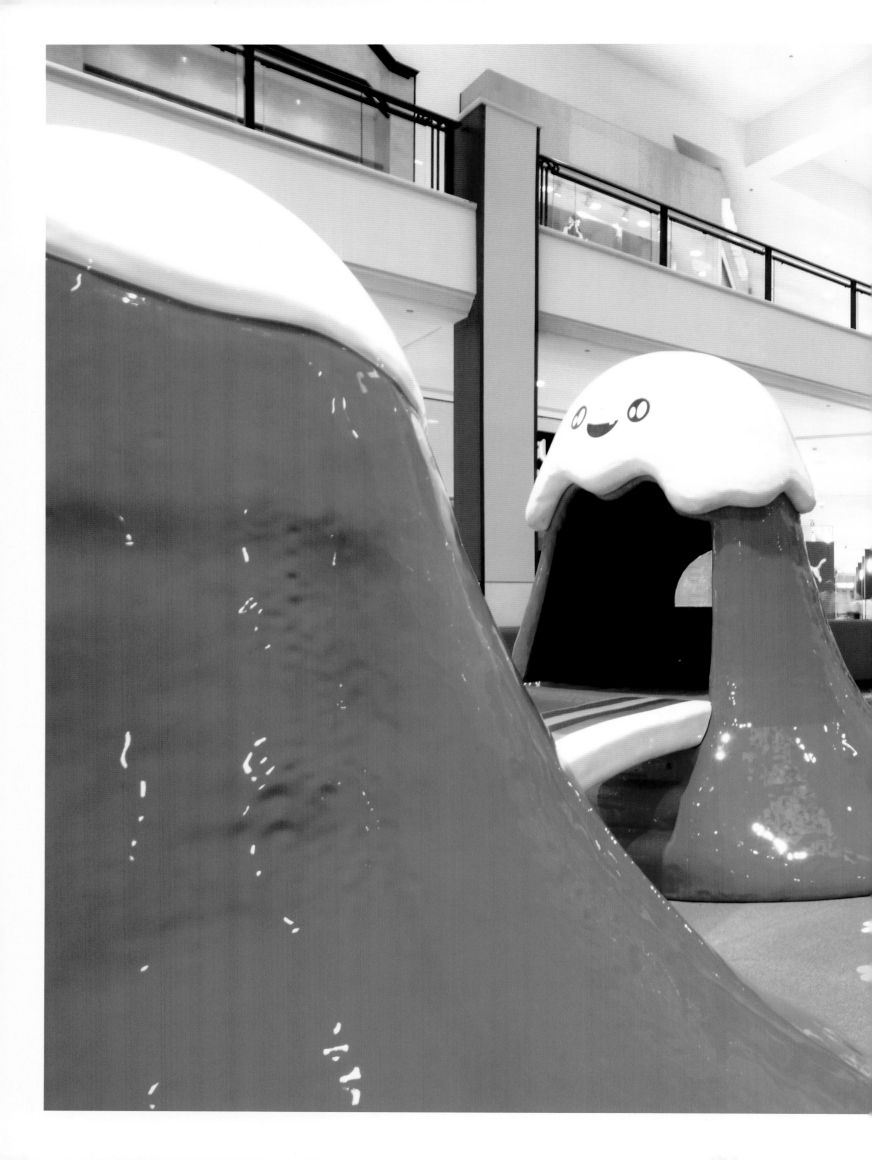

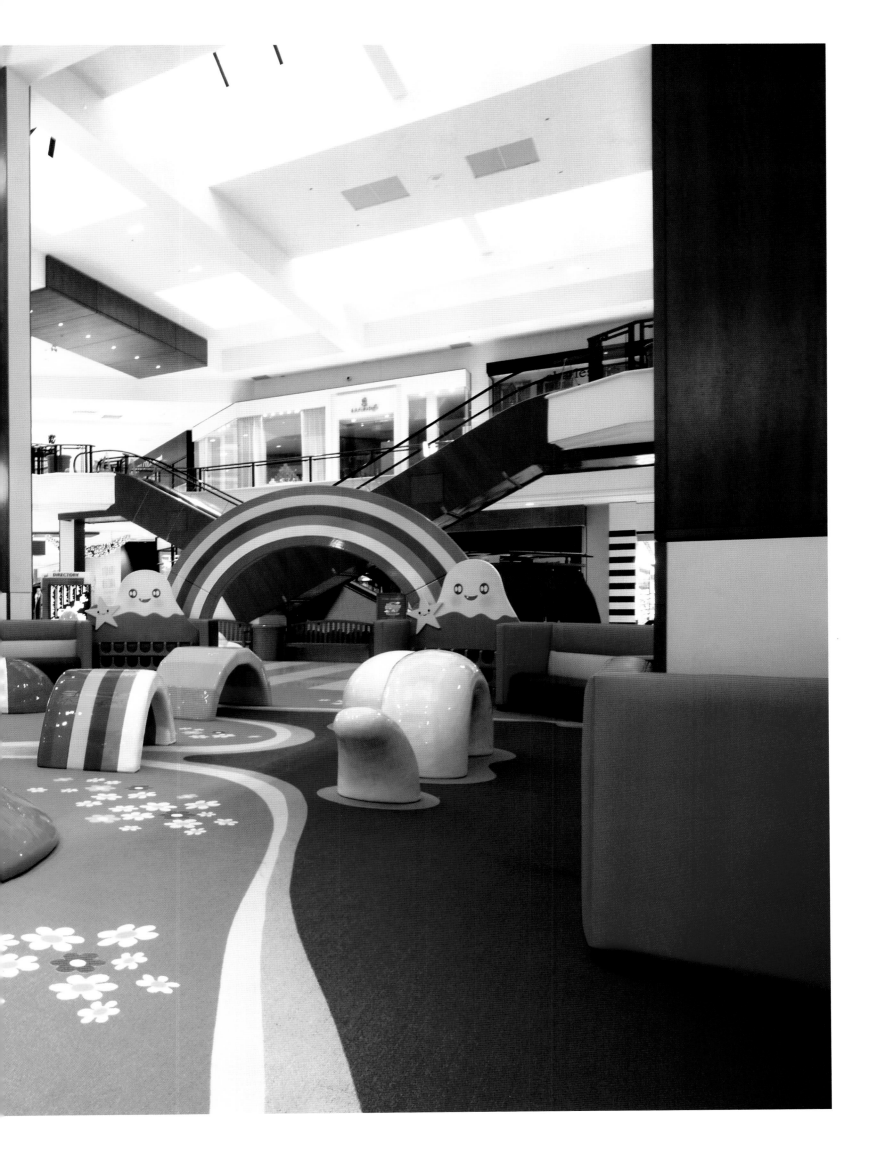

Building Blocks Prints, 2010.

This page:
"The Sleeper"
Edition of 100. Silkscreen.
14 x 14 inches.

Following pages:
"Little Cloud"
Edition of 100. Silkscreen.
20.1 x 15 inches.

"Rising Sun"
Edition of 100. Silkscreen.
15 x 19.1 inches.

"Uprising"
Edition of 100. Silkscreen.
4.5 x 4.75 inches.

These portrait-like prints were created to inspire, taking concepts of emotion and propelling them forward with animistic soul. A concept like 'moving ahead' might be represented by a character moving to the side. Each print is reductively monochromatic, and the shapes are simple, creating an impactful, yet intimate, effect.

Detail of "Dream Maker"

THE HEALING ARTS

The Chilean-French filmmaker Alejandro Jodorowsky promotes a brand of neoshamanism that he likes to call "psychomagic." Jodorowksy's psychomagic is a molding of spiritual endeavors, including Tarot, with psychological practices and genealogical study into a pragmatic approach to understanding the subconscious. FriendsWithYou utilize a similar form of modern shamanism in that they draw together several forms of spiritual practice into their own form of "psychomagic" in the form of concentrated healing efforts. Notions of spirit animals, sacred places, and other shamanic constructs merge into a ritualistic psychic healing through art objects and performance.

In the FriendsWithYou universe, plush toys take on healing properties as they accompany their owner through life, magic concoctions as if created in a witch's cauldron take on the form of customized charms, and rainbows proffer self-empowerment. The work forms a deeply generous position, pur-posefully gifting the viewer with power and encou-ragement. Positivism runs through their oeuvre, FriendsWithYou purporting a sense that an affirmative spirit holds great value, and can be utilized as a healing device.

The shaman works with individuals to rid bad things and to solve problems. As the use of specific visual imagery can generate physical and emotional benefits in the viewer, FriendsWithYou act as the shamans in this ritual. They are the practitioners, designing situations and producing images and sculptures that allow for a healing process to take place. An important aspect of this is a lowering of expectations and a full trust in the practitioner. Instead of subverting that trust like Dominique Gonzalez-Forster might, FriendsWithYou embolden the viewer by allowing them to trust them, and this positivist spirit creates a space where non-cynical joy is possible, a rarity in the art world.

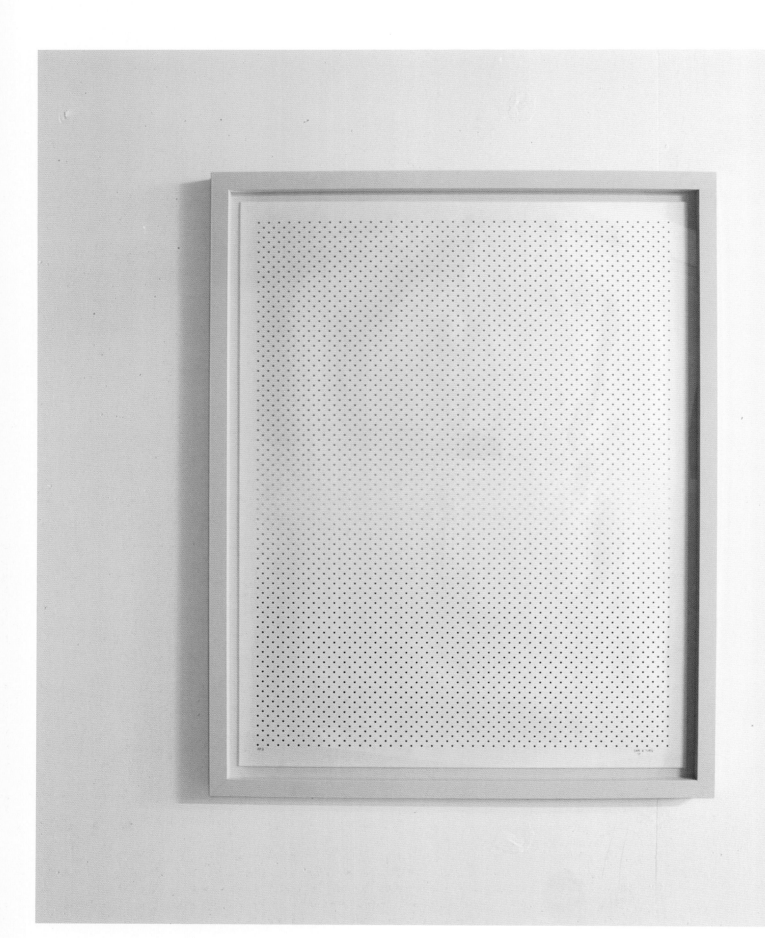

MAXWELL WILLIAMS Something that I came across that I thought was pretty telling was a review of your ':)' exhibition at The Hole in New York on *Artnet* by Elisabeth Kley. She starts the review with a quote from art critic Carlo McCormick where he says, 'My mother died last night. I would have never come out, but I knew that this would make me feel better.'

SAMUEL BORKSON Carlo thinking we could cheer him up made me feel awesome.

MW I think it really gets the crux of your work: when you walk into a FriendsWithYou show, there are symbols and histories, but they are synthesized to genuinely emotionally make you feel better. What is the process to getting to that point where it's positive?

SB We're disconnected by modernity, disconnected from communities, disconnected from praying together, and disconnected from the idea of how to re-enter those communities if we even know about them. We're so far from the tribal module that people are hurting. I feel so lucky for being able to connect with Tury and be open to this everyday process of consciously being healing workers; it's like social engineering for spirituality. We're all sad. Every day, functioning in this world—it's a tough thing. We're realizing that. We are observing the state of things very naturally, even just how we are and how all our friends are. It boils down to: don't take life too seriously. Let's play. Let's make this a joyous journey. Why don't we make our trajectory be brave with love? We're starting the next hippie movement, but it's open source, so that everybody can touch it.

ARTURO SANDOVAL III I think being positive has a lot to do with how we're put together. It's our nature. It's part of our survival and part of our own specific psychic manifestations that we have incorporated into the work. That is the dogmatic part of the work that comes with an opinion, because those are things that work for us. Gesturally, the happiness is a projection made by the viewer. People say that happiness is the rarest of commodities, but it's been proven that that's not really true. Even if our happiness levels seem to be going down, realistically they're not at all. To us, we see the faults of the system that we put in place to achieve this perceived happiness. Sam was saying how we didn't take things seriously, how we saw how simple it was to make yourself happy with self-empowerment. If what we want is happiness, and we see that that's the better way to navigate our social existence, then it's not that hard to be happy by being joiners, and

present, and mirroring what you see. If what you see is a smile, you can't help it but smile back.

MW Buddhism has healing properties—a lot of people turn to the teachings of Buddha for contentedness through meditation and acceptance. The Buddha effigy isn't precisely 'happy,' per se, but would you say that you adopt a lot of Buddha's healing abilities?

SB He can turn into a 'Happy Buddha,' which is what we've adopted. Really, what Buddhism is about, this is something deep inside our work, is saying that every emotion is valid inside of us. Buddha felt hate, he felt weirdness, but at the end of his life, he was like, 'Everyone is godly. We're sad, messed up, good, happy, bad. It's the range of emotion, and that's okay.' I feel like we concentrate on that in the same way. Our work is bright, and positive, and happy looking, but there's other emotions behind it as well. It is a range of emotion that is needed to create the yin and yang of that system.

MW What I take away from your work is that it's not escapism. How is confrontation a part of healing?

SB It's a now moment—the 'being here now.' It's when we can become conscious, and we are not on autopilot. Once you're confronted with that, you're now like, 'Right now, I'm feeling a little bit pissed off.' You realize that and accept that, and move forward to figure the problem out. Some people are way more balanced and cool like a river, and some people are more hectic and chaotic, but that's all valid. We utilize a lot of metaphorical mirrors, and reflective tools. Imagine looking at another person, and then imagine that you're the other person for a second. It brings you to a whole another level of how each other is perceived at this exact moment. It's really amazing to be here right now is my point—that we can talk about these lofty ideas of world unification. They did in *Star Trek*, why are we as a human race so far behind? What's going on?

AS But on *Star Trek* it was just an idea, you know? Ideas are cheap. From an idea to actuation is another thing.

MW There *is* a result to looking at your work, like Carlo McCormick's change in mood. Is this something that's conscious?

SB We're directly invested in that. We're completely into result-based engineering. We built these pieces with their purposes, which is also why we remain medium non-specific, so that we could have freedom in these different 'idea holders.'

Edition of 24. Silkscreen.
38 x 50 inches.

"Sunset #5" is an editioned print, featuring a rainbow gradient within a dot pattern made to explore the representation of a sunset. The dots are, upon closer inspection, actually the number 5, creating a spatial interaction with the viewer.

What I mean by that is that each piece is a vessel. Either it's a figuration—meaning it's a living idea—or it holds a power. It's an agreement that Tury and I made about every piece of work: it either evokes something that gives you power, or it is a spirit or animist harbinger of some emotion.

MW A lot of your works are amulets. In a sense, you're 'blessing' those amulets. How do you get someone to heal him- or herself?

AS Speaking to how we got Carlo to feel more positive, it has to do with him knowing our work, and having some expectation of what he was about to get. Again, from our own personal points of view, we tend to center towards the positive versus centering towards the neutral. It's better for us. If you're going to pick the Buddha, and his solemnity, and how he was just being content with it, we're saying you could be content, and get a giggle out of it. Our personality traits, we use those kinds of tools on our daily lives, and that seeps into the work.

MW Artists often use cynicism that point out the world's problems, whereas you use optimism, but you're still addressing those darker themes as well. Why are you constructive and upbeat where others are pessimistic?

SB Even if we show the darkest moment, it's meant for positive engagement. It's not just, 'Let's be shit, and draw, and fucking drink beer, and do heroin to death.' Even if we show you that you're dead, it's for good. I feel that we're getting more seriousness inside of our silliness, because we've grown. We started as these almost clown-like, funny fool-types, but we have grown, and we're beyond the early stages of being able to find the tools to do all these things. Now, we're learning how to engage these bigger ideas.

AS I wasn't even positivist at first. The first Friends-WithYou toys were more whimsical and just odd. We're trying to be awkward, because we were awkward. We were strange. They were positive, but it wasn't all smiles. I think that the happiness in that first

project came out of the skewedness of it. We were ourselves skewed in how we were seeing things, and then we framed it in a positive way.

SB 'Friends,' the first project, were these little tiny friends that were microorganisms that we had developed in a lab. They were engineered at the microscopic level to help people. That was the whole concept. They had been enlarged. Some were quirky, and some were jerks, and some brought you wealth or death, and some took all the color out of things. The idea was that these things were of service to use in any way that you wanted to.

MW And that was before you could really even articulate that you guys were positivist?

SB Way before.

MW It's really interesting the way that the certain aspects of your work have stayed within your work from a pre-history of being self-aware of what you were doing. You have evolved as artists more than other artists are willing to admit.

SB It's hard work to get anybody to notice you from Miami. This was the first year of Art Basel. Miami was a wasteland with no cultural identity. It's beautiful to grow your seeds, till them, work hard as a farmer, and then have results actually start to happen. We now have the pure freedom of being able to work on what we want to and manifest things that could only be dreams.

MW Have you ever been healed by art? Does working with all this positivity have an effect on you?

SB There is a personal journey embedded within the healing arts concept. In the beginning, for me, art was completely a healing practice. It was never a hobby; it was a need to expressing and harnessing this crazy energy that I had. I was in a dark place, and making art was the only focused way that could let me be hateful and angry and expressive freely with all the emotions that I felt, but with-

out actually hurting other people. My first lunge at art was a powerful exertion of negativity, but now I have good vibes and good magic. I became drawn to the feminine, open, cute, *kawaii* feeling. I secretly wanted to be nice and smiley. The want and need for that was baked into both our personalities. Just working in a therapeutic way with bright colors, symbolic ideas, and vibrant forms brings peace and empowerment.

AS I don't feel, for me personally, that it was so ever about healing myself, so much as the idea that our works are an exercise in finding god or finding effective manifestation of the fifth element. What made the work healing at the beginning was that our happenings were positive. It was an ongoing exercise on positivity, and on being spirit driven. It wasn't as if we were saying, 'This is broken; how do we fix it?' It was more, 'How do we keep this positivity going forward?' When I'm in my own exhibition, I'm feeling happy, but when I'm concepting, it's not a requirement for me to be happy. It doesn't correlate as much. I think about those things more abstractly and deliberately as opposed to a thing where I feel happy, and I make happy things.

SB It does affect me. My heart is with the work. Everything that I make, even if I'm feeling the full range of emotions for the day, it goes into the creation of the thing. When I create, I'm channeling my whole being through all my actions of creating art. It's not necessarily happy or sad, it's whatever it is in that moment, and it fluctuates. That being said, where I came from—sad, lost, no parental relations—I feel grateful on a regular basis. Even my best days when I was a miserable, sad person don't compare to my shittiest days here.

MW I'd like to bring up Alejandro Jodorowsky. He is obviously a kindred spirit in the sense that his entire philosophy right now is to live life as a healer. You put yourselves in the position to be the people that are doing this healing to. How do you guys see yourselves in the sense that you're making works that are meant to be healing?

There is a personal journey embedded within the healing arts concept. In the beginning, for me, art was completely a healing practice. It was never a hobby.

SB I think at early points in his career, he was more into really being affecting, evoking, and evocative. The graphic novels, like *The Incal*, show the transcendental side of him. I feel like he made a science through his visual and storytelling. *The Incal* was one of the first works of art that I experienced in my life that was transcendental, next to Hayao Miyazaki's work. Their work holds such sacred truths. The symbolism that Jodorowsky uses carefully and subtly transcends thought and opens perceptions and makes you think of the androgyny of the man and the woman. That said, I don't deem myself as a healer. Jodorowsky viewed people who said that they were healers. He's like, 'No. I think everybody can heal themselves.' Through that understanding, that is where I feel like the healing emanates from. I feel like the art that we're doing is taking a step back, and letting the vessel do the healing. This is a visual art that we put up that's allowing the viewer to make his or her own step towards healing. That's the key towards something very amazing that Jodorowsky says: the

person needs to step into the magic. We're offering it out there on a golden plate as much as we can, putting it out into the world, even forcing the viewer to play on it, but for them to take that step further is all in their hands. We're just opening up that door for just the possibility of that. When you can know that you can manifest those things or you can be healing yourself through active, conscious thought—that is one of the most powerful things in the world. Everything can blossom from there.

MW There are lots of parallels in your work and his. Your early work was more Dadaist in nature in the way that you approached it, and that you were just trying to be irreverent or something. His early works were very Dada and very surreal—they were the definition of post-surrealism. He has since moved into this place where that imagery and that idea that Dadaism is actually a legitimate way to think about the world still exists, but he describes himself as working in healing arts. You obviously started with that Dada aesthetic and went into this

area where some of your work can be described as healing arts.

SB I think it was always for healing, even in its irreverence. Even the original plush toys, in their own way, were supposed to be anti-cynical because of their silliness. 'Get Lucky,' our first installation, each altar was meant for you to gain something for your life, or at least thinking about it with a color and a power attracted to it. One was 'get wealth.' One was 'get love.' One was 'whiteness' for calmness, beauty, and openness. One was 'blackness' for the power that you need. We were trying to open those ideas for people. We gave them the ability to talk to a god, which was this character called the 'Fur Liaison' that you could speak to and he would react and speak back. It was as if we were saying, 'Okay, so we're bringing our god from this amorphous nothingness and putting him in this big furry animal creature. You're able to speak to him.' We were giving the people the power over the whole thing: 'You're the creator now. What do you want to do?'

Psychic Stones, 2013.

This page:
"Everything"
Unique multiple.
Sacred objects encapsulated in resin.
6 x 4 x 3 inches.

Following pages:
"Happiness"
Unique multiple.
Sacred objects encapsulated in resin.
6 x 4 x 3 inches.

"Wealth"
Unique multiple.
Sacred objects encapsulated in resin.
6 x 4 x 3 inches.

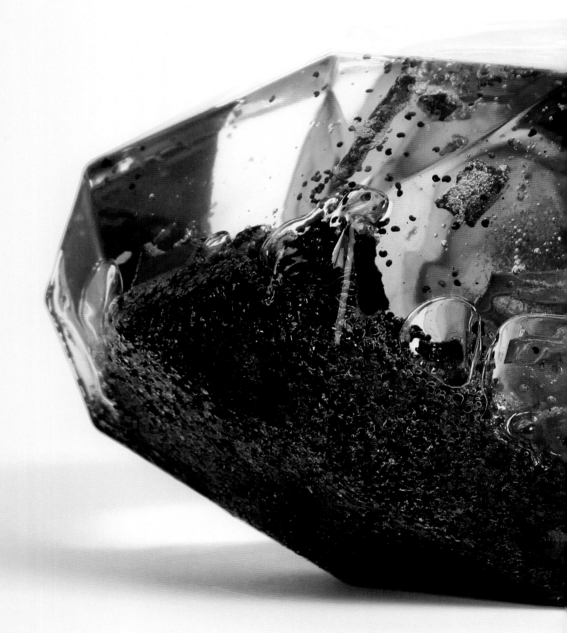

"Psychic Stones" are created for healing, focus,
and self-empowerment. The process begins
with the user consciously creating a personal
focus they want for their life. Embodying the
role of shaman, the artists ask the collectors
a series of questions and craft the stone from
their answers, creating artistically divined
items. In inviting the collector into the creation
process, the artists allow for a collaborative
exchange, resulting in a piece that embodies
both the FriendsWithYou aesthetic and the
personalized wish of the commissioner. This
resulting high gloss urethane stone will be
filled with objects tailored to the collector.
Through this, the stone becomes an amulet of
connectivity, protection, and self-empowerment.
Each stone comes with a custom magical ritual
explaining how to use and care for the stone.

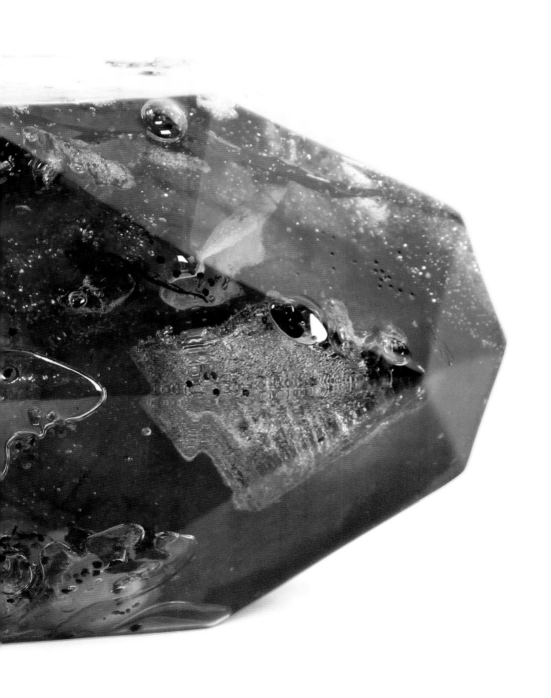

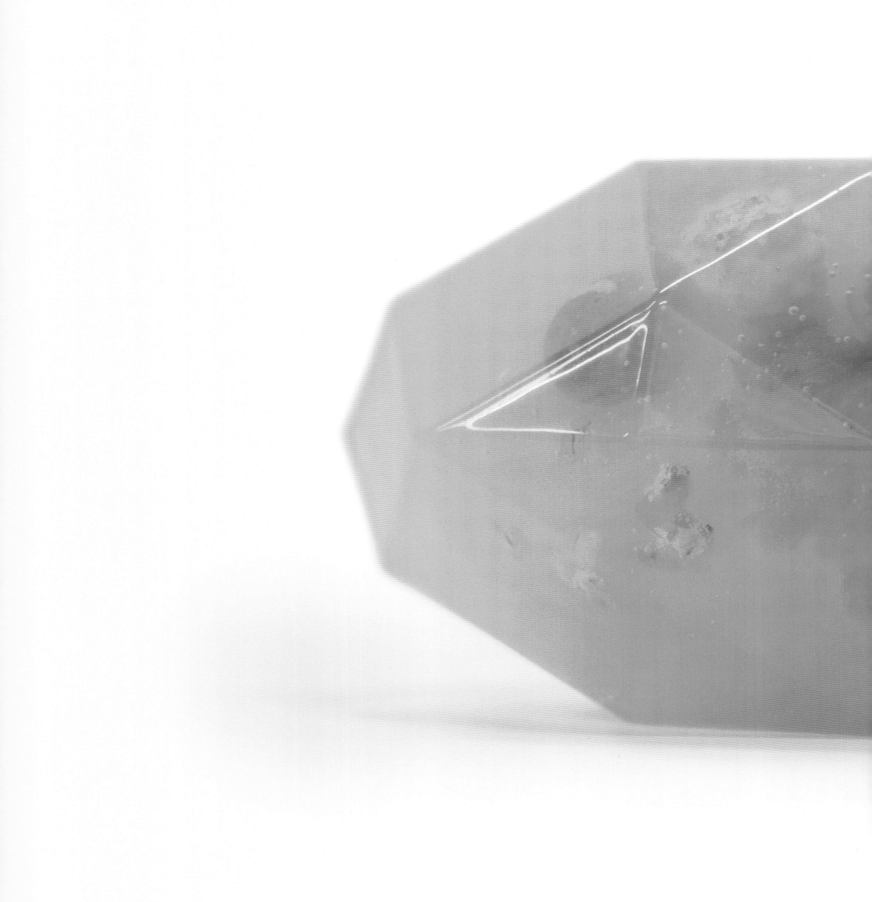

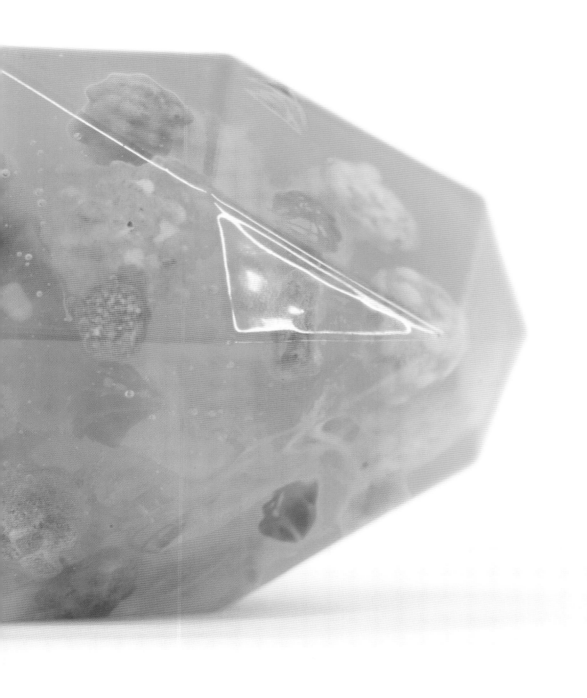

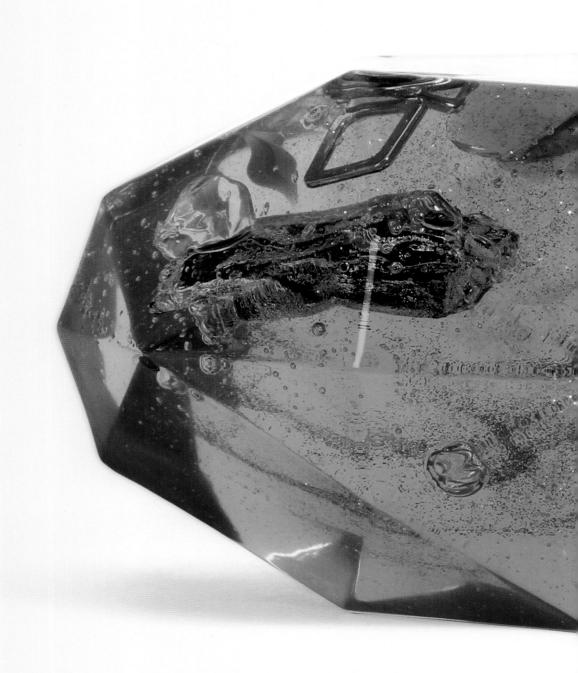

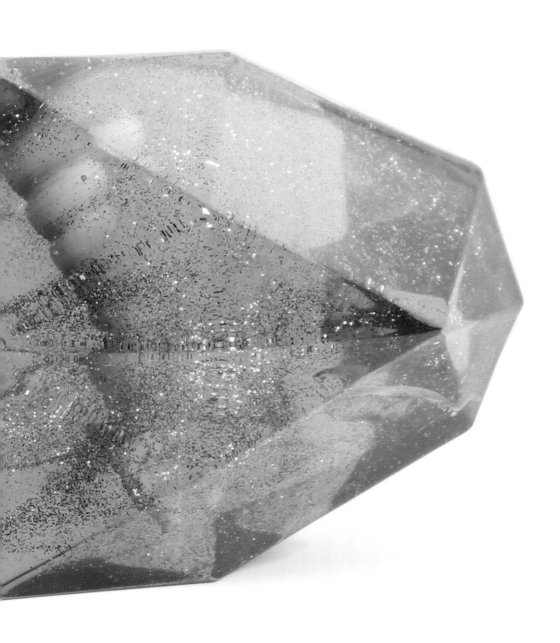

Dots, 2013.

Digital Pattern.

Dots represent many things in the Friends-WithYou canon. They can evoke the Hindu traditional bindi decoration, which women wear to represent the sixth chakra, ajna. The anja is also a representation of the third eye, and in this, FriendsWithYou are asking the viewer to look inside themselves when they are viewing their art. The dots can also be read as the patterns of the cosmos, and the idea that the whole world is made up of dots, a representation of subatomic geometry. Specific solo exhibitions have featured entire galleries painted with dots in this galaxial form.

Red Light, 2013.

Edition of 48. Silkscreen print.
24 x 36 inches.

Part of FriendsWithYou's healing properties comes from a willingness to experiment with therapeutic color combinations. In "Red Light," an analog gradient shows the movement from dark to light, while the red color is representative of motion, as in fire and blood. The red is active, but it is mixed with a calming lightness, creating a mixed mood of power and serenity.

It boils down to: don't take life too seriously. Let's play. Let's make this a joyous journey. Why don't we make our trajectory be brave with love?

See You Inside, 2013.
Edition of 48. Silkscreen print.
24 x 36 inches.

FriendsWithYou utilize optical illusions to
help their pieces achieve a functional
emotional transformation. This striped face,
called "See You Inside," is meant to be
stared into until a change takes place, and
your state and the piece's state are blurred.
The print, which enacts motility like a Bridget
Riley painting from the 1960s, acts as a
portal into a new mind-realm.

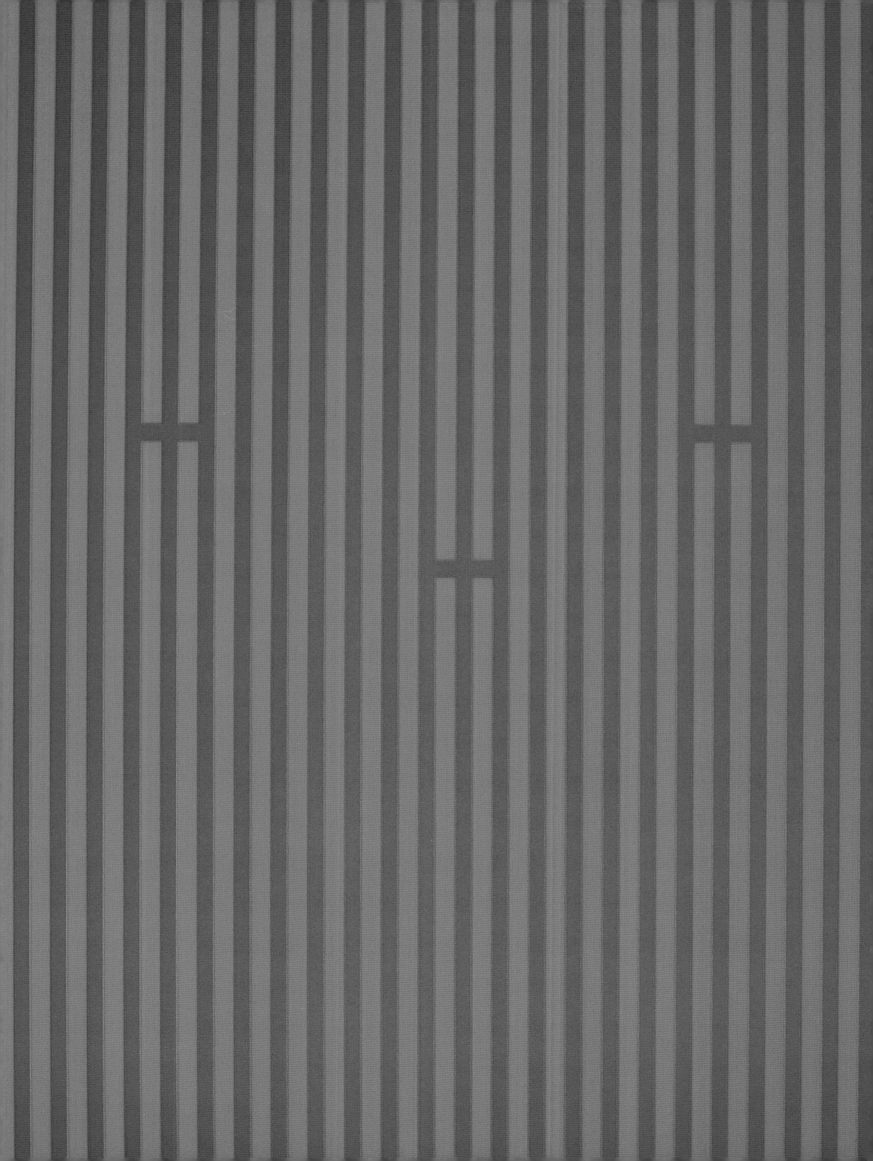

In Between, 2011.
Car paint and acrylic on lasercut MDF.
38 x 26 inches.

"In Between" is a series of prints that was
created and conceptualized during Friends-
WithYou's transitional period. The prints are
simple, checkerboard characters, whose
eyes that are almost hidden, representing a
mascot for finding oneself in between the
lines and within the pattern.

Weeble Wobble Wish Come True, 2008.
Vinyl toy.
Dimensions variable.

The Wish Come True characters are reimag-
ined as "Weeble Wobbles," small weighted
objects that jingle when shaken. Each of
the characters has its own power, and this
power is transposed to the possessor. The
Weeble Wobbles are an accessible ritual.
The viewer then absorbs the powers of each
figure in the Wish Come True universe.

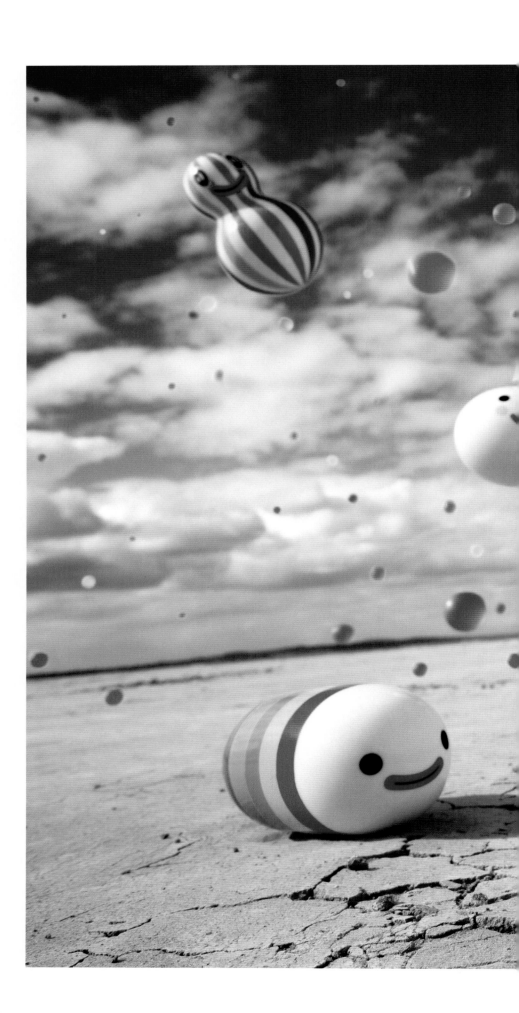

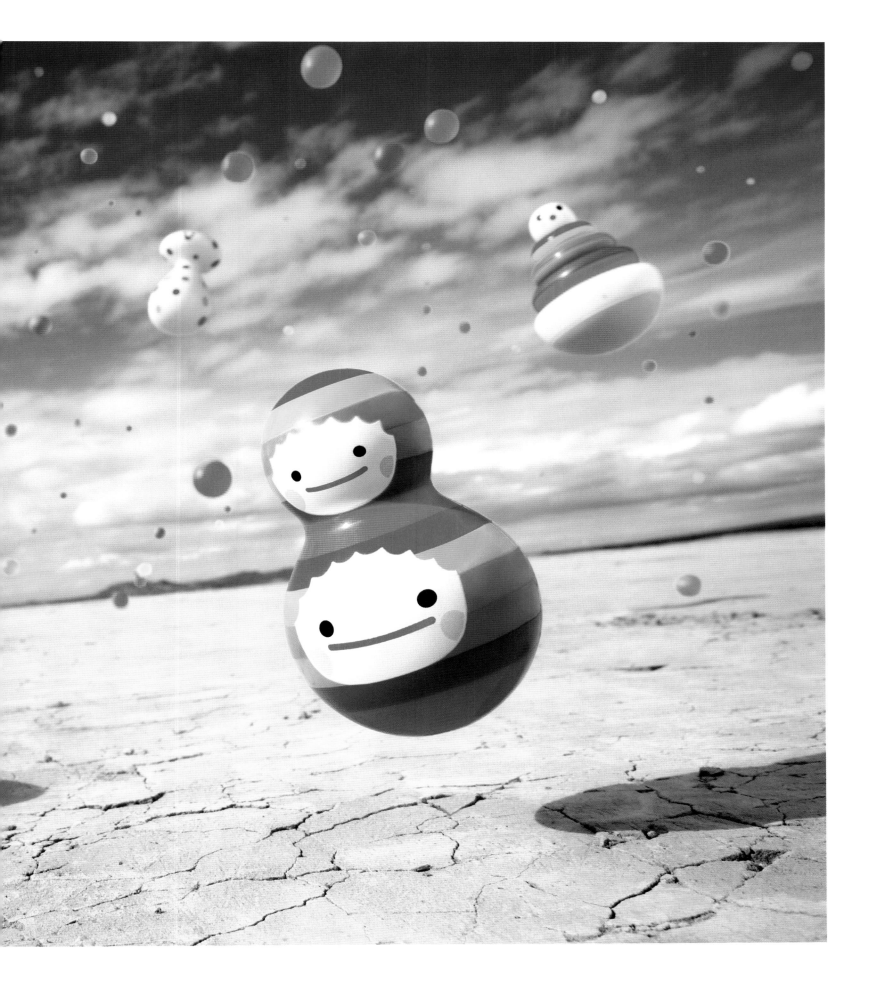

Wish Come True x Hello Kitty, 2011.
Collaborative multimedia project.
Dimensions variable.

When FriendsWithYou's Weeble Wobble Wish Come True toys became a successful foray into take-home empowering amulets, they caught the eye of Sanrio, the company behind the iconic global phenomenon Hello Kitty character. Sanrio approached FriendsWithYou with a collaboration, which offered the artists an opportunity to spread their message to a broad audience. FriendsWithYou approached the collaboration by absorbing the Hello Kitty character into their Wish Come True universe. The concept behind Wish Come True for Hello Kitty is to put wishing amulets into the hands of the audience through childlike characters such as Rainbow King. Hello Kitty became a powerful advocate for those ideals. The characters are imbued with messages of environmental teachings, respect for the earth, and empowerment within yourself.

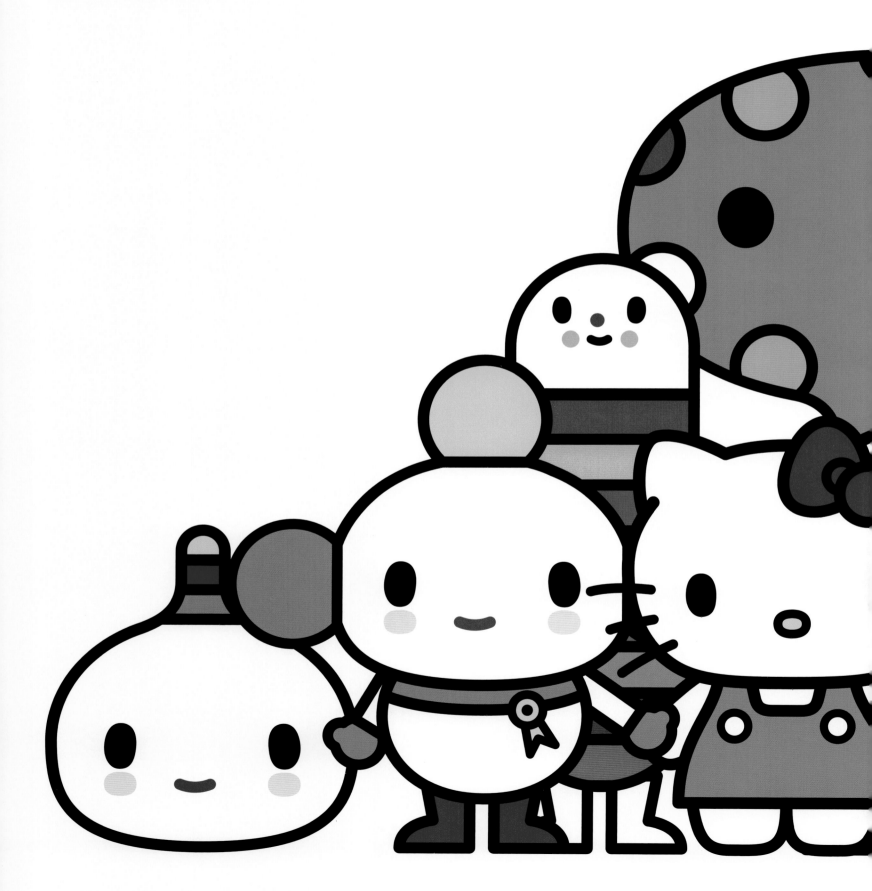

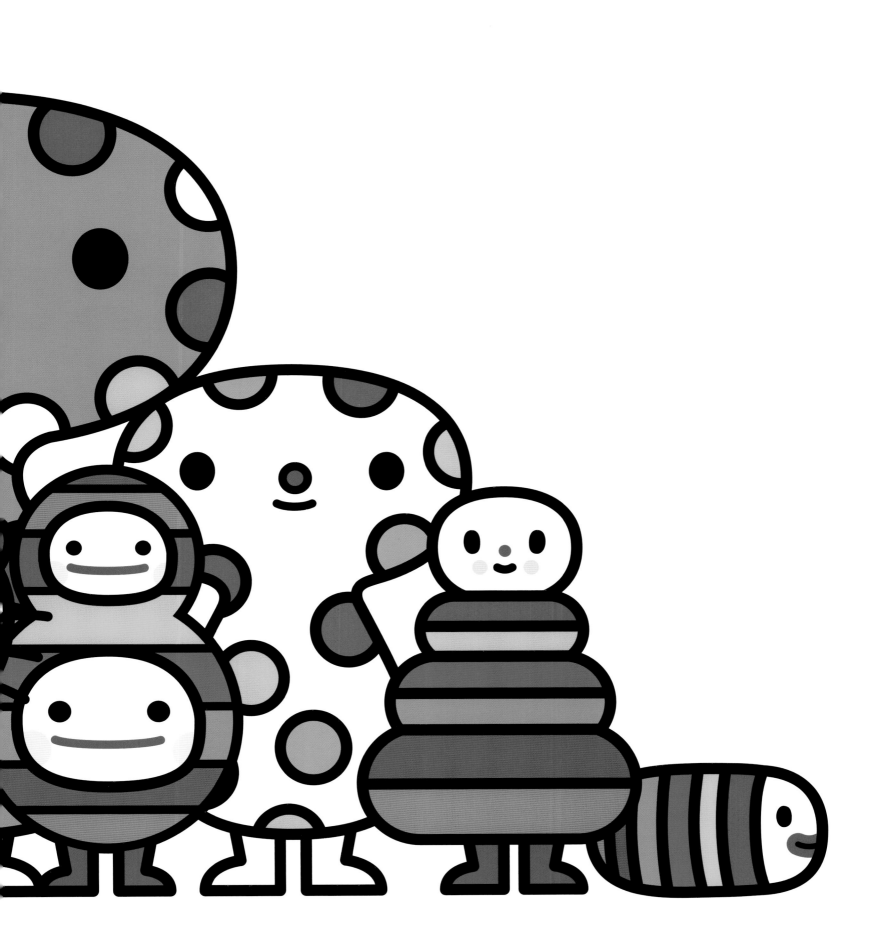

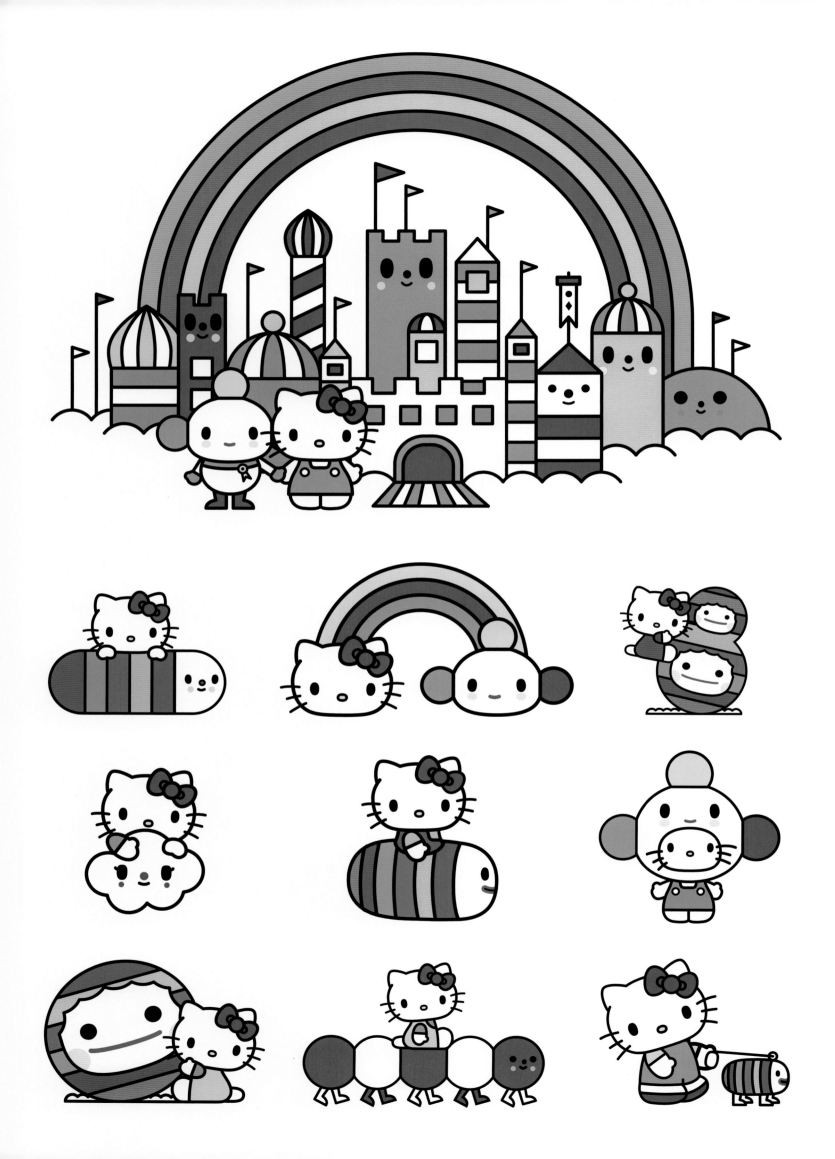

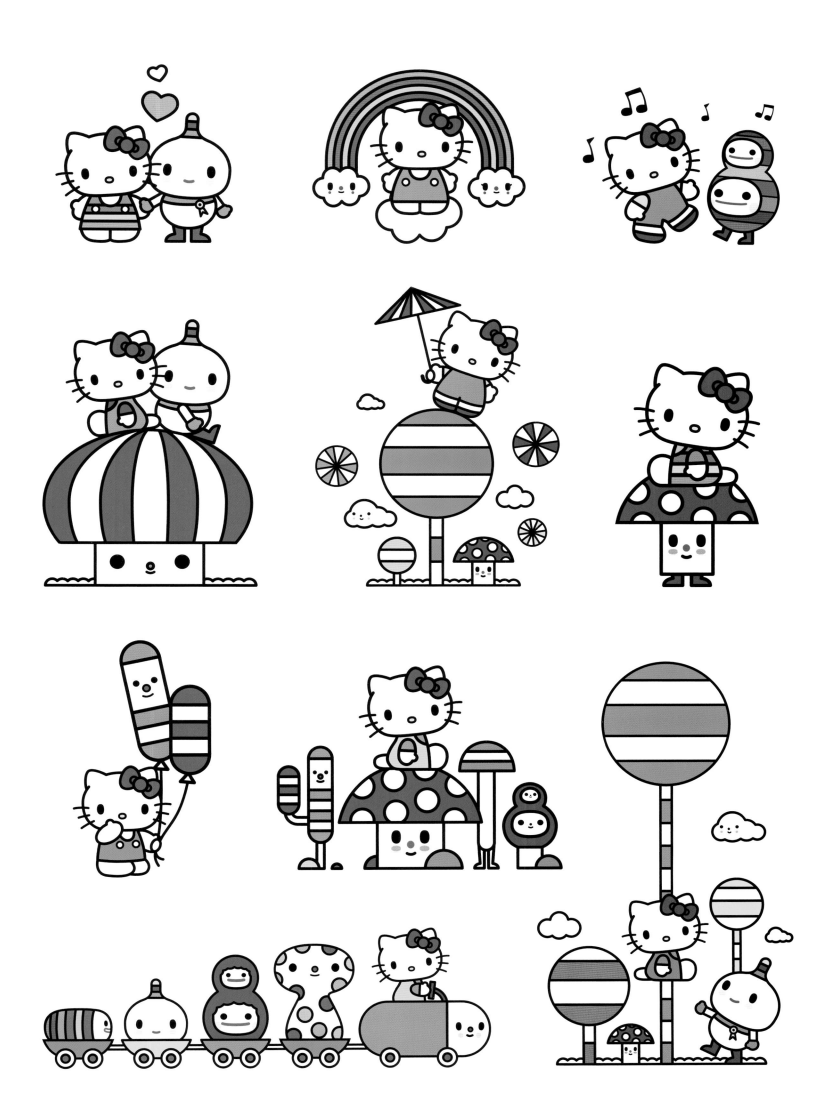

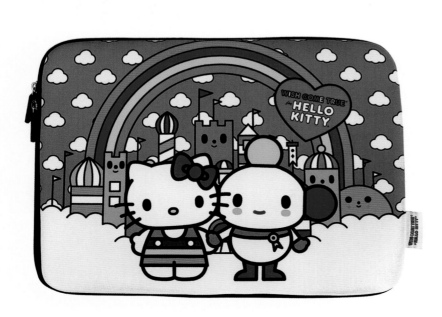
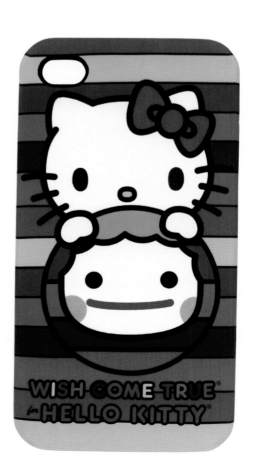

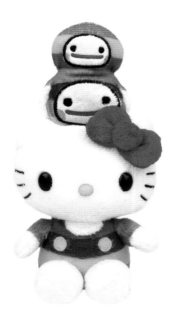

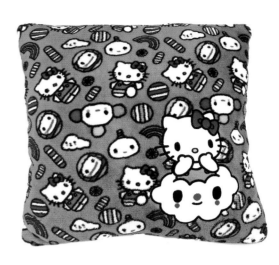
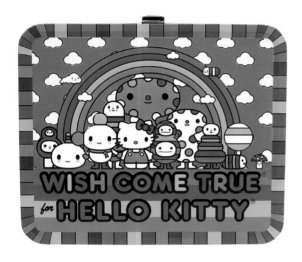
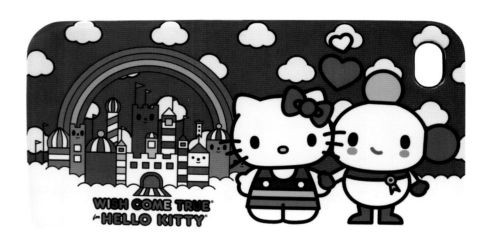
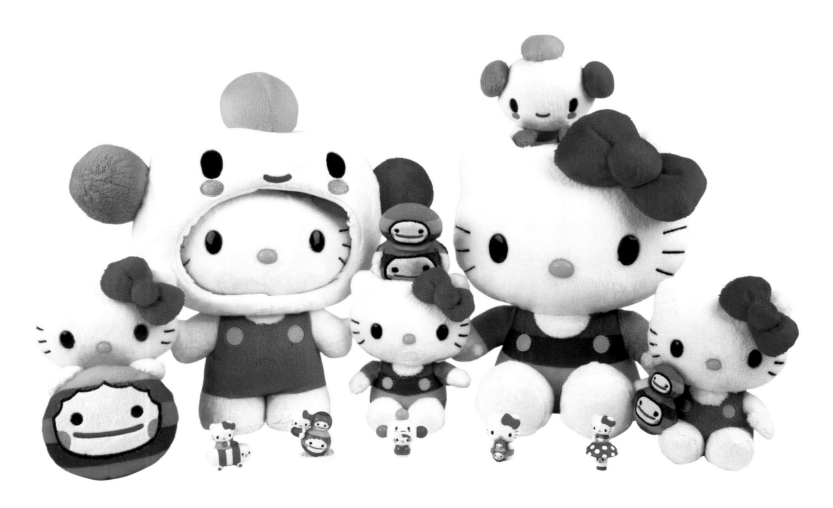

Friends, 2002.
Limited edition plush set.
Dimensions variable.

An early FriendsWithYou endeavor, "Friends"
is a series of plush sculpture amulets. A narra-
tive story accompanies the Friends, who are
re-imaginings of microscopic beings enlarged
one billion times their original size. Each plush
"Friend" is meant to offer luck and instill a sense
of self-empowerment in its owner. The plush
"Friends" may also act as companions, their
figurative quality a presence that can provide
comfort. This quality of exploratory healing of
the inner child features similar qualities to those
Mike Kelley utilized in his found plush objects
used to create his signature "cuddle puddles."
Shown here are Malfi, Red Flyer, Barby with
Spirit Suit, Shoe-Bacca, Brother Kino, Mr. TTT,
Albino Squid, and King Albino.

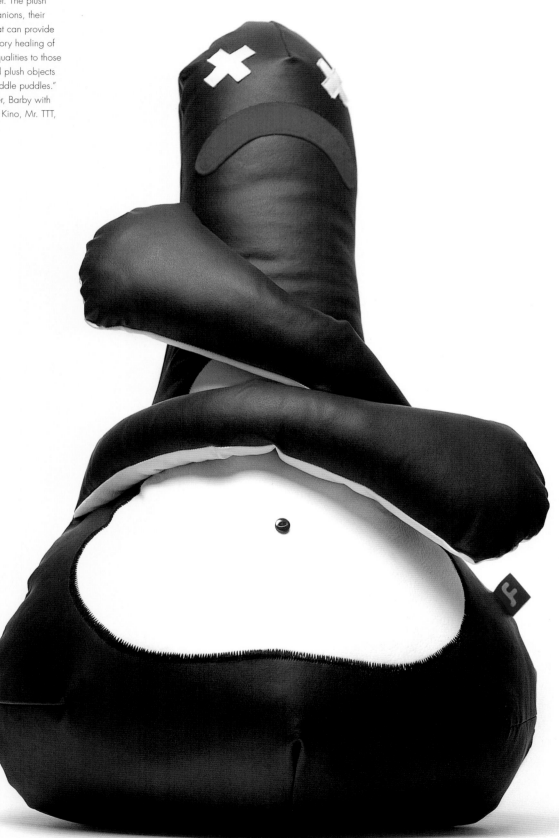

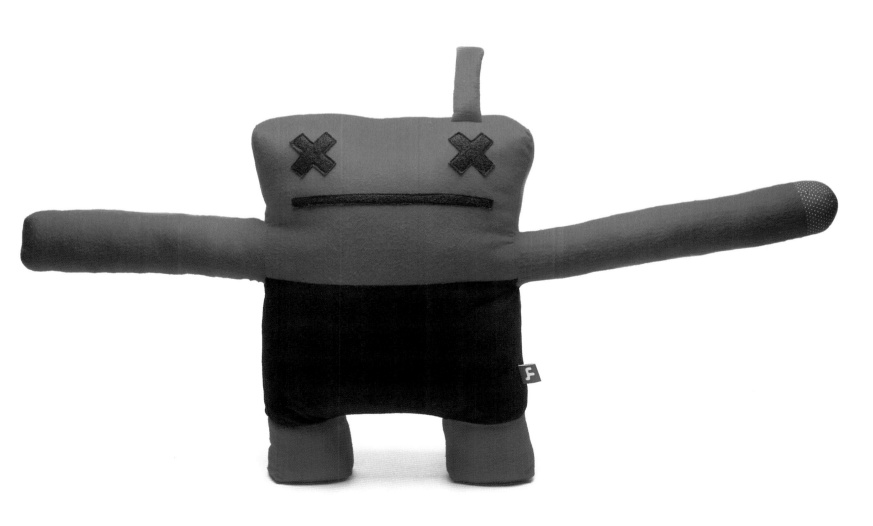

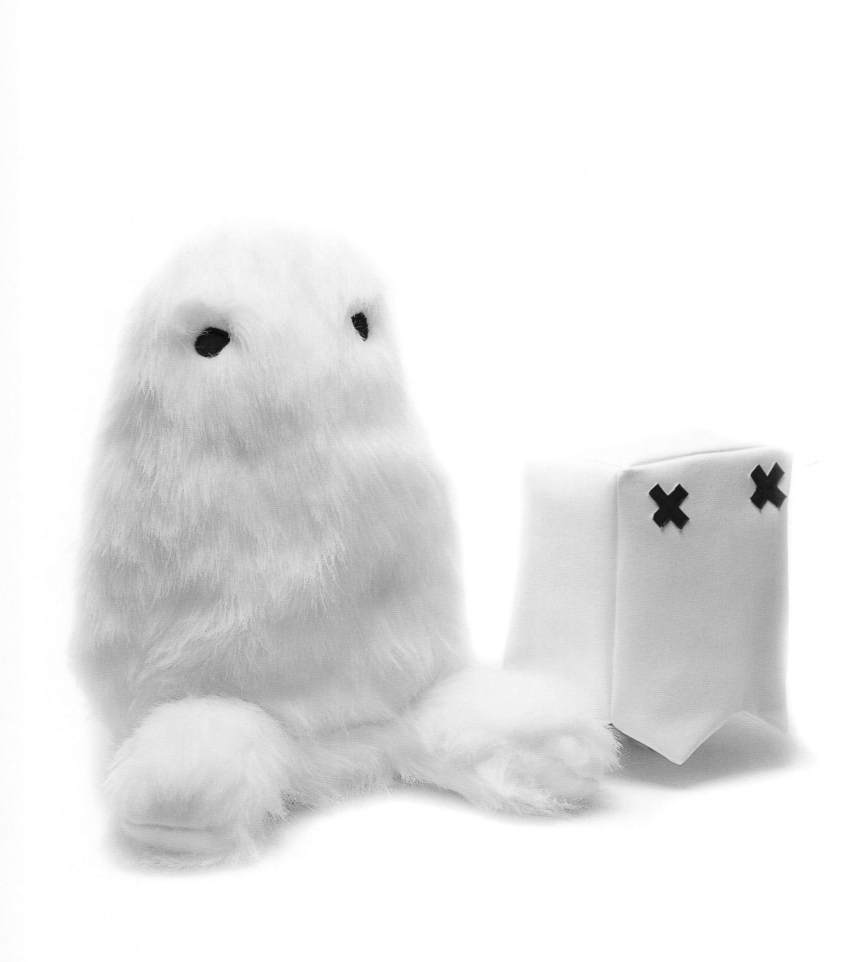

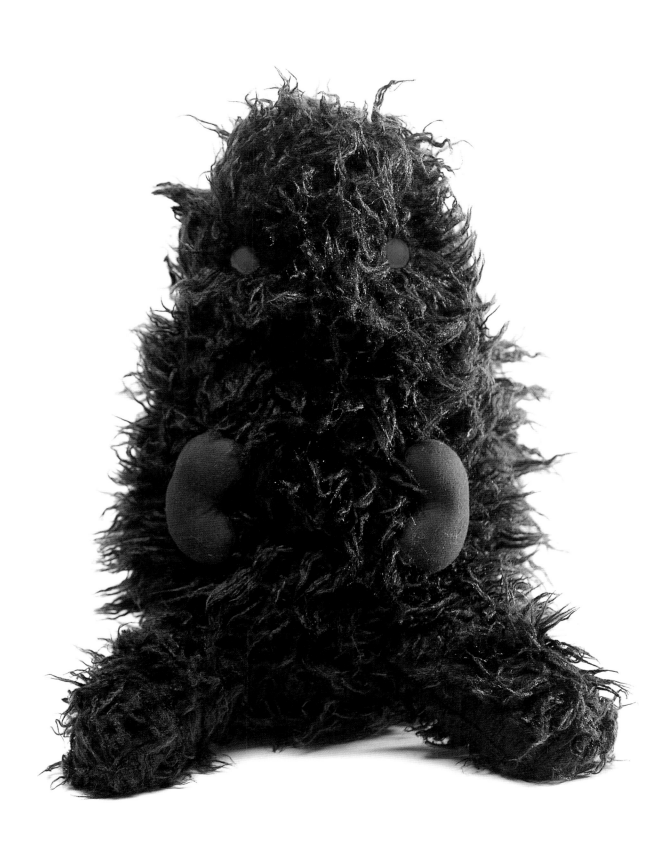

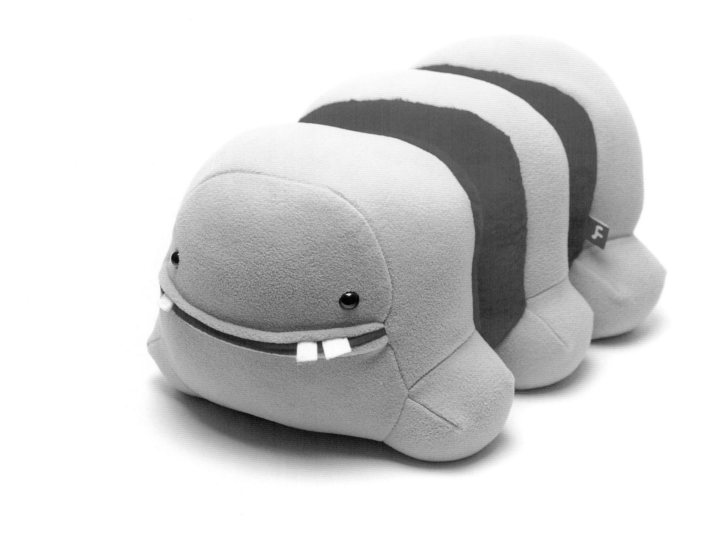
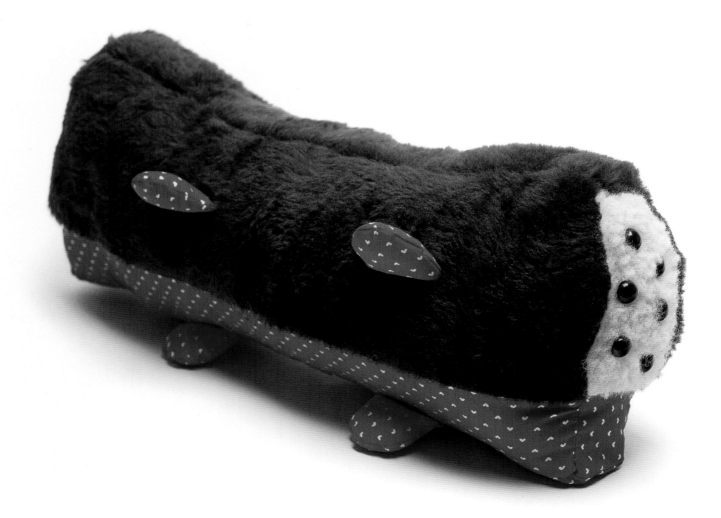

The Good Wood Gang, 2005.
Edition of 500. Wood toy set.
Dimensions variable.

This page:
"Blackfoot a.k.a. Captain Bingo"

Opposite page
(clockwise from top):
"Lucky Doovoo"
"Sweet Tooth"
"Mr. TTT Burger"
"Albirdo"
"Squid Racer"

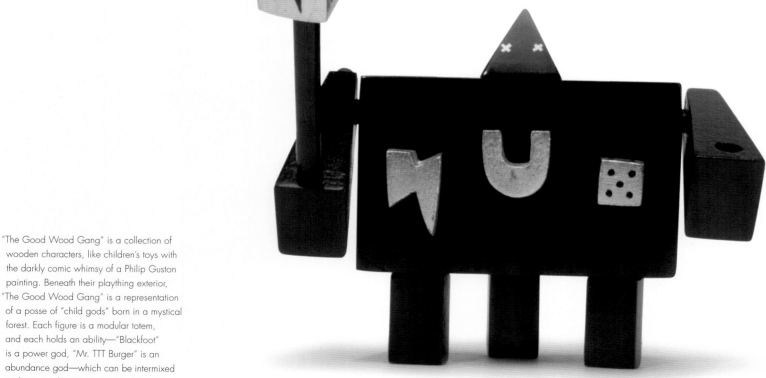

"The Good Wood Gang" is a collection of
wooden characters, like children's toys with
the darkly comic whimsy of a Philip Guston
painting. Beneath their plaything exterior,
"The Good Wood Gang" is a representation
of a posse of "child gods" born in a mystical
forest. Each figure is a modular totem,
and each holds an ability—"Blackfoot"
is a power god, "Mr. TTT Burger" is an
abundance god—which can be intermixed
and arranged to create new archetypes.

Rainbow Wash Windows, 2013.
Vinyl gradient window treatment.
192 x 1164 inches.

The healing properties of light and color are long documented, and through this work FriendsWithYou utilize chromotherapy to connect their audience to the reconsideration of ordinary spaces. By bathing viewers in rainbows, FriendsWithYou engender healing through approximation, much in the same way James Turrell or Olafur Eliasson experiment with the reactions to the properties of light and color. Viewers may move through the space and absorb the healing properties of the windows, even if they are unaware of the work.

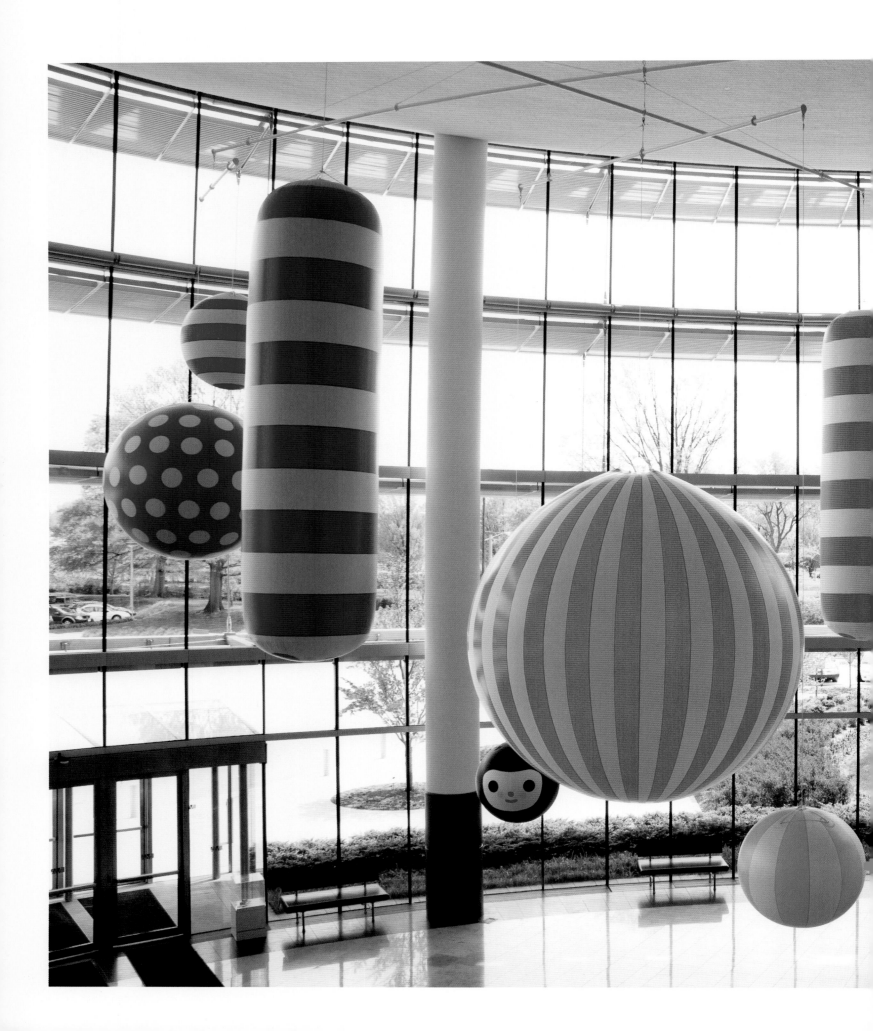

Dream Maker, 2008.
Inflatable mobile.
Dimensions variable.

"Dream Maker" is an installation of inflatables arranged as a miniature solar system. The solar system acts as a type of zodiac, meant to relate to the viewer's fortune and dreams as it rotates on its axis, drawing an emphasis to a conflation of astrology and the preternatural reading of stars.

I feel like the art that we're doing is taking a step away, and letting the vessel do the healing. This is a visual art that we put up that's allowing the viewer to make their own step towards healing.

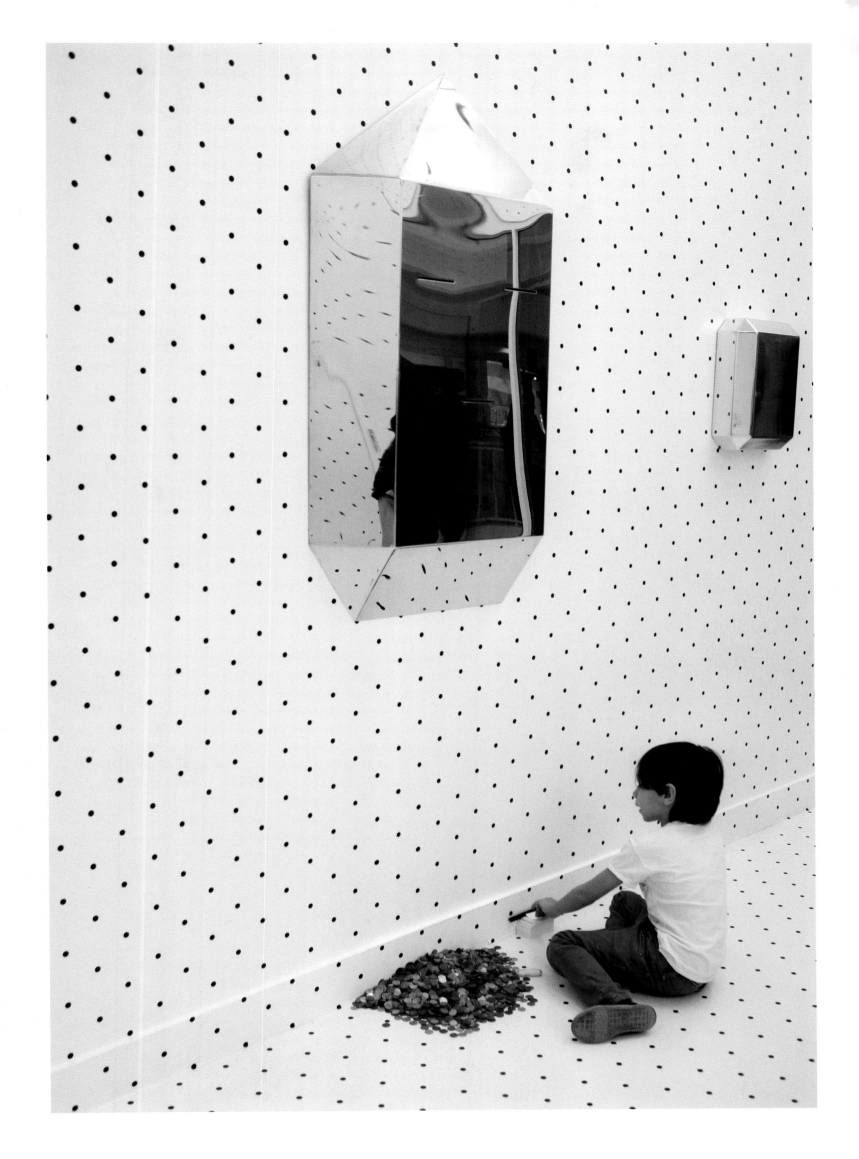

The Wish You Well, 2011.
Stainless steel.
27 x 5 x 47 inches.

"The Wish You Well" is an amalgamation of several religious rituals meant to be healing. Taking elements of the Wailing Wall, Chinese wishing trees, and the practice of throwing coins as an offering into a well or a fountain, the "Wishing Wall" subverts these sacraments for the gallery. Pennies and slips of paper are provided on the gallery floor, and the viewer is able to make a wish by putting either a penny or a written blessing into the slots of a diamond-shaped face made of stainless steel. The act of wishing is a signifier of belief, a stepping forward into the sacred realm, and FriendsWithYou are providing the situation to activate this trigger. The act of wishing provides the viewer with the foundation to have an introspective moment, and the mirrored steel of the face underscores that self-awareness.

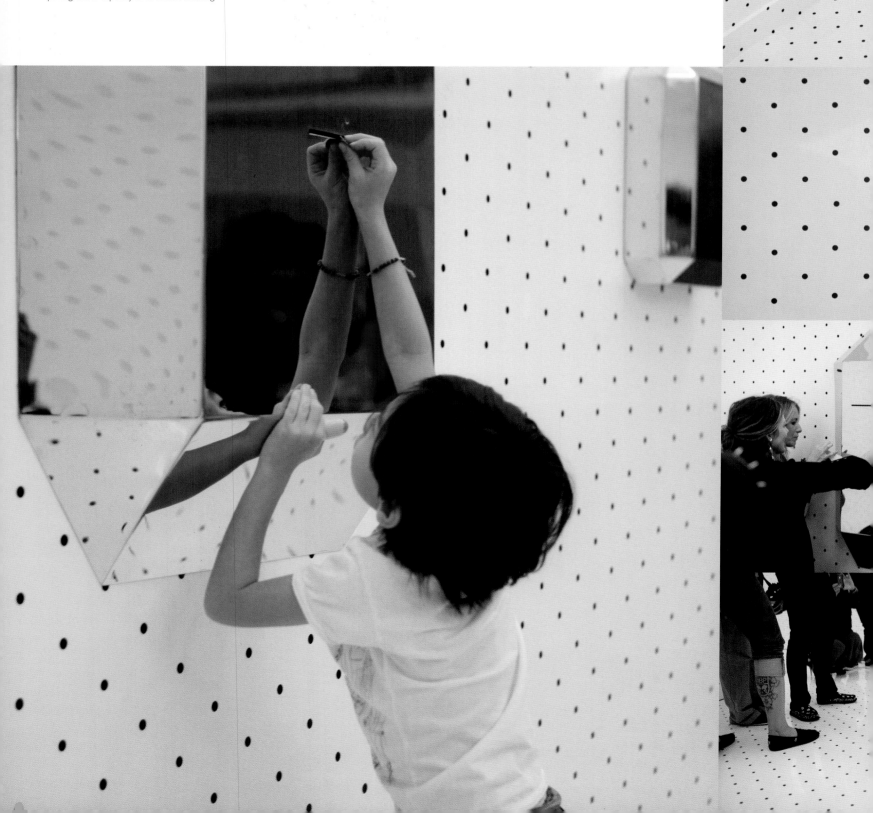

107

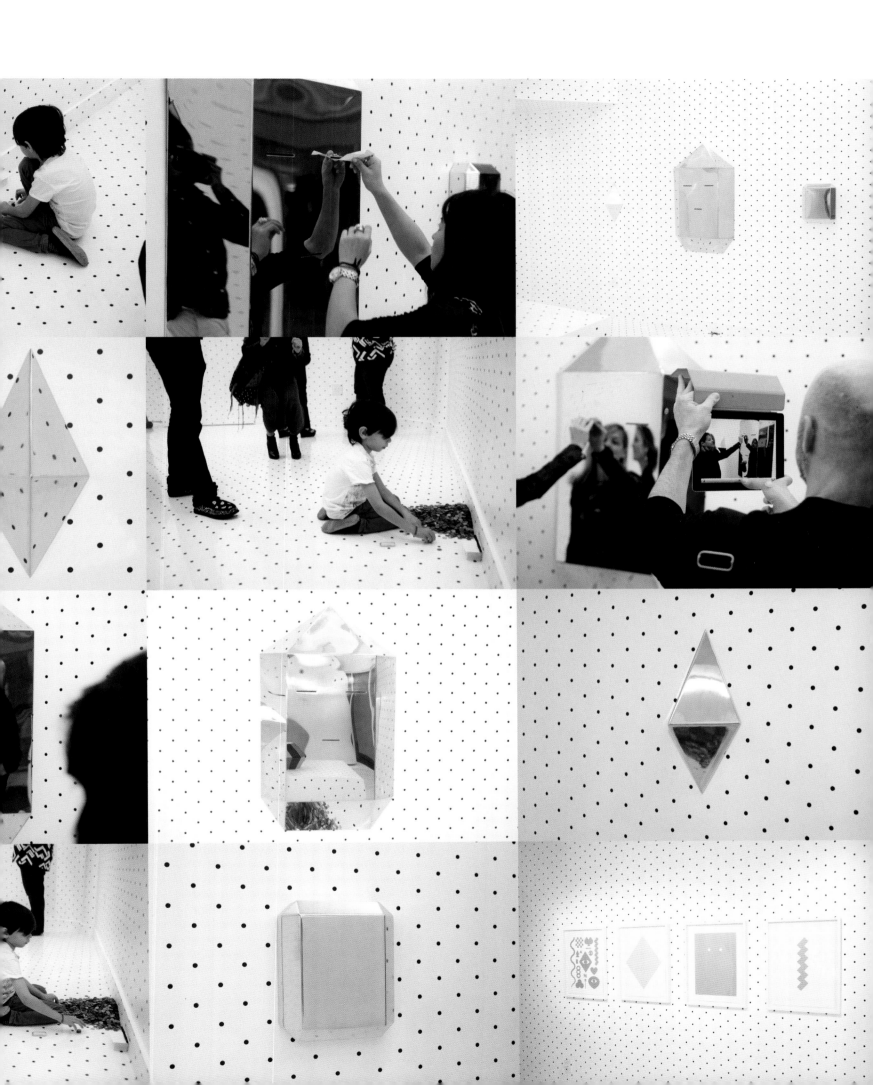

Gold Amulet Prints, 2010.

This page:
"Protection"
Edition of 50. Gold ink screen print.
24 x 18 inches.

"Power"
Edition of 50. Gold ink screen print.
24 x 18 inches.

Opposite page:
"Insight"
Edition of 50. Gold ink screen print.
24 x 18 inches.

"Luck"
Edition of 50. Gold ink screen print.
24 x 18 inches.

The "Gold Amulet" prints were Friends-
WithYou's first attempt at making prints that
had actual healing benefits. Religious objects
are often looked at with bias, so these prints
are a portable, aesthetically neutral way to
bring the influences of insight, power, protec-
tion, and luck in amulet form into the home
without the baggage of sectarian religious
iconography.

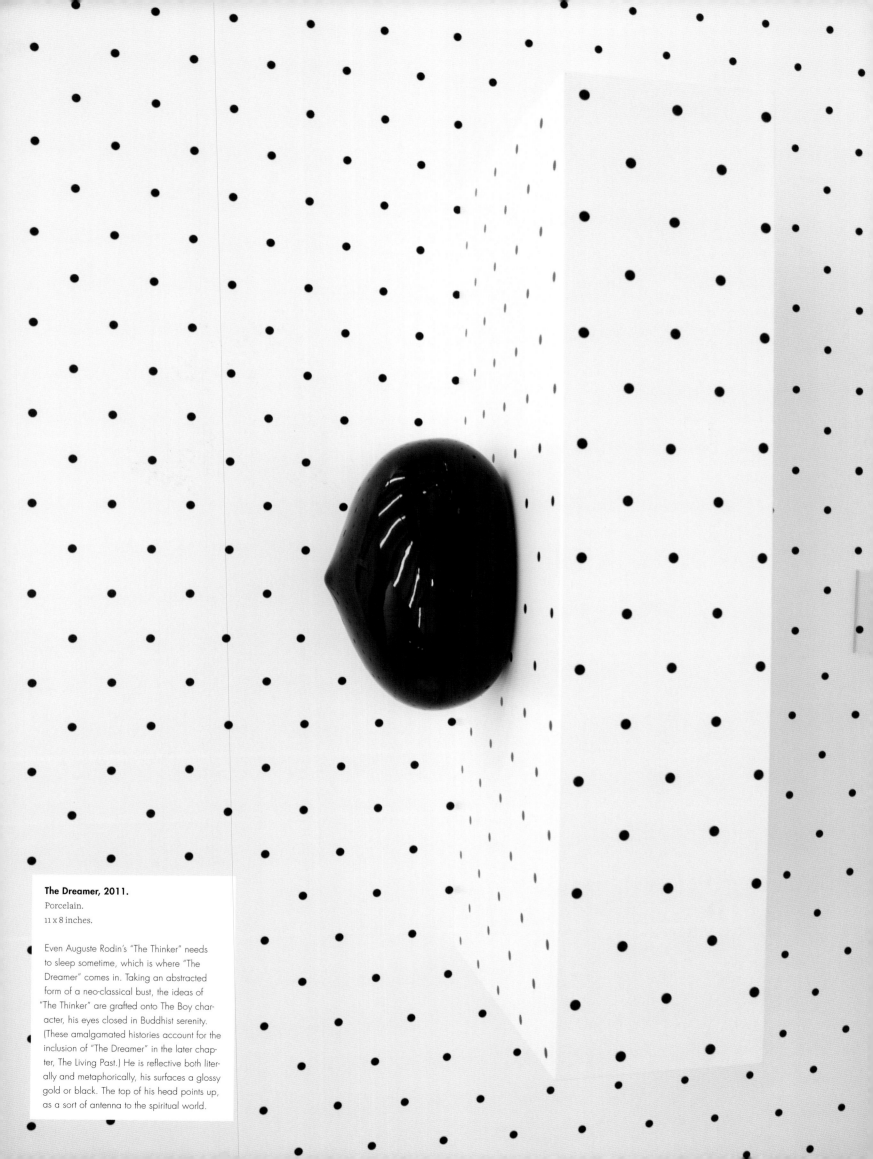

The Dreamer, 2011.
Porcelain.
11 x 8 inches.

Even Auguste Rodin's "The Thinker" needs to sleep sometime, which is where "The Dreamer" comes in. Taking an abstracted form of a neo-classical bust, the ideas of "The Thinker" are grafted onto The Boy character, his eyes closed in Buddhist serenity. (These amalgamated histories account for the inclusion of "The Dreamer" in the later chapter, The Living Past.) He is reflective both literally and metaphorically, his surfaces a glossy gold or black. The top of his head points up, as a sort of antenna to the spiritual world.

A CONVER-SATION WITH ALEJANDRO JODO-ROWSKY

The influence of Chilean-French filmmaker, writer, and spiritual sage Alejandro Jodorowsky on FriendsWithYou's work cannot be understated. Whether it's the Dadaist spectacles of Jorodowsky's early-'70s cult films *El Topo* and *The Holy Mountain*, or the later teachings of psychomagic—Jodorowsky's therapeutic concoction of psychotherapy and mysticism—as elucidated in the graphic novel *The Incal*, the influence is palpable. FriendsWithYou's own exploration of the spiritual realm exhibits a clear and open approach to self-healing and transcendent knowledge, making a kinship to Jodorowsky perfectly natural. Currently living in Paris, Jodorowsky spends much of his time giving guidance, making graphic novels, and offering wisdom to his legion of Twitter followers. FriendsWith-You sought answers from Jodorowsky over the phone.

ARTURO SANDOVAL III What about the human condition, in its current state, needs healing?

ALEJANDRO JODOROWSKY We each need to be modest [and] humble—not to heal humanity, but to heal one person. Nobody can heal the whole of humanity. Every person is a different world. Every person is complex. Every person has a universe inside his mind. Myself, I do collective [acts of healing], and I do individual [acts of healing]. [My] collective [acts include] socio-psychomagic. I make an act in Mexico City for the people who were killed in narcotraffic: 8,000 people came. I gave confidence. 5000 people came in Chile [to another act]. In a coffee shop, I [gave], without [them having to] pay, a visit to any person who came every Wednesday for years. People came from all [over] the world. Now, I am making [a] healing act [at] this moment: answering you without [knowing] you, without [knowing] what you will do [with] what I say, I am giving you my time. That is to heal another person. I am satisfying what he asks. That is healing. Healing is to realize reality is your interior. Every person is disguised [as you]. You are disguised. You, [who] are listening to me, is me disguised as you. And I am you, disguised as me. You need to take possession of the world. It's your family, completely. The planet, the universe: everything is yours. You cannot change the world, but you can start to change the world.

SAMUEL BORKSON Person by person?

AJ Person by person, yes. Now, I am a little famous, [so] I can make acts for a lot of people, also. I make acts now for thousands of people.

SB If the artist is a healer of sorts, then is art the medicine for the world?

AJ What you call medicine is not peace. [*Laughs.*] Medicine is to give consciousness to a person. To develop his capacity, that is to heal. It is not to heal an illness, because from the moment we are born in our family, our society, and our culture, we are prisoners of principle. We need to work to be free of that kind of prejudice. We are in a dying economical world. This economical world is dying, because it's killing us. It's killing the planet; it's killing humanity. We need wars, selling weapons, and all kind of terrible idiocy. The only way we [can] heal the world is to *sembrar*. *Sembrar* is [Spanish for]—

AS —plant.

AJ —to plant consciousness. That is a possibility.

SB Through the graphic novels and writings, and through your films, we found transcendent messages. Was that always a conscious effort from you?

AJ Yes. You need to make aware to the [reader or viewer] that consciousness [cannot be] received like that. You need to make your [own] consciousness. You need to expand that [by yourself]. You need to go through the transformation of your [knowledge about] your mind. You need to work in your mind in order to construct your mind. That is healing. Because the neurons on the brain [number in the] millions and millions, and we use very few. But we need one day to use all the neurons of our mind. The day we use all the neurons of our brain, will we [be in the] divine kingdom, the paradise. That is the key to heal: is the use of all your energy.

SB What do you think that it would take to reach this paradise? Do you feel that humans are evolving?

AJ One day [in a few] centuries. I don't know, but we need to work towards that *now*. But why? Because what you call a 'normal [American] person'—*el Americano corriente*—is destroying the planet. [*Laughs.*] Your Obama is destroying the planet, because he's not a healer. [*Laughs.*] He's a servant of your economical catastrophe. You Americans, you are killing the planet.

SB Sorry about that.

AS How do you define existence?

AJ Existence is not a concept; it's indescribable. It is not defined; it is felt. When Ramakrishna was asked, 'Do you believe in God?,' he responded, 'I don't believe in God, I know him.' But if I were to make an effort to respond with words, I'd say: existence is to be doing what one is doing.

SB In your own words, do you think you could help us understand the definition of 'god'?

AJ Today, somebody asked me, 'What is god?' And I answered, 'What is common in every person—[the] common center of all the isolated circles.' What is god? You cannot define god with words. You cannot think of that. In a moment, you will start to feel this energy everywhere, this consciousness everywhere. Everywhere is a consciousness. Nothing is by chance. Everything is a miracle. [*Laughs.*] The only thing you can find everywhere is the forgetting of miracles. We are like monkeys, you know? We are very limited. [*Laughs.*] We have a little brain. If you compare yourselves with the universe, you are nothing. But this little we are is very important, because we are creating consciousness.

AS Do you believe that the use of psychomagic, and the healing arts, and symbolic psychic art, does it help create consciousness?

AJ Yes. It helps a lot. I heal a lot. I make [people] happy. To be happy is to be what you are, and not what the other person wants you to be. It's freedom—freedom to be what you are. That is healing. You need to be what you are, not what your parents, your society, or your culture wants you to be. We need to become what we are.

SB What is happiness to you?

AJ Happiness: silent intellect, a heart full of love, godly and satisfying sex, a healthy and protected body.

SB Does happiness lead to consciousness?

AJ Happiness is the essence of the human being. When you realize all the idiocies you learn from the moment you were born, you come to an emptiness. And this emptiness inside you is full of felicity. Happiness. But happiness is not to have. Happiness is not inert. It's the contrary. How you say in English? *Tener* is 'to have.' *Not* to have—that is happiness. Happiness is *not* to have.

AS **Do you believe that there is a necessity to create a unified spiritual system in the world?**

AJ This is the danger of a unification system: we need to create in every person the maximum of consciousness, but not with only one idea. All the roads lead to the truth, but there are different vehicles for transport the truth. The truth can be Communist, Catholic, Buddhist, Atheist. Those are the vehicles. Through those doctrines, you can come to truth, if you are honest, if you don't lie to yourself. [I believe in] a unified system where the temple is our own body, the priest is our conscience, and god is our soul.

AS **Do you feel that some of those pathways have been corrupted?**

AJ All the ways, they are corrupted. The religions are killing us like the atomic bombs. How terrible the religion today: the church is terrible; Islam is terrible.

SB **This is one of the main ideas for FriendsWithYou: we redesign for modern times a spiritual pathway and to raise consciousness through almost secular ways that are non-religion dogmatic.**

AJ Yes, but to do that, you cannot do a red book like Mao. [*Laughs.*] You cannot make a bible. This is not freedom. You need to teach freedom to the person, and every person needs to have his way. You need to realize the temple is your body, the priest is your mind, god is your interior god. Evidently, now nobody believes in politics. Nobody believes in the honesty of economy. Nobody believes the dollar is god, [even though] they need the dollar. Nobody believes in the religions, [because of] the pedophilia scandals, all that. Nobody believes in wars. Nobody believes in art. Nobody believes in love. We don't know what to do. We need to re-create everything. That is your task. Everything needs to be re-created. There is not one concept that is not foolish. You don't [create] your [own] ideas. You receive these ideas from the family, society, the culture, the economical interest. You are a slave. [*Laughs.*] And the presidents are the ventriloquist puppets, because behind the presidents are the persons of industry. That is the reality we live. Every one of us is in this reality.

AS **Do you believe that we are in a spiritual crisis? Do you believe this will lead us into a more conscious state?**

AJ The universe is continually expanding, as is the human brain. Despite the fact that our culture instills in us a fear of change, as we expand our comprehension of true values, the society begins to mutate. Crises bring about the first tremors in the uncontainable metamorphosis of our spirits. When the butterfly

flies, it does not feel any sorrow for the caterpillar that bore it.

AS Is listening to one's unconscious the most practical way to heal oneself?

AJ What is unconscious? For Freud, unconscious was an enemy. [*Laughs.*] Terrible. Unconscious is what you really are! You need to make the connection between what you call your awake—your conscious—and your unconscious. The unconscious is really the conscious in you. And what you call conscious is really ill. [*Laughs.*] The ego. You have the ego and the essential being. And you need to recoup your essentiality. And for that, you need to not think only with words, with intellect. You need to unite yourself with intellect, emotionality, sex, and body.

SB I'm interested in your thoughts about death. What happens when you die?

AJ I don't know. I have yet to die. Each night, when I sleep without dreaming, I submerge myself into death. When I awaken, I submerge myself into sleep, a slumber where I confuse what I dreamt with what we call 'reality.'

AS In the Tarot, we find a spiritual teacher. Why is it important to tap into our inner truth? Does a healthy cycle and personal understanding of our role, our existence lead us to a better life?

AJ Nothing leads us to a better life. The life we have is perfect. The Tarot teaches us to realize this. Our inner treasure, if searched for in the exterior, becomes invisible.

SB If you could advise us, FriendsWithYou, on what it requires to continue what you have begun with your life's work, what would your advice be?

AJ Be yourselves, not what others want you to be. What you give, you give to yourself. What you don't give, you take away from yourself. Don't want for anything, that isn't also for others. Always work on what you love, and always make what you are doing something that you love. Don't use your art to convert yourself into a spiritual guide; the spiritual guide is your art. Do not create your art in search of a foreign result outside of the art itself. Let your only reward be to achieve an honest work of art that can live on its own, outside of your womb. If everything is an illusion, then always search for the most beautiful illusions.

SB Do you feel that it's important to leave behind the ego when creating art?

AJ Yes, yes! Because the ego is your artificial personality. You need to break the ego. You cannot lose [the ego], because if you lose the ego, you are mad. You have no identity. But you need to use the ego like you can use a pencil. It [cannot be your] master. You need to [work with] ego in order for him to obey you. [*Laughs.*]

AS Why does it seem our own mind is sometimes against us?

AJ What you call 'our own mind' is your artificial ego created by family, society, and culture. This ego is against you— that is to say, the ego is against your essential, impersonal, and authentic self.

SB As an alchemist, what have you found is spiritual gold?

AJ 'I am nothing, can do nothing, know nothing,' said the Lead. 'You are everything, can do everything, know everything,' said the Gold.

SB Can we talk for a second about the future? What is the most ideal future that you can imagine?

Always work on what you love, and always make what you are doing something that you love. Don't use your art to convert yourself into a spiritual guide; the spiritual guide is your art.

AJ I will tell you what is the ideal future. One is the future of the individual. In the individual's future, you have death, you have ignorance—not knowing—and you are not important. Humanity has three futures. Humanity will completely know the universe; humanity will live until the end of this universe; and humanity will transform into the consciousness of the universe, because we are going to reach an immaterial state. Pure consciousness.

AS How do we become conscious?

AJ Everything you want to find, you have it already. It's you. Consciousness—you have it already. Everything's there. You need to free yourself. Continuous expansion. That is not psychomagic, that is meditation. In order to develop consciousness, you need to give something to somebody every day. Give. Myself, I am giving my time to you. Down in the street, there is a beggar who is there. I adopted him, and sometimes I give money to him. As much as I can give today, I give to him. And the restaurant, the Chinese restaurant where I go, [the owner] had a child. I gave the name to the child: Thor. Six months ago, I went to the hospital

to [see a] dying person who wanted to meet with me, not with a priest. I took [him in] my arms. I gave a consultation [to] another person [on] how to make a child. Et cetera. Every day I give something to somebody.

SB What we really want to do with our mission is reach as many people as possible, like what you've done with your films and with your comics. We want to bring this consciousness and this healing idea to as many people as possible. What would you have us do?

AJ Everything is open to you: the Internet, television, art— everything is useful for that, for consciousness.

AS What do you think of these three words: magic, luck, and friendship?

AJ Friendship: to learn to create something together. Magic: to learn to see the continual miracle. Luck: to learn to sow if we would like to reap.

Cloud Heart, 2013.
Unique multiple.
Vacuum-formed acrylic.
20 inches diameter.

"Cloud Heart" is another version of the simple spirit rendered by FriendsWithYou. With the contented grin of a smiling Buddha, Cloud Heart is a white vacuum-formed acrylic bubble with facial features that adopt a serene disposition, drawing the viewer to a similarly tranquil space, as if one were looking at a cloud or the moon.

THE LIVING PAST

Much of FriendsWithYou's work points to archetypes of the soul, which Carl Jung described in his conclusive psychological tome *The Archetypes and the Collective Unconscious*. "The human psyche contains," Jung avers, "all the images that have ever given rise to myths."[2] The psychic heirlooms that humankind is bestowed with are rediscovered via analogy. These analogies and histories are what the artists mine, but what FriendsWithYou do uniquely is to take those heirlooms, mix them up, and reposition them for modern consumption. Whereas many artists, such as Llyn Foulkes' take on Disney archetypes, leave the archetypes intact, FriendsWithYou visualize completely new characters in the form of a pastiche.

What at first seem merely like amusing characters are, in fact, taken from deep historical paradigms.

The characters are usually displayed with simple faces and forms in order to highlight the various archetypes. The Hindu god Jagannath, Disney characters, the Buddha, Santería gods, and a variety of other archetypes are puréed into a mixture of decipherable stereotypes. Often whatever negative characteristics the archetype possesses will be stripped and transformed into a powerful positive spiritual creature. Oftentimes, a tangible ritual or god won't even be referenced, the character will come from a primordial concept culled from the remotest early human periods.

[2] Jung, Carl. *The Archetypes and the Collective Unconscious*. New Jersey: Princeton University Press, 1981. Print.

Wish Come True (Paintings), 2007.
Watercolor.
52 x 46 inches.

The "Wish Come True" paintings are a
compendium of the artists' studies of shapes,
characters, and inspirations. Scattered
through the paintings are weird jewels, amor-
phous subspecies, Japanese characters such
as Doraemon and Anpanman, Smurfs, and
everything from giant outer space gods to
unseeable-to-the-naked-eye molecular spirits,
blown up to proportionate size for the study.

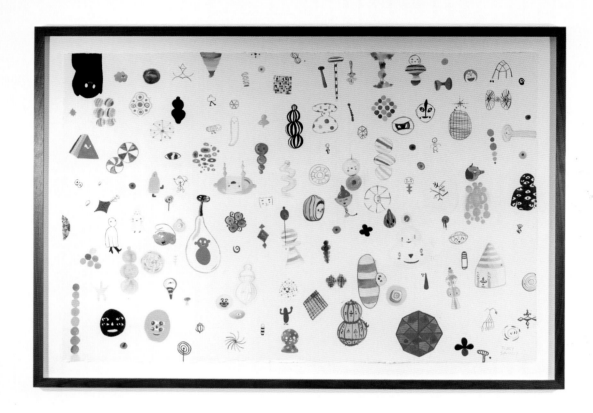

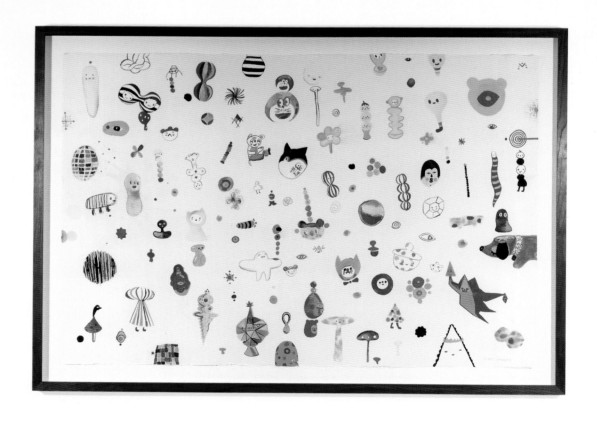

MAXWELL WILLIAMS To talk about 'the living past' is to talk about myth and the idea of why humans have come up with myth and where these myths come from. And as you've said, FriendsWithYou is remixing these histories. Where does the living past start for you? Does it go back to Carl Jung's archetypes? Joseph Campbell's ideas of mythology?

SAMUEL BORKSON The character Malfi, who was probably one of the first things that we did, was very much drawn from popular iconography. We were taking powerful iconic elements, even if they might contain a difficult or negative history, from things such as blackface. Mickey Mouse actually started with a minstrel-like idea. This idea was the epicenter and the human race adapted to it. Everybody knows Mickey Mouse. We were all taught this one unified world archetype, which is this performing, dancing entertainer.

MW How did that idea make it into your work?

SB We were trying to be loud and evocative. We were confronting this racist thing and putting a positive spin to it. It was the seed that grew the awareness of what we were doing and allowed us to keep growing it. It started a lot for us, taking something powerful and putting it out there: 'Now, Malfi is a god. We're taking those unsavory elements back and turning them into a powerful god that brings you wealth or death.'

MW Walt Disney was really good at doing the similar thing of taking the past, taking history, and turning it into these cartoons with these archetypal narratives and all these types of things. How did Disney manifest itself into your work? Was that early on where you recognized that Disney was an organic kindred spirit within your work?

ARTURO SANDOVAL III I think we have very different takes on this, because I didn't grow up with Disney. Those things did not affect me at all as a young person. By the time I was exposed to Disney, I actually hated it. My dad had a contract with

Disney, and I would go every year, three times, over and over again. When I got to be 14 years old, I rebelled. I hated all those things. I did recognize that everyone was into those movies. Disney movies are like Alejandro Jodorowksy's films—those things are transcendental. All the stories couldn't be older stories. They're very ancient things. And since that's what we were addressing, I couldn't deny it any longer, and it became interesting again to me.

SB I think everybody rebels against Disney at a certain point.

AS I never fell in love with it. I got into it late, but I've always been fascinated by the cult. Disney is a super modern device to deliver those ideas, and I love that.

SB That's even a big reason for us making characters. What we've developed these characters to do is to embody these very significant ideas—to take a character and hide a concept in it. We've called it a 'happy virus.' We're trying to impact the world and we see those means as a way to do it, by finding pieces of recognizable things that you love. That's why we draw on Pinocchio for The Boy character. We draw on Mickey for Malfi, but there are ages of archetypes that Mickey is based on. He is the 'boy' spirit, the 'god' spirit, the 'trickster' spirit.

AS I think that the archetypes are proxies. We were never very in control of them when we were messing around with the early exhibitions that relied on a lot of archetypes, like 'Get Lucky' or 'Cloud City.' Those were very much our pieces that employ those delivery systems and pivotal experiential razors.

SB We worked on reducing those paradigms and very carefully structuring them. They're very, very well thought out to evoke feelings and to have power. When I'm drawing Malfi, I love to draw him until I'm smiling. If it's really making me happy, I'm like, 'Okay, it's getting across.'

MW Certain aspects of Malfi for instance aren't positive, but at the end, as a collage, he is a posi-

tive thing. The histories of him have been subverted. Can you talk to me about conflating the origins?

AS There is remixing. We give very loose visual clues to the things that we're drawing from. That vagueness, too, gives you an inherent reassessment of the actual symbol. If you don't put too many clues in it, or if you have enough clues to make it recognizable, but not enough to immediately know it, then you're truly projecting into an archetype.

SB We make these for that response. We engineer our characters to be positive. We destroy the past of what his influences have been—racist or godly or some evil spirit—now we're portraying it in this positive, real way. Just upon looking at the characters that we're making, like Rainbow King and Malfi and The Boy, they're meant to be transcendent. That is the theme: to remix these archetypes into these powerful harbingers that you trust, since you know them already from life.

MW Do you look for specific traits in the histories you come across? How does it get researched?

AS We just react to it naturally. We developed our visual language by mimicking the things that naturally manifest themselves to ourselves. Then we make a note of those things, and all that information gets jumbled in there, and the unconscious does what it does. Then it spits it back at you, and the next thing you know, you're drawing.

SB And then we remix. That remixing gives it its own new alchemy. That's where those things gain more power. We look at archetypes separately, and then we bring them into our work in this minimal new presentation, and it swirls into a new existence.

AS We work on those things as designers. We are making conscious decisions that affect the outcomes. The concepts are never by design. It's also about how we see our practice as very modern, like another take on Super Flat. Out of the nature of also being in collaboration, it makes it easy for us to agree on the archetypes. Sam says 'Red' and I

What we're saying is that beyond the story itself is the meaning of the story. We want the Cliffs Notes. Take me to the meaning of the story, and leave the story out.

say 'Blue,' and then we're like, 'Purple it is. Purple is awesome.' That's basically how we collaborate.

MW There are enough archetypes in the world. It's almost an infinite well.

SB They're repeated, too, so it's more than infinite—it's exponential.

AS That rabbit hole goes deep. Also, there definitely is a censor on those concepts that are beyond the self.

SB It's as if we're capturing all the attractive things of every religion, and fusing that into the most palpable easy-to-digest visual.

MW How do you see your work fitting into these myths of modern times?

SB We're the un-myth basically. We're having fun with Malfi and these elements that have allegories for these ideas. They're in many religions and many cultures, but our take on it is completely open source. All these traits are valid, but everything else is also valid.

AS We're trying to get a lot more metaphysical with it, and being away from the myth lets you do that. Because a myth was just made by a mythmaker.

SB The Bible, for instance.

AS There was always someone there that wanted to tell a story. We all want to tell our story.

SB And those stories have great purposes and meanings and they're valid in our realm and in our lives and in these religions as well.

AS But what we're saying is that beyond the story itself is the meaning of the story. We want the

Cliffs Notes. Take me to the meaning of the story, and leave the story out. We're part of that three-minute punk rock song generation. We're children of the Internet.

MW What kinds of archetypes interest you the most? Is there a type? Is there something that you really connect with?

AS We have explored a few types. We haven't addressed a grand multitude of them. Malfi being the trickster, with his raw energy—

SB The Boy is the empathetic spirit. We've subdivided the archetypes into a few prime emotional buckets. Rainbow King is the embodiment of a rainbow god. We found that the Zuni tribe and the Hopi tribe have rainbow gods in their traditional artworks. We took this primary color thing, with a geometric head, and brought this analog, fragile humility to it. This powerful, beautiful light is the maker of that idea. Every time you see a rainbow, that's the magical thing. The icon of 'The Cloud' is an archetype. Many Native Americans thought that clouds were spirits moving through the sky. The Boy is the pure empathetic spirit. We've crafted him to what we have seen people respond to, and engineered him to that emotion with these very basic forms.

AS We intermix these origins; it's a 'Lego archetype.' We take the strong legs of this archetype, and put on the willpower and the wiseness of another one.

SB It's not like a cartoon. It's not anything yet; it's like a pure being. We've framed it before: the soul. The Boy *is* the soul. It's synonymous of that character. Whatever other meaning you want to give it, you can.

AS Jung goes so far as to say that archetypes

are very peculiar in how they manifest themselves—they each relate to different psychological categories. I will argue that yes, at the psychic level, they do that. With the ones we look for, we say, 'Okay, this has enough of those values to spur those concepts, but we're going to articulate it in a neutral way.'

SB The archetypes that we've chosen are universal ones. Out of all the archetypes we could have chosen, it could have been like a woman or an old man—there's billions of them. We chose the ones we did because they're the most familiar to us. We know the heart of them. We are the embodiment of them; they are embodiments of us. The Boy, Malfi, Rainbow King, and these other main FriendsWith-You characters are ideas that have manifested themselves. They are a part of our own personal anima that we share together, too.

AS Take Rainbow King as an example: we have this idea of kings and we understand their importance. But we also have to consider the real mythological power that kings have had on the history of the development of the psyche.

SB And so we took the idea of 'king' and made it into the most humble creature. We took the 'king' archetype, which is this powerful, disgusting, macho vision and we made him a delicate, fragile, cute friend that is loveable. We completely reversed it.

AS We said, 'We're not going to put a crown on him, but we're going to call him "king."

SB So, we're taking this preconceived notion of 'king' and 'boy' and 'rainbow'—those three words together—and making a new idea. It's not an archetype as much as it is an idea. We're just using these things that are archetypes and now expunging them to nothing. It's an optimistic archetype—what we wish this archetype really was.

Malfi, 2001–2013.
Various character iterations.
Dimensions variable.

Malfi is perhaps the most iconic Friends-WithYou character. He is seen either in a stoic sleek black, or a white polka-dotted, like a Damien Hirst spot painting. His bowling pin-shaped body and floppy arms give him a innocent posture, and his lippy grin and wide, reflective eyes resemble those of the 19th century black cartoon character, the Golliwog. Elements of the Hindu god Jagannath, Mickey Mouse, and Voodoo gods are also recognizable in Malfi's visage. Malfi is a pastiche of these characters, and yet the archetypes are merely visual, retooled for a modern character who is meant to be used only for positivity. According to FriendsWithYou, Malfi is a "magical wizard who brings joy to everyone." Malfi has been recreated in several art objects, having been a character in the FriendsWithYou library since 2001, when he was introduced as part of a series of hand-sewn amulets. He has been reimagined as a plush toy and a balloon in a beach parade during Miami Art Basel in 2006.

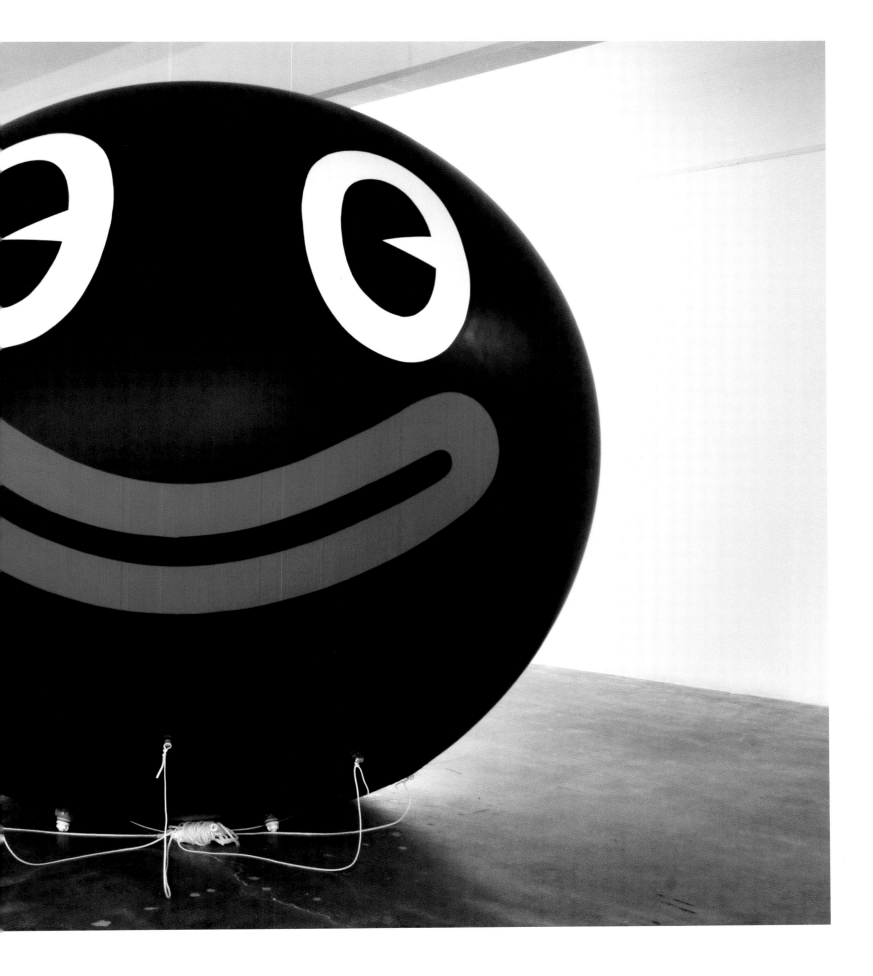

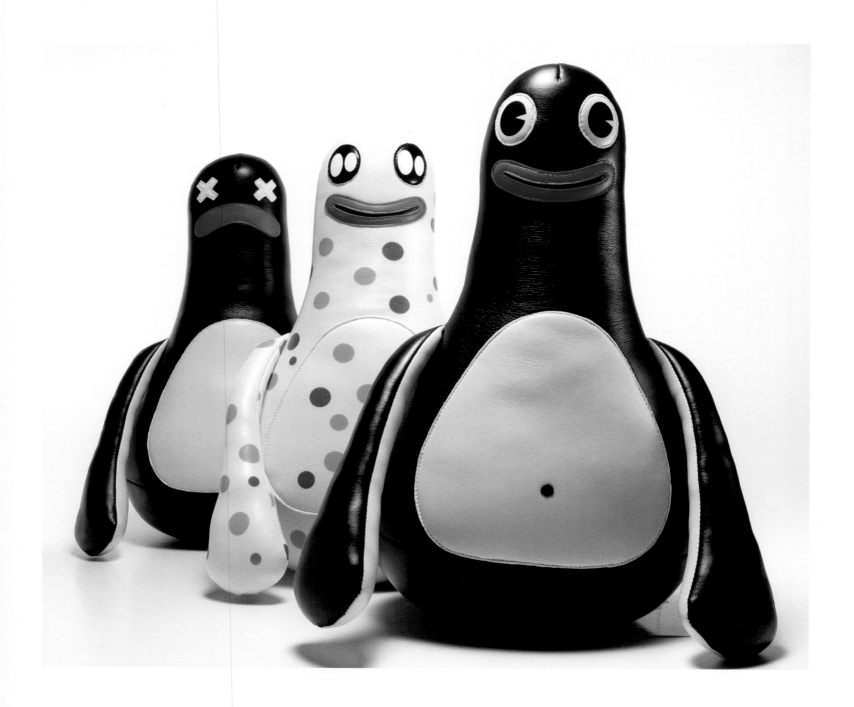

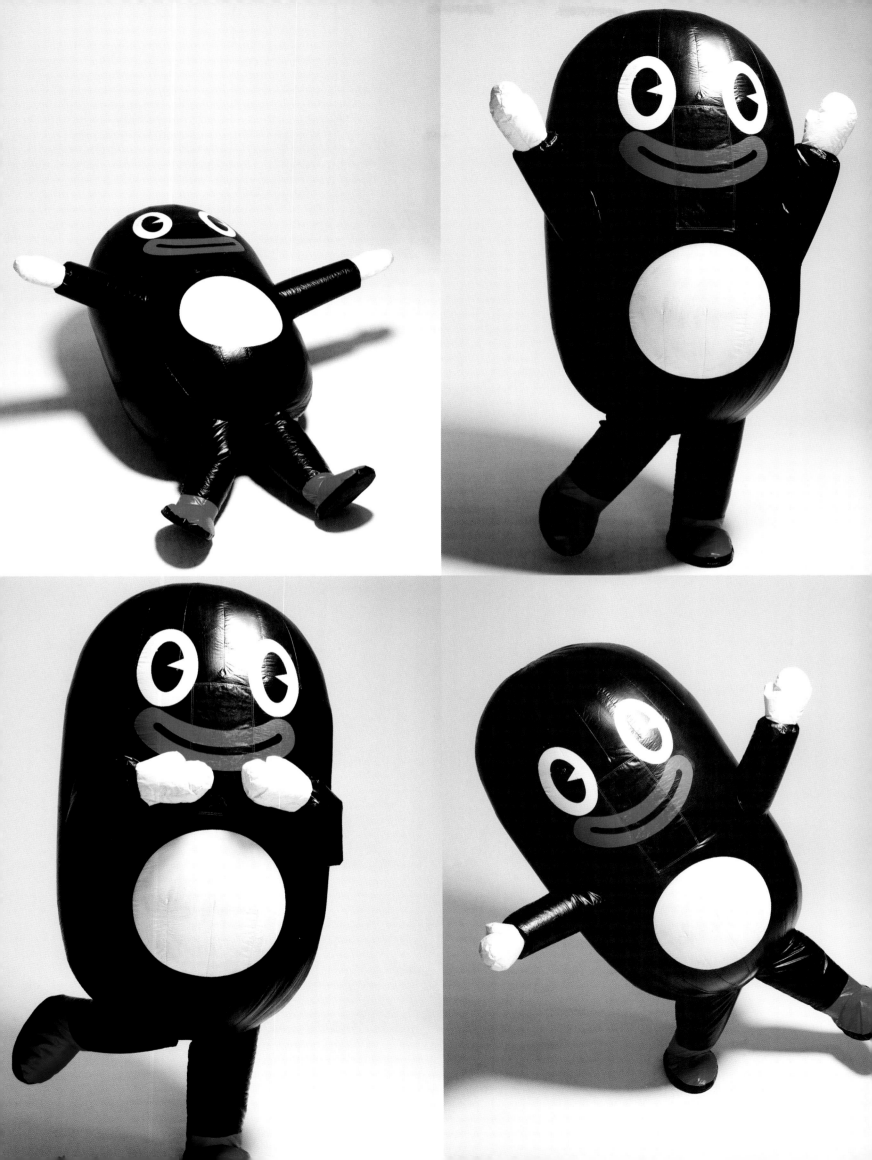

Get Lucky, 2004.
Multi-media installation.
Dimensions variable.

"Get Lucky" was a large-scale installation at BOX Art Space in Miami, Florida, featuring a series of shrines leading to a large altar behind curtains, where the viewer had the opportunity to interface with a god character. The fully immersive experience was the vehicle for FriendsWithYou's intense deciphering of mythology and symbolism. All the sacraments, down to the emblematic colors of black (for power) and white (for cleansing), as well as symbols of love, wealth, the earth, and blood, were utilized. The installation as a whole takes the form of a church or a shrine, and there are elements of Shintoism, Catholicism, Santería, and Hinduism. The installation was a direct result of a visit to Japan, during which the artists discovered the animism found in Hayao Miyazaki's films—specifically Totoro—which have influenced them until the present day. The most pronounced expression of animism was the "Fur Liaison," a white plush beast which sat atop the large altar. In this, "Fur Liaison" is a stab at representing a god—in other religious institutions, gods are metaphysical, but this was a satirical representation of a corporeal manifestation. The installation was interactive—the viewer pulled blocks and there would be a randomized outcome. "Fur Liaison" would give the viewer a gift (a plush toy called "Lucky" or a handpainted block), or he would communicate back in auditory tones.

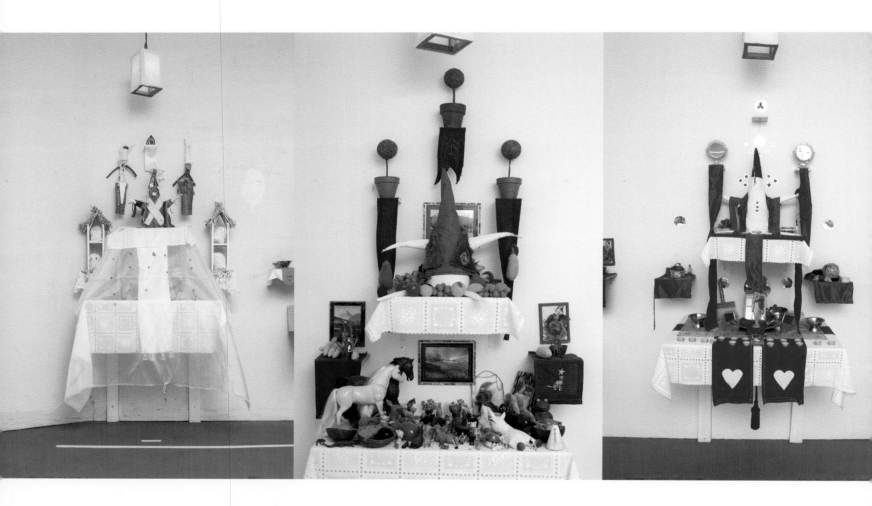

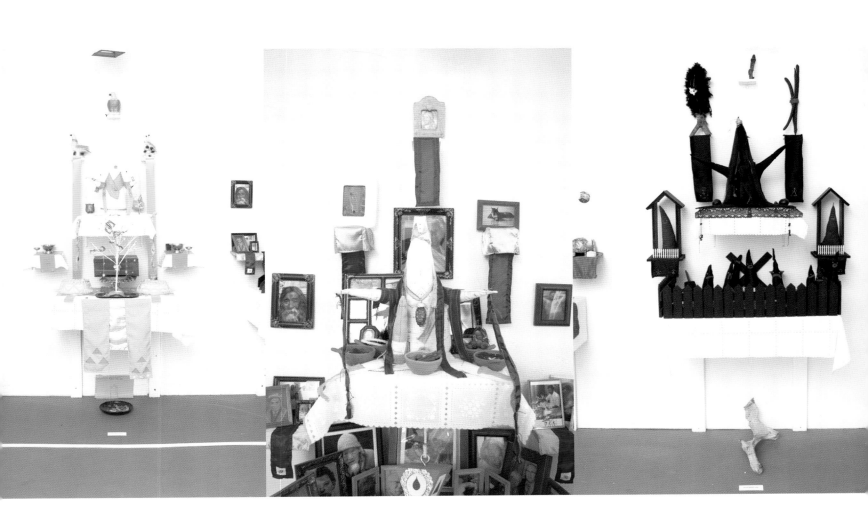

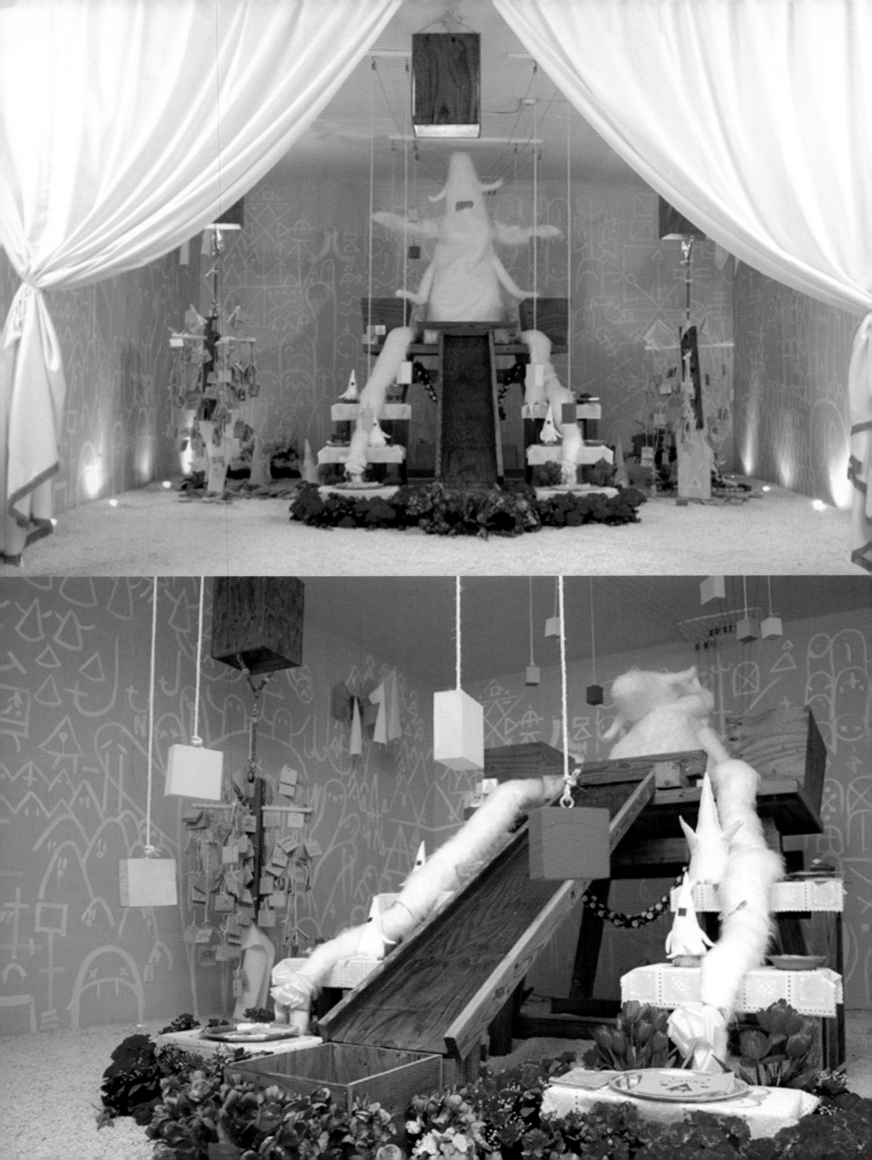

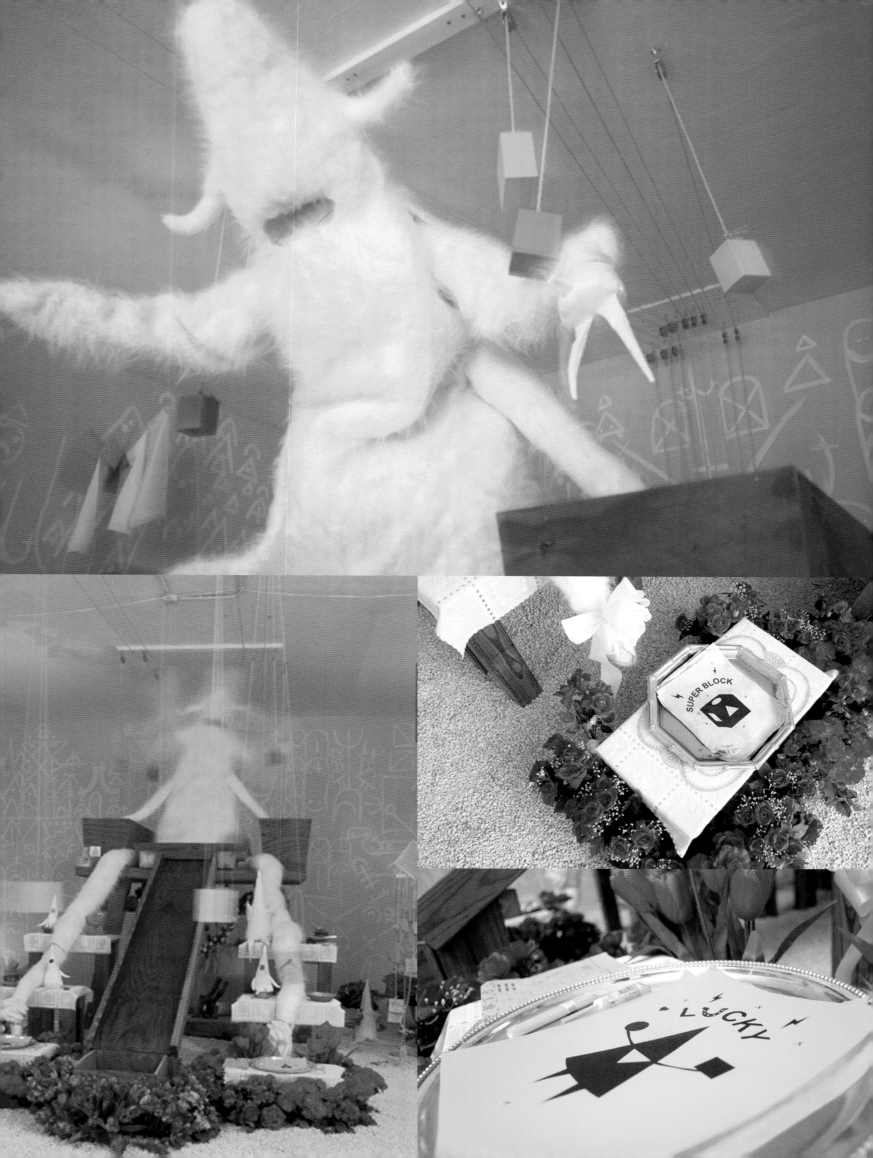

The Boy (Plush), 2002.

Unique multiple. Plush toy.
11 x 6 x 3 inches.

The Boy character is the archetype of an em-
pathetic child spirit; he is the embodiment of
youthful creativity. His open mouth and naïve
expression give The Boy an innocent air, but
deep down The Boy is the incarnation of an
elemental vulnerability that has carried on in
humankind since the origin of man. The Boy's
spirit is, in essence, the everyman's journey,
humanity boiled down, and a fragile soul
wrapped into one pastiche. Visually, The Boy
is carefully rendered to achieve this empathy:
the placement of his eyes far apart to evoke
innocence, the open mouth to remove any
emotional cues. The Boy is an amalgamation
of spirituality, from the sun to Buddha to spirits
described in early animism.

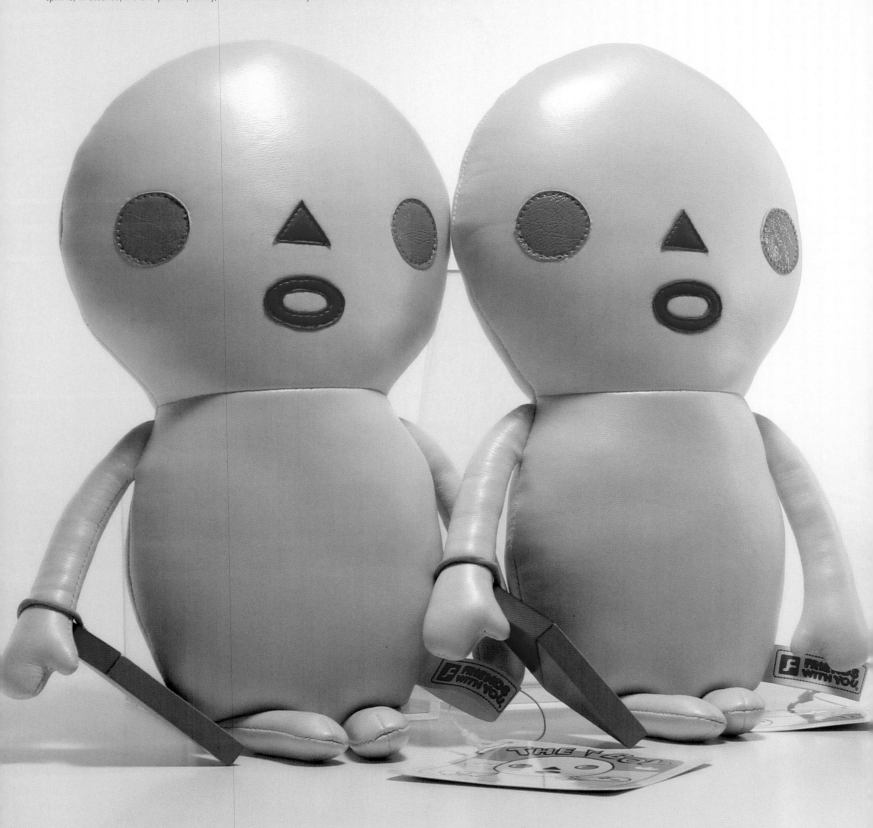

Booboo Boys, 2005.
Exhibited in "Hanging by a Thread"
at The Moore Space.
Mixed-media installation.
Dimensions variable.

"Booboo Boys" is an interactive installa-
tion that features The Boy character as
little gods. The heads of gods hang from
a contraption. The contraption has bells
on a pulley system. The viewer pulls
the rope, and the bells ring. Then the
viewer may write down a wish on a slip
of paper and insert it into a box upon
which resides another god. There are
echoes of several religious rituals, which
reiterates FriendsWithYou's ability to take
tidbits of several different religions and
put them into one, modern, easy-to-use
ritual for the contemporary viewer.

The Boy, 2010.

Edition of 9. Bronze.
5.5 x 8.25 x 5.5 inches.

"The Boy" sits with his arms clutching his legs, invoking a docile, contemplative stance. The position could be read as fetal, though his blank features leave interpretation open. In this, The Boy maintains an innocent constitution, lending him a vulnerability, but there is strength in his humanness. The bronze material gives the sculpture a formal, modernist quality.

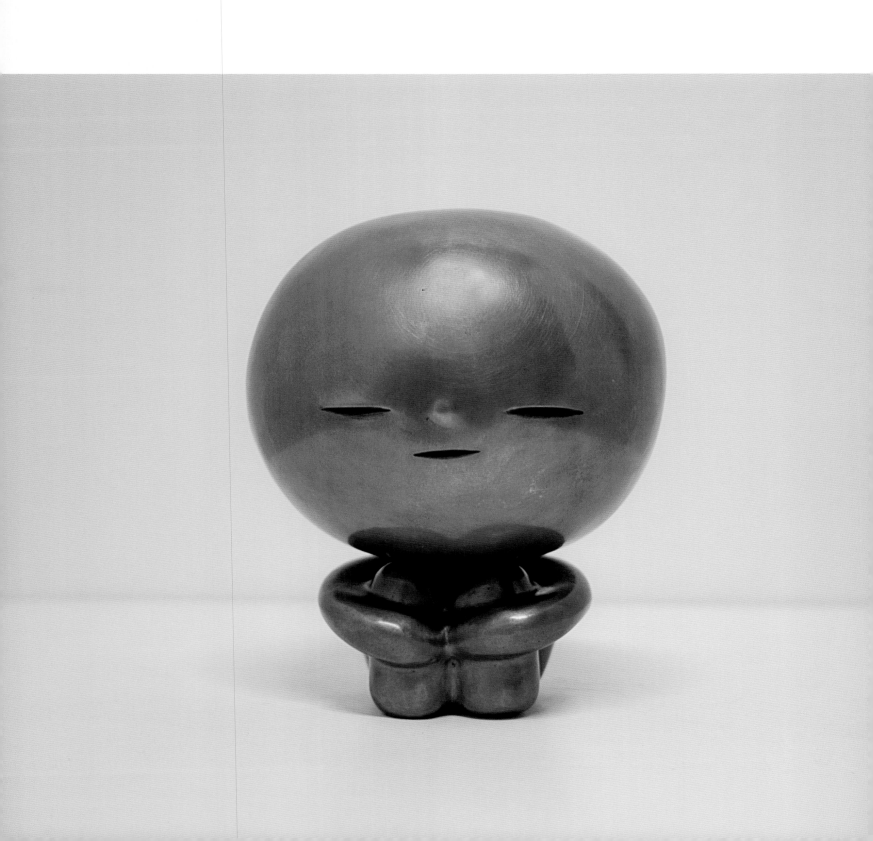

Sleepy Head, 2010.
Edition of 9. Bronze.
8.5 x 6.75 x 6.75 inches.

In "Sleepy Head," the ovoid character lies
horizontally, almost as if he were the blissful
descendent of Constantin Brancusi's "Sleep-
ing Muse." The heaviness of the bronze
underscores the heaviness of sleep, giving
the piece a calm serenity. His shape gives
him the ability to roll along, suggesting the
movement that occurs in a dream state.

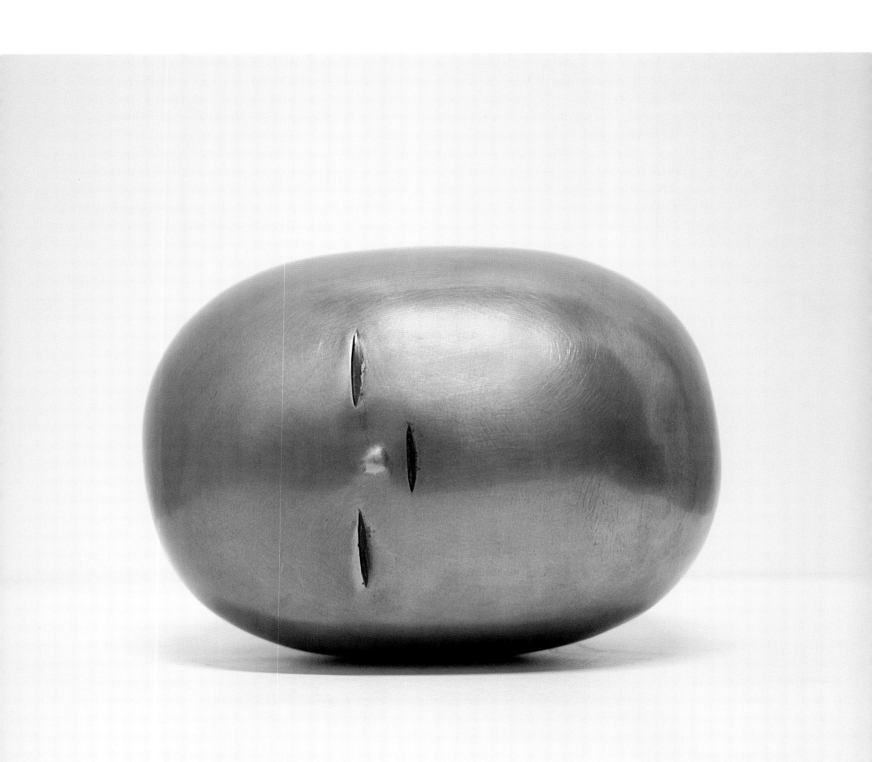

The Dreamer, 2010.
Porcelain.
9 x 13 inches.

"The Dreamer" (as seen earlier in the Healing
Arts chapter) plays out like a formless version
of Auguste Rodin's "The Thinker," giving the
piece a universality that suggests that "The
Dreamer" is every dreamer. The dollop
shape that "The Dreamer" takes becomes
a thought bubble, or the embodiment of a
dream, its antenna pointed to the skies as a
radar for dream state activity.

Little Buddy, 2012.

Edition of 25. Porcelain.
6 x 5 x 6 inches.

"Little Buddy" is a shiny, gold- or silver-glazed
porcelain art object, but more importantly,
he is a guardian amulet. Meant to be kept
by the bed to increase subconscious activity
during sleep, "Little Buddy" has a simple
face. The simplicity portrayed in the face
represents the innocent soul in all of humanity,
allowing the viewers to explore their own
emotions.

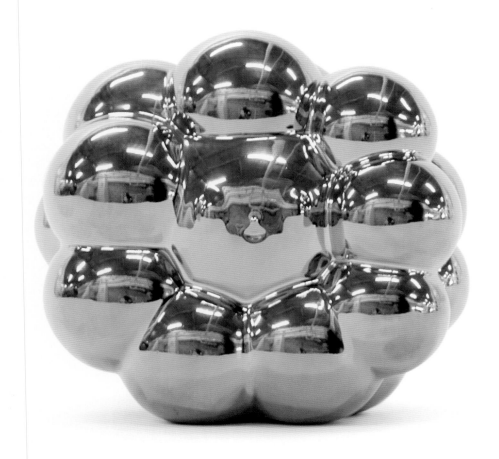

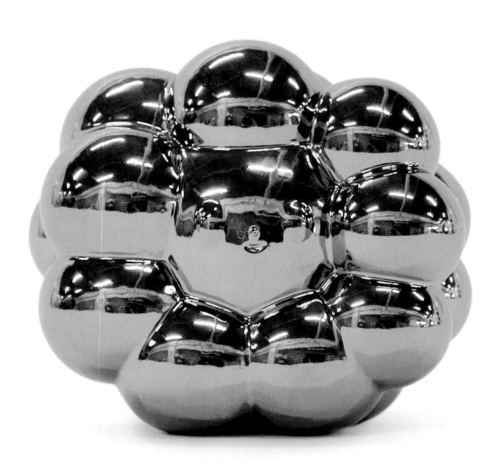

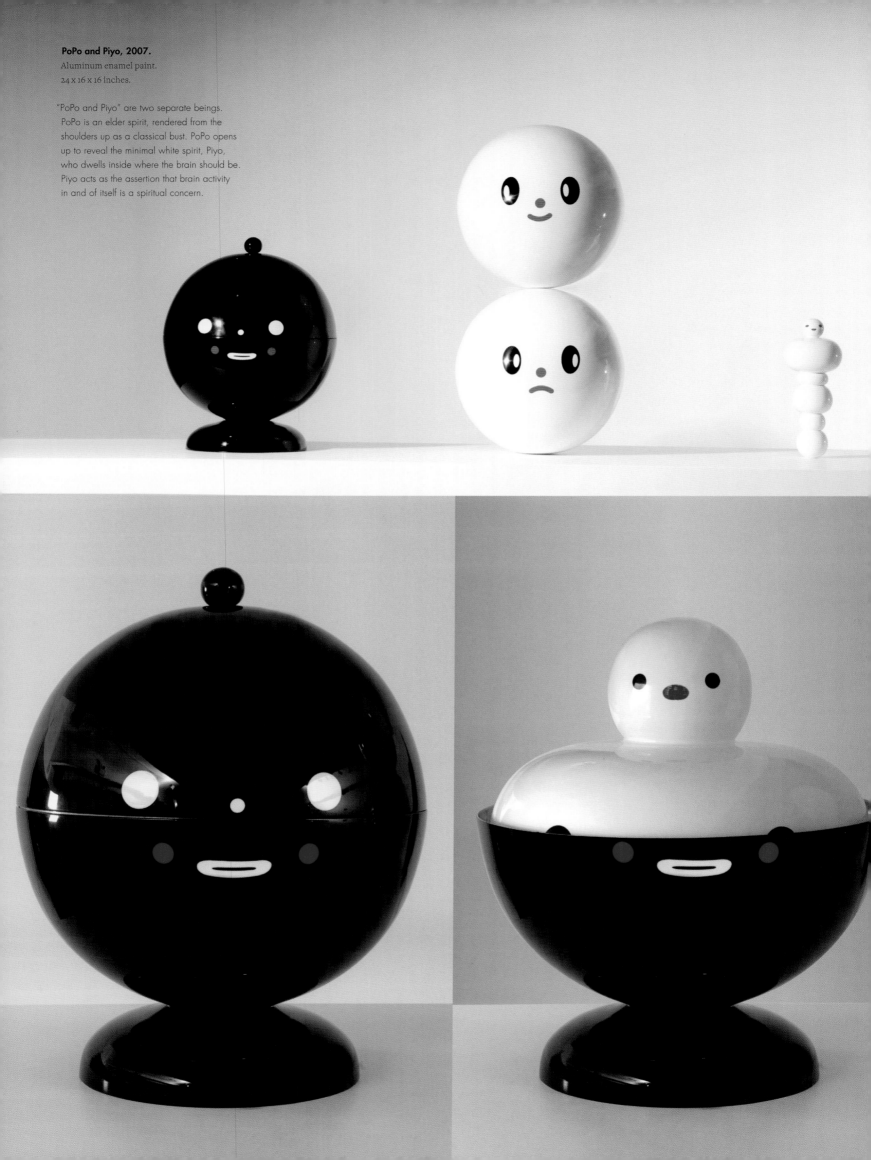

PoPo and Piyo, 2007.
Aluminum enamel paint.
24 x 16 x 16 inches.

"PoPo and Piyo" are two separate beings.
PoPo is an elder spirit, rendered from the
shoulders up as a classical bust. PoPo opens
up to reveal the minimal white spirit, Piyo,
who dwells inside where the brain should be.
Piyo acts as the assertion that brain activity
in and of itself is a spiritual concern.

Buddy Chubb, 2007.
Aluminum enamel paint.
32 x 16 x 16 inches.

"Buddy Chubb" acts as an avatar for the
two artists and FriendsWithYou, drawing
Borkson and Sandoval into their own myth-
ology. The two heads are the two selves, in
reconciliation of the pair of egos that could
exist as separate entities. It is a union that
shows the duo's duality—not in opposition,
but in union.

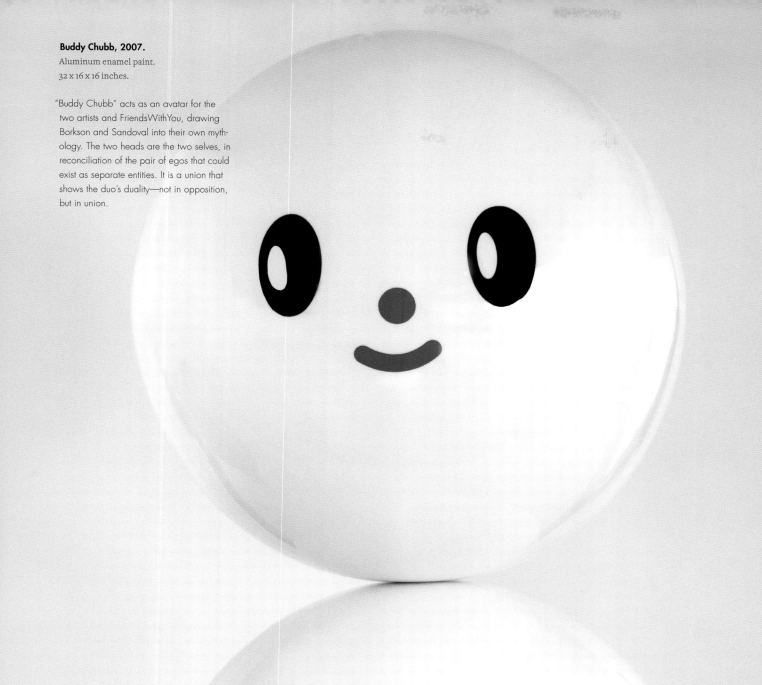

Plasma Eyes, 2009.
Edition of 50. Silkscreen.
38 x 50 inches.

With its use of triangles and rich colors,
"Plasma Eyes" is an oversize print meant
to induce the viewer to a powerful place.
Triangles are loaded with heavy spiritual
history, from Pagan (three spirits) to the
Greek (who saw the triangle as a gateway).

RAINBOWS
STRIPES
SACRED
GEOMETRY

"The theosophical worldview must work with a higher geometry that transcends ordinary geometry," wrote early 20th century philosopher Rudolf Steiner in *The Fourth Dimension: Sacred Geometry, Alchemy, and Mathematics.*[3] Steiner's theosophy contends that the things around us that make up natural geometrics and mathematics can induce an innate spiritual sense of power. FriendsWithYou's semiology unifies these repeated symbols—among them stars, crosses, swastikas, and crescents—that crop up in disconnected global sacraments, playing into their ability to deconstruct religious concepts and iconography and reassemble them for the modern viewer.

Similarly, the rainbow represents the idea that every spiritual culture utilizes color in their theosophical practice—brought together, the rainbow becomes a powerful form made up of all the colors that humankind can visually perceive. Because of this, many Muslim, Hindu, and Native American beliefs consider the rainbow to be a powerful icon with healing properties. FriendsWithYou utilize these ideas and have created a sort of chromotherapy, a New Age concept of healing through color. Through rainbows, geometry, and the use of stripes FriendsWithYou create objects and optical illusions that have deep meanings through the ages.

[3] Steiner, Rudolf. *The Fourth Dimension: Sacred Geometry, Alchemy, and Mathematics.* Massachusetts: Anthroposophic Press, 2001. Print.

The End, 2011.
MDF, lacquer paint.
4 x 8 x 192 inches.

The rainbow is a recurring theme within
FriendsWithYou's work, and it's easy to see
why. Not only is the rainbow a powerful
spiritual symbol—the Navajo believed it was
a serpent that could be ridden into the spirit
world—but it is the entire color spectrum,
something utilized greatly in FriendsWithYou's
vibrant works. "The End," which resembles a
John McCracken–style wall leaning, is liter-
ally an offering by the artists to the viewer:
the end of the rainbow is finally within grasp.

When you do something hard-edged or geometrical, I think that to some extent you do get into the metaphysical realm.

MAXWELL WILLIAMS When I started to look at your sacred geometry, I'm reminded a lot of Rudolf Steiner, the fourth dimension, hyper-complex numbers, and the idea that mathematics is spiritual. Is that where a lot of your influence comes from?

SAMUEL BORKSON I've always been very entranced by numbers. I learned, early on, about how language is based on numbers, and has Hebrew and Kabalistic origins—certain numbers meant certain words meant certain ideas. That was a very interesting springboard. What we feel from reading books on religion, or books on tribes, is that we're finding a lot of this information is preset into our modes of communication. We're expanding upon the unsaid dialogue of visual simplicity.

MW When you come across something that you recognize as being in a sacred geometry context, how do you talk to each other about it?

ARTURO SANDOVAL III There's an aspect to it that we get to intuitively. Looking at our body of work, we can bundle certain pieces into this chapter, but as we're making it, these are executions that just seemed like they fit the language at the time. When you do something hard-edged or geometrical, I think to some extent you do get into the metaphysical realm. I think hard-shaped, minimal, reduced geometrical ideas lend themselves to be very open-ended and universal. They transcend the symbolism that is so loaded, that we have been trying to circumvent. We're very 'jazz' about our use of sacred geometry, in that we're referencing it at will without much strictness to the rules. We're not trying to set in stone a very solid discourse, and make rules to this geometry and numerology that we're trying to use. We do it as it comes for fun.

SB It's about finding these base tones to every language and naïvely approaching them with all of our inset information. For instance, we start learning about why 12 is such a crazy number. There's 12 months in a year, there's 12 apostles of Jesus, and there are 24 hours in a day, it's a multiple of three. All these things then start becoming magical to us. We're discovering the sacred truths of our lives as humans, which are filled with all this information.

AS We are, to some extent, learned about rules of numerology and geometry, but when we're making an artwork, we don't reference it directly. We don't try to put a hard base on it. We're doing it, and then we're like, 'Oh, this is how this fits.'

MW One of the things that makes your work so disarming is the sense that you guys are learning right along with the viewer.

AS We've done that under some actual directedness. I think that from the beginning, when we started making geometric work, it was like, 'Okay, if we're reassessing the symbols, then there's no real need to really explicitly reference where they're coming from.' If you do that, then you're just doing a dissertation of that symbol. If we're going to treat it as art, then we'll just accept the result however it comes out. Then we'll recontextualize it so it makes sense in the storyline, or the theme of that exhibition, or that series. We try to go at it impulsively as opposed to academically.

SB We're engineering the feeling and the science and the color. The actual manifestation stems from the thing that we want to evoke. That's how we start art pieces, at conception, when we're just talking about them. We're like, 'Oh, the idea of stepping through something,' or, 'The idea of looking at something that looks like it's moving,' or, 'The idea of being able to take your feelings and smash a bad idea,' or, 'To physically experience joy and play with people in an unfamiliar territory.' I feel like those wants for ourselves, for these healing emotions and these things are what we're discovering for ourselves, as you have mentioned. We're bringing the viewer on a learning adventure. That's one of the most beautiful things I feel about the openness of FriendsWithYou, and how nice I feel being a member of this collaboration, is that it's not so didactic or heavily academic. That would make us trapped. I feel super free. We can bring anything into our work with the set rule that it just has to have spiritual essence, or that it has to be a vessel for some kind of empowerment, or a healing device, or a learning device.

MW I think that people can see there's something happening in your work, but once you step in and start to peel away some of the layers of the onion, it becomes a lot clearer that there are some really powerful ideas happening. For instance, this idea of sacred geometry is, actually, if you do look into the idea of geometry, it is actually a spiritual concept.

AS It is also New Age.

MW Sure. Steiner was the godfather of New Age mysticism.

AS Which is a rather modern movement of spirituality. New Age is just about taking a full assessment of the knowledge of the world that we have now, and merging it with some kind of metaphysical, spiritual sprinkle on top. We feel that is part of our discourse, because it is an attempt at redesigning spiritual ideas.

We can bring anything into our work with the set rule that it just has to have spiritual essence, or that it has to be a vessel for some kind of empowerment, or a healing device, or a learning device.

SB I feel like once things become encapsulated—New Age-y—I feel that's the kind of thing we destroy in our own special way. We're not trying to define it as much as being open-sourced about it: 'What I and my culture sees in the number three versus what you and your culture, with everybody in the world.' I feel like we're paring it down to the bare understandings as if we were cave people.

AS Edward Burnett Tylor, the 19th century English anthropologist, always references 'natural religions.' If you try to see with a clean slate how we started cultures and the actual development of all the systems that eventually became religions, the first religions developed by pure assessment—pure sensory interpretation of all that's happening in our physical world. We are at the point now where all credibility with all major religions is tapped out. It was tapped out a hundred years before, but at this point it's just passé. These things are bankrupt of real power.

SB But I also see that a prime, beautiful example of it really working is a 10,000 person church in the middle of the country. Those people are getting the spiritual connection that they need. A lot of people that look at that and say, 'Oh, this stuff is discredited,' but we see value in those spiritual gatherings.

AS What we're trying to say is that, we try to see the natural religions. We have a hint of it—we know this number three is powerful. We're not going to put any dogma behind it; we're just going to use it. We know that this symbol is powerful. Our job is not to dissect that symbol to death. It's about recognizing that those symbols exist, and we're presenting them again in a cultural sense, under new bracketing.

MW Numbers and shapes have consistently been a part of every religion. The rituals and the symbolism still hold the power that they originally had. Does this play into the idea that you're taking those original rituals and symbols and synthesizing them for the modern audience?

SB Those mega-churches, or the men that walk around Mecca, turning and walking back—that power is inaccessible to us because we're not Arabic, or we don't dive into Christianity—but those rituals are so powerful. We're providing that power for everybody, including the people that take part in religious ritual. Our take on religion is so open-sourced, so clean, and without any attachments. It's as pure as we can design it.

MW Does that mean there's a certain reverence for transcendence in your work? In all those places, what you're describing is this idea of reaching a higher state of being through this ritual.

SB That's what happens in those churches where 10,000 people are touching and feeling the spark of this beautiful power. That's supposed to happen inside of humans more. A lot of society is disconnected, and they're not connecting with that.

AS What we are doing is to take that divide and really frame those symbols that are now overburdened. They've lost their true meaning. What we're getting right now is an indecipherable fuzz masking the true meanings of the symbols. The fuzz is too loud to actually hear the real original myth. We take that original myth out, and we present it in a different context. I think that there's a little bit of a re-branding of those symbols, away from any dogma. We serve those symbols and those emotions and that activity away from any true ethical imperatives, which is what differentiates what we do from an actual church or religion. There's no ethical involvement at all. We're serving our work at face value, we don't need any commitment, you don't need to obey any rules—you don't need to do anything. We're just asking you to come and experience it. Having this discourse inside of an art setting is interesting. I suppose if we were truly trying to make a cult, we would pick one of our variations and we would stick to it, and try to get as many followers as possible, and build. It's pretty easy to make a cult: you attach yourself to the symbols.

MW Do you think some people do connect to your work because they're kind of entranced by the kind of faith-based symbolism?

AS Well, I would argue that 'faith-based symbolism' isn't the right term. I would call it 'archetypical symbolism.'

SB Our symbolism is based on the primal thing, just geometric shapes. They're the most reduced forms. Even the figurative forms that we do are very reduced characters. The placement of eyes and mouth gives it a feeling, the slight tweaking of that makes a different emotion. It's like 'binary Hinduism.'

MW When you talk about this kind of sacred geometry, and especially rainbows and stripes: these are the things that I think people must have been really confused by early on. Without even having the words to articulate it, early humans must have thought, 'How on earth did this rock get such a geometric shape?' Or, 'Why does this triangle-shape always happen?' Or, 'Why is there a rainbow?' These things must have been the earliest questions of what it means to question existence.

AS Forget about any connotation about those symbols. When they were first used, they came from things that were ingrained in our nature. Front, back, left, right—it was so crude. It's the same thing with fear, how we sense fear and to what degree we sense fear. It's so hard-wired into our mental system that you react to it. You can't help it. I think that we definitely use those symbols to get that sadness of not being able to reject that alignment because it's ingrained now.

SB When primitive people saw rainbows for the first time without all its ingrained history, it was magical. Every primeval human through Australopithecus all saw the same thing. It's ancient. Similarly, the swastika was found in all these different places. They were mapping the sun, or they were trying to make a symbol of the motion of something. It's a motion idea. That happened through all cultures before there was any religion. The path that symbol took is really insane: a symbol of motion that is used by every native in the world, to be used in such a powerful, beautiful way. It was indoctrinated by Buddhism and Hinduism and many religions thereafter, and then re-indoctrinated by the Nazis. It's such a crazy thing that Hitler chose that symbol: one of the most primal symbols.

MW The journey of the meaning of symbols and even the journey of words, and the way they change throughout history, is really interesting.

AS Graphic symbols were also switched. Rainbows weren't always a positive thing. A lot of Asian cultures believed it was the tail of the dragon. It used to come and take them down to the underworld. There are symbols in some cultures where they mean one thing, and in others they mean something else.

SB Like the snake in the Bible versus the snake in early Mexican native beliefs. Mexicans believed the snake was their pathway, their water, their deliverance. It was everything.

Next page:
Two of a Kind, 2010.
Edition of 100. Silkscreen.
22.7 x 15 inches.

The two characters in "Two of a Kind" are identical, but the placement of the Op Art style stripes gives them the illusion of two different emotions. The lines themselves have a vibrational effect, giving the piece the illusion of motion. In this, the two characters are unified as a two-headed entity with a dizzying optical effect.

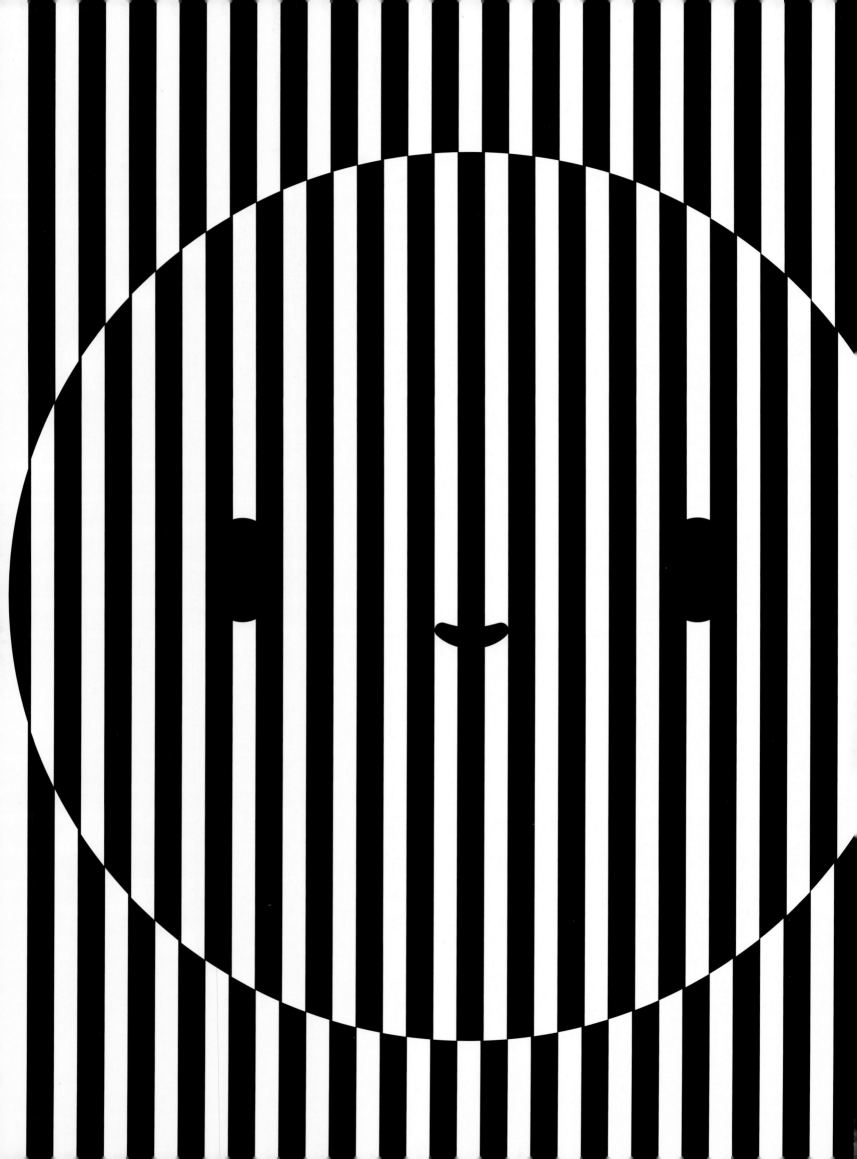

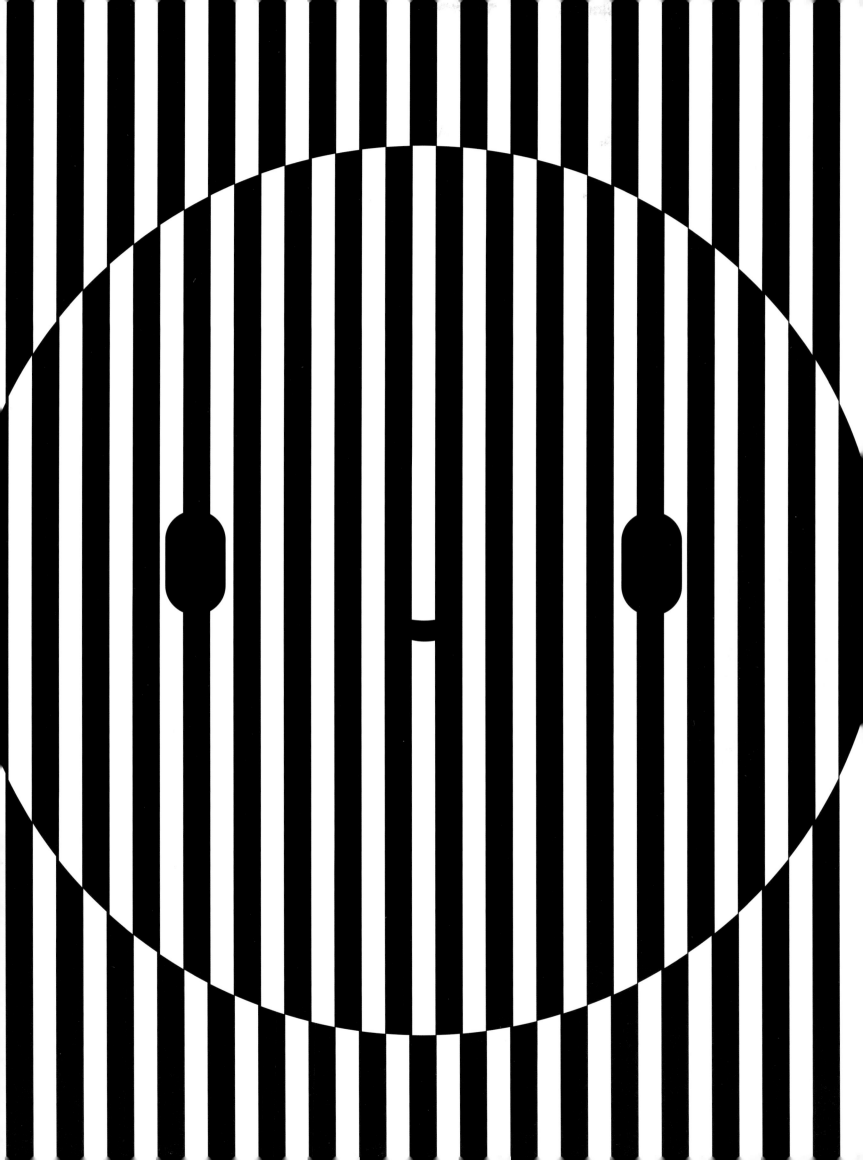

In The Beginning, 2011.
Installation.
Dimensions variable.

"In the Beginning" was an exhibition that
played on the reconciliation of opposites.
The merging of the artist duo's backgrounds
overlapped, and the result became a series
of prints and sculptures. The trajectory of
the works was an experiment away from
consciousness, and the Op Art quality
engenders that movement towards the
abstract metaphysical.

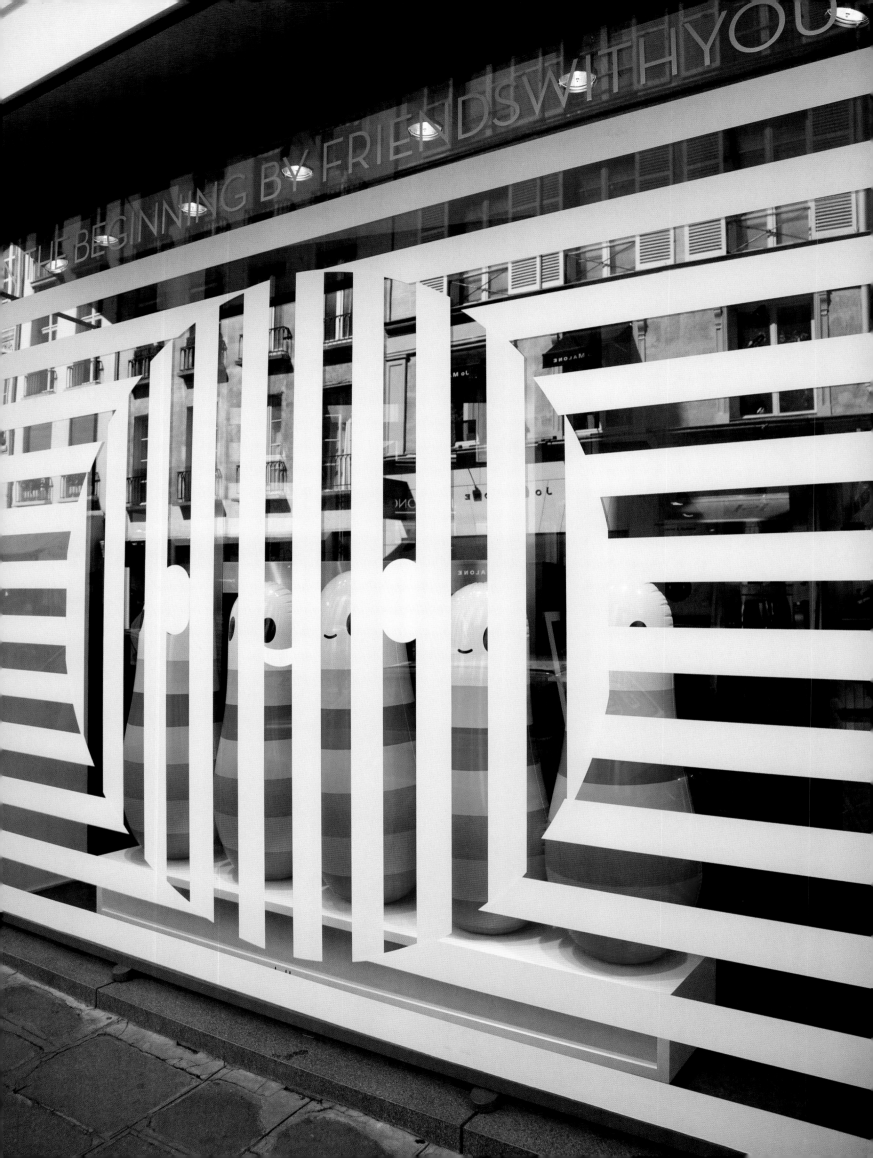

Space Gem, 2011.

Edition of 12. 52 piece wooden puzzle.
14 x 11 inches.

"Space Gem" is a segmented sculpture, crafted like a 3-D puzzle game, with a rainbow composition representing the convergence of all of FriendsWithYou's monochromatic characters. In this, "Space Gem" is the synthesis of a series of tonal work, his spirit emitting light and color from his various slices.

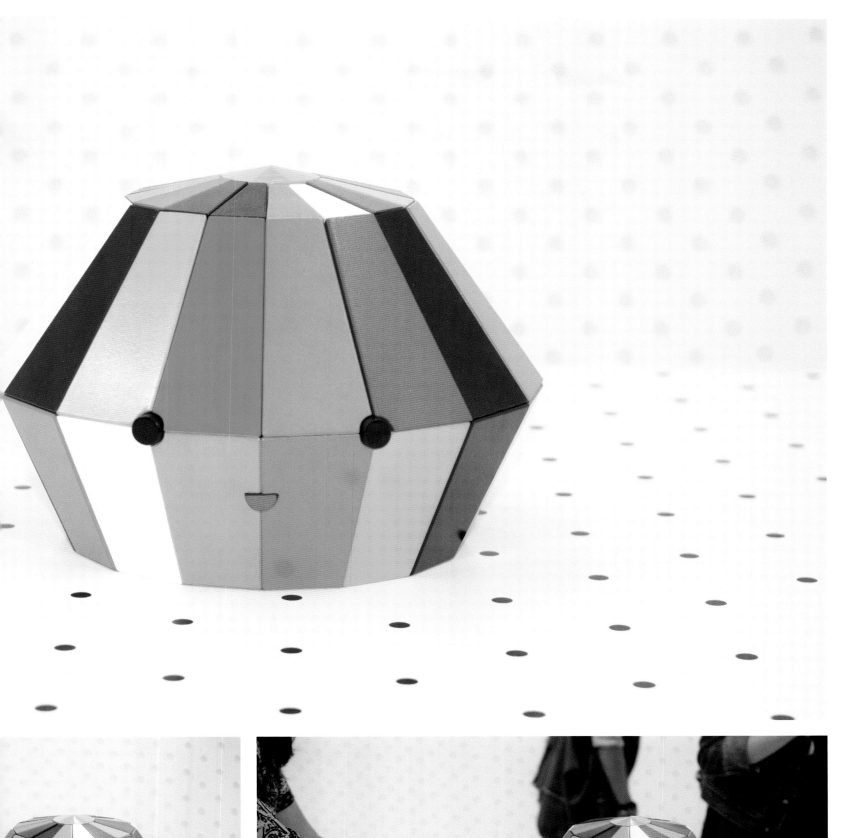

Plasma God, 2011.
MDF, lacquer paint.
60 inches diameter.

"Plasma God" is a figure that performs a
blast of light from each of the colors of the
rainbow on the viewer. Utilizing the color
palette of the rainbow, "Plasma God" instills
the viewer with the powers of each color,
his geometric shapes emitting light in con-
centrated pieces.

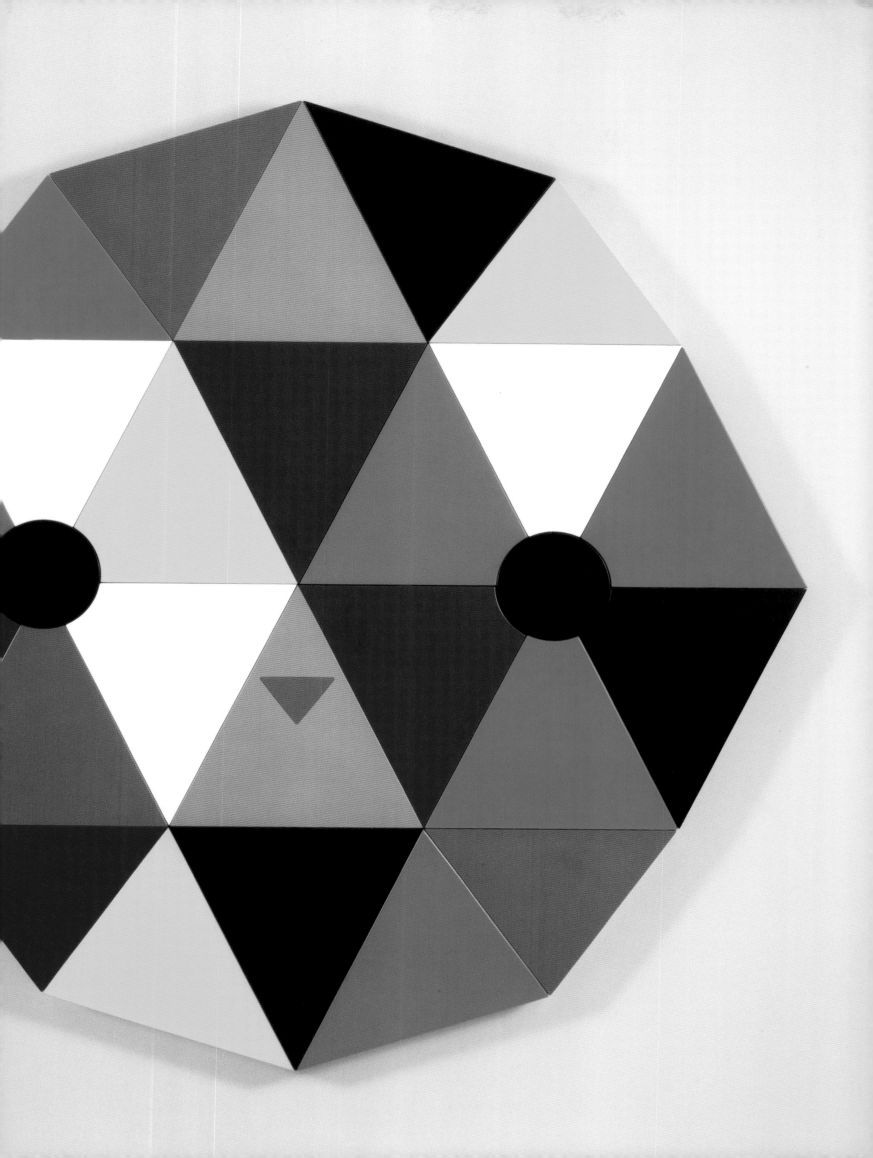

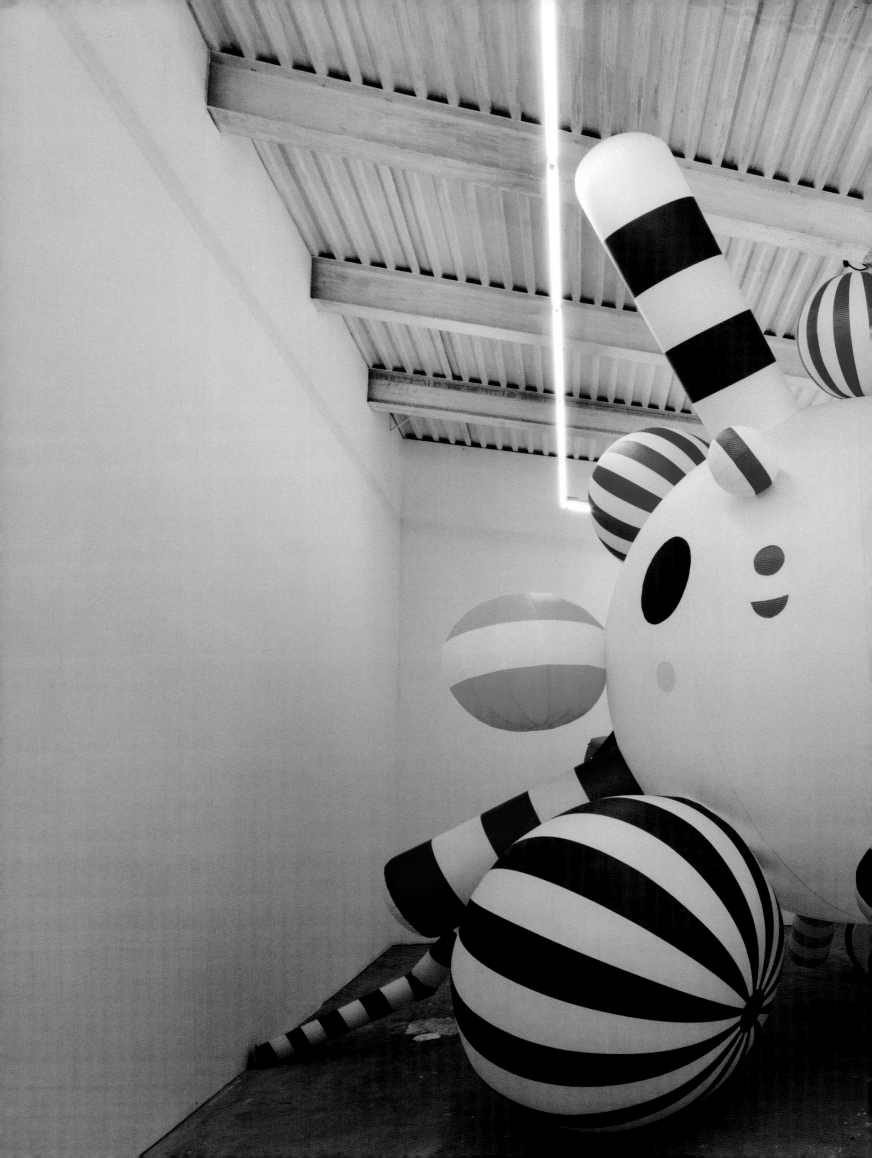

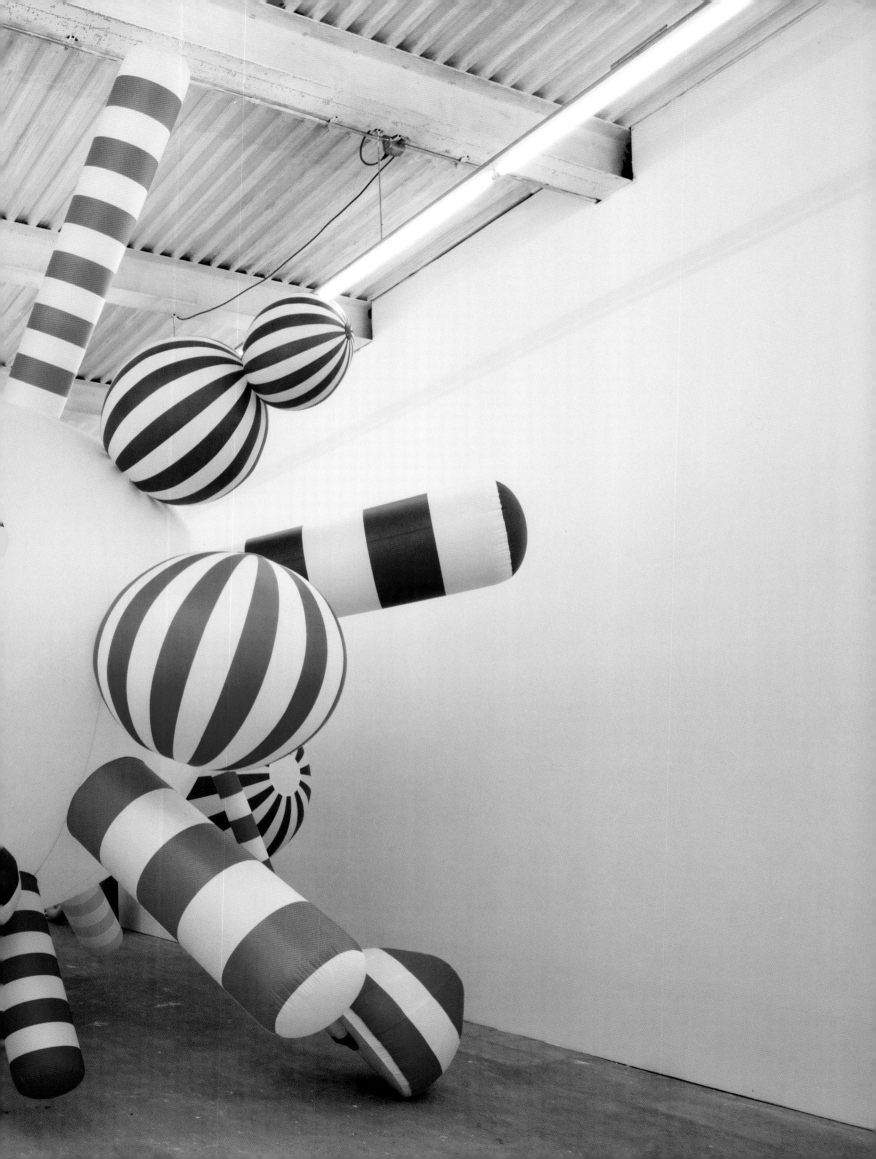

We're serving our work at face value, we don't need any commitment, you don't need to obey any rules—you don't need to do anything. We're just asking you to come and experience it.

Starburst, 2010.

Inflatable sculpture. Ripstop nylon.
300 inches diameter.

"Starburst" takes his name from the cycle of the life of a star in the FriendsWithYou universe. He is a pure soul character with ideas and emotions bubbling off of him—every day, he awakens, ideas and emotions run through him, he explodes, dies, and then rises again the next day—a metaphor for our consciousness. "Starburst" is chaotic and busy, with protuberances jutting out in every direction, like the constant flux of our everyday lives. In his emotional ebb and flow, "Starburst" also acts out the phoenix mythology, rising again each day in whatever setting placed.

"Starburst" is one of FriendsWithYou's most enduring traveling sculptures, having been shown worldwide in exhibitions since 2010.

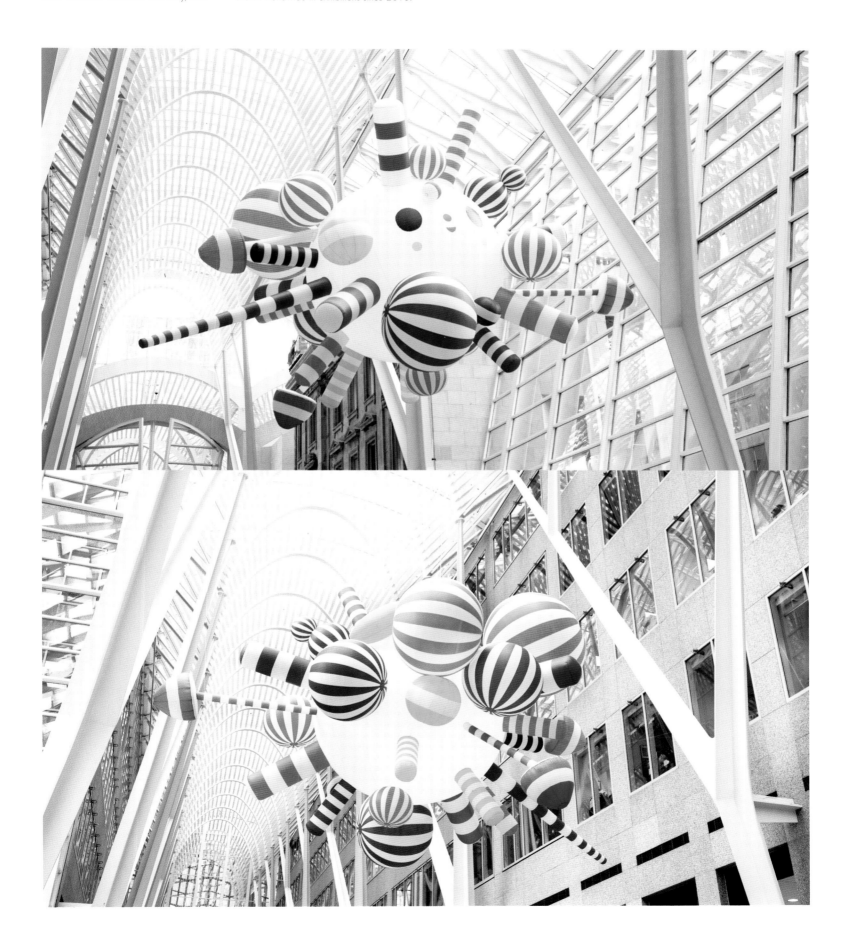

The Portal, 2011.

Lasercut MDF, car paint, acrylic.
72 x 135 inches.

"The Portal" is a stoic god—a chanting monk
that breathes out and sucks you into him.
A large-scale, 30-foot painting, the piece
is epic and powerful, with stripes that imply
the kinetic movement of breathing. In its
presence, the piece feels like it's in motion,
referencing Op Art.

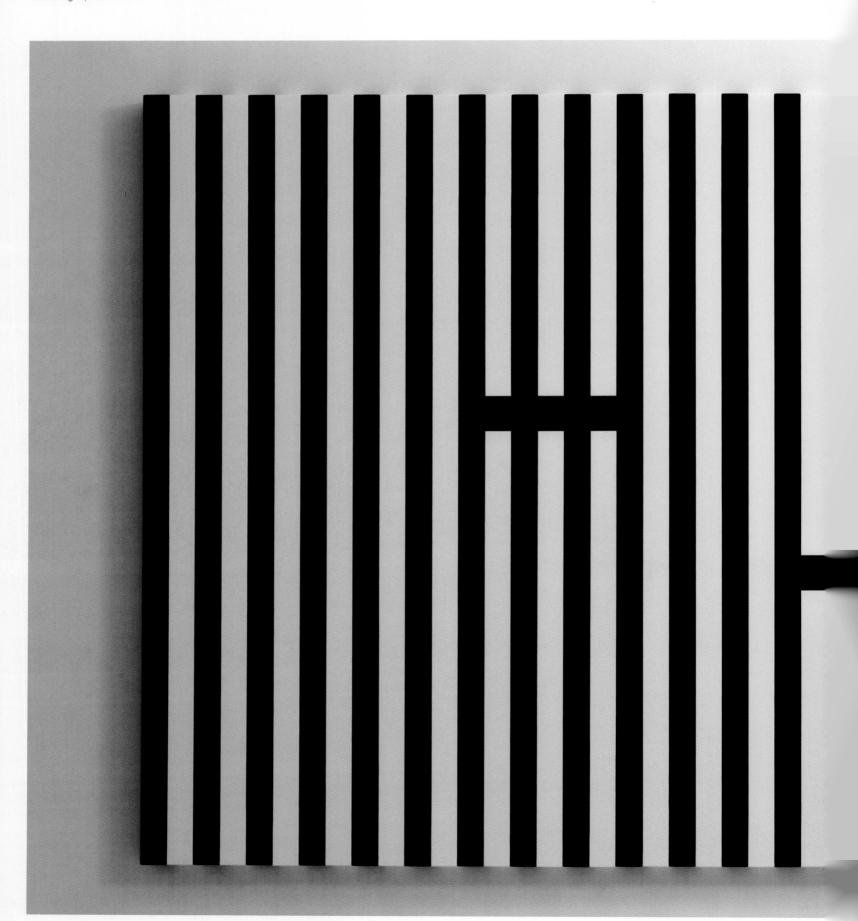

Previous page:
The Devil, 2010.
Cel-vinyl on wood panel.
78 x 48 inches.

With its measurements of 6 foot 6 inches,
"The Devil," from the Building Blocks series
of prints, challenges the American belief
system that the sacred value of the number
6 is inherently linked to evil. This plays
into FriendsWithYou's investigation into the
different histories of sacred symbolism—for
instance, the snake in the Christian Bible rep-
resents evil temptation, but in Mayan beliefs,
it is the shape of the universe.

This page:
Inside Out, 2010.
Cel-vinyl on wood panel.
57.5 x 48 inches.

"Inside Out" is a humorous piece, and
denotes FriendsWithYou's first step into taking
a simple abstract striping idea and giving it
life. There is an interplay between the figure
and the painting—the character within the
painting hides behind the lines playfully as if
he were a child behind his mother's legs.

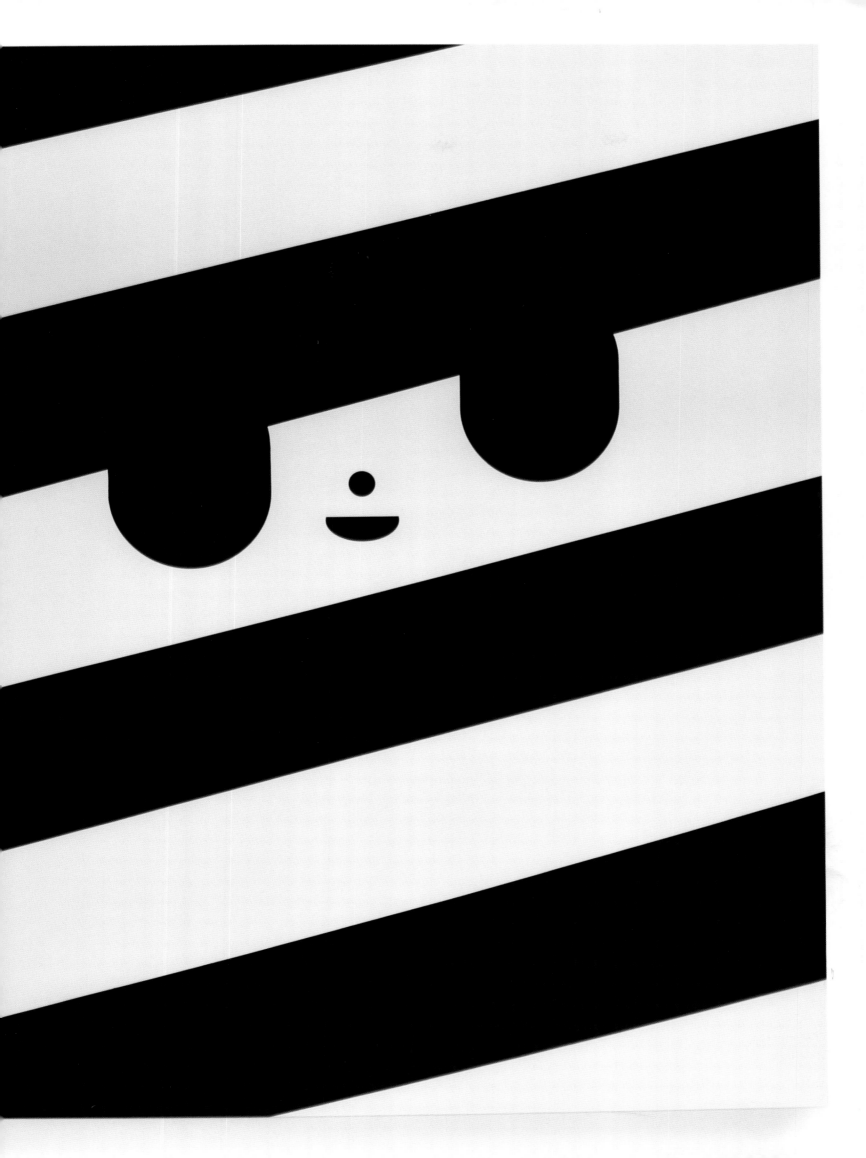

Previous page:
Light Waves, 2010.
Cel-vinyl on wood panel.
72 x 48 inches.

Seen in person, "Light Waves" undulates
with kinetic wavy lines, giving those that
look at it a trance-like effect like a cuttlefish
hiding from its aggressor, building an illusion
through an analog effect. "Light Waves"
represents the waves of the FriendsWithYou
universe, emanating into the viewer.

This page:
Phantasm, 2010.
Cel-vinyl on wood panel.
54 x 57 inches.

Representing a wizardly character with a
kinematic Op Art enchantment, the idea
behind the lines in "Phantasm" is that they
continue beyond the canvas, in the way a
great pop song continues after the song is
complete. "Phantasm" exists within the same
genus as "The Phantom" characters, who all
"disappear" by hiding within their stripes.

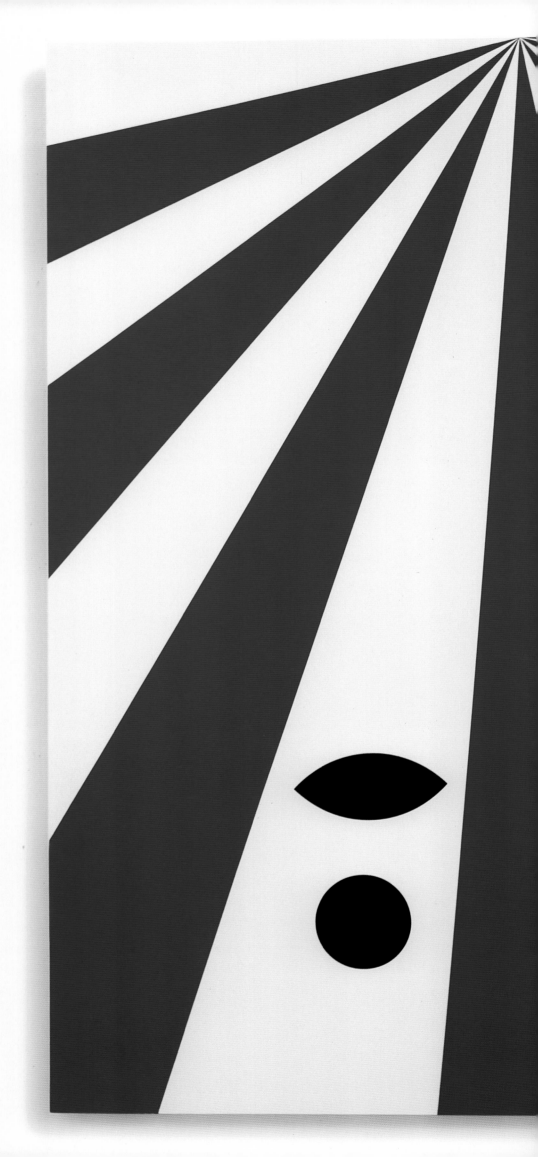

Friendship Flag, 2009.
Edition of 100. Silkscreen.
26 x 36 inches.

With a toy-like appearance and simple ge-
ometry, "Friendship Flag" is FriendsWithYou's
attempt at making a flag with undertones
of animsm. Not only is "Friendship Flag" a
literal flag, but he is a happy, pleasant repre-
sentation of the emotional connection to the
displaying of a flag: pride and celebration.

Our symbolism is based on the primal thing, just geometric shapes. They're the most reduced forms. Even the figurative forms that we do are very reduced characters. The placement of eyes and mouth gives it a feeling, the slight tweaking of that makes a different emotion.

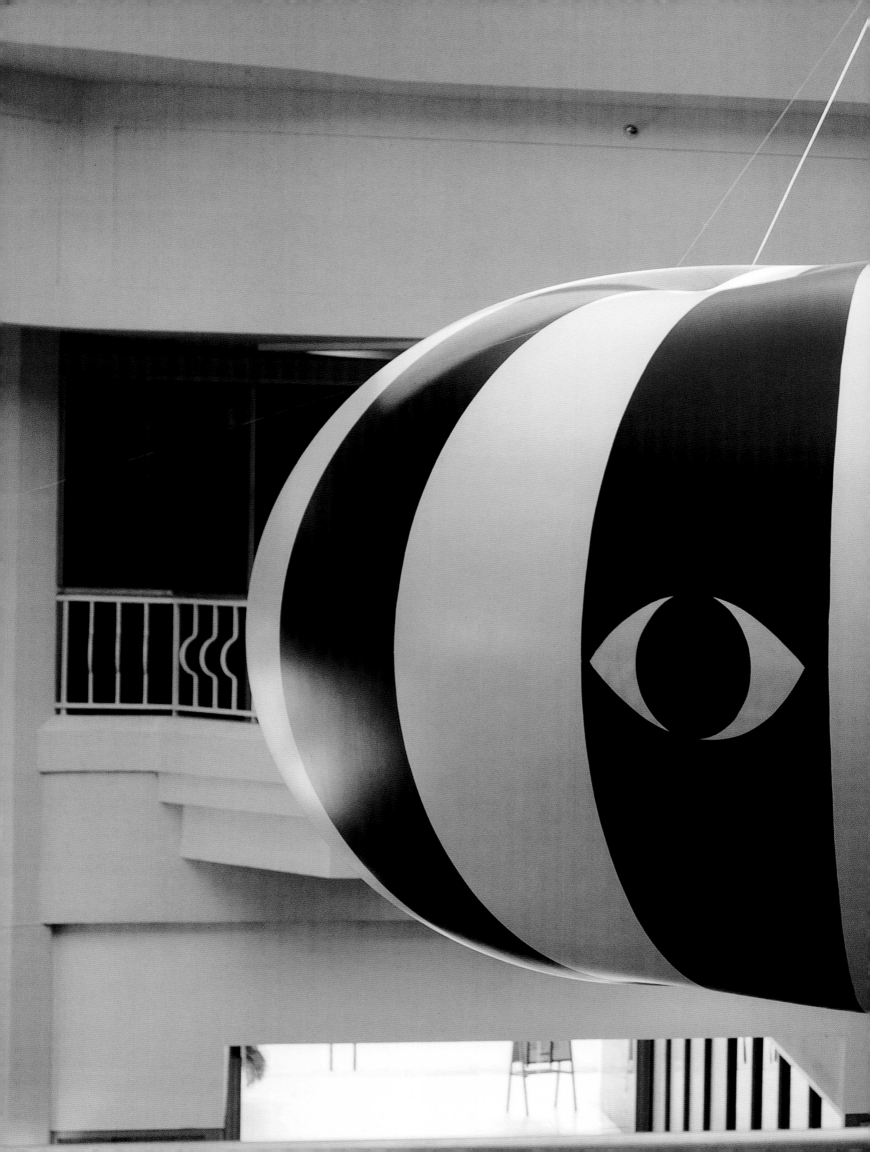

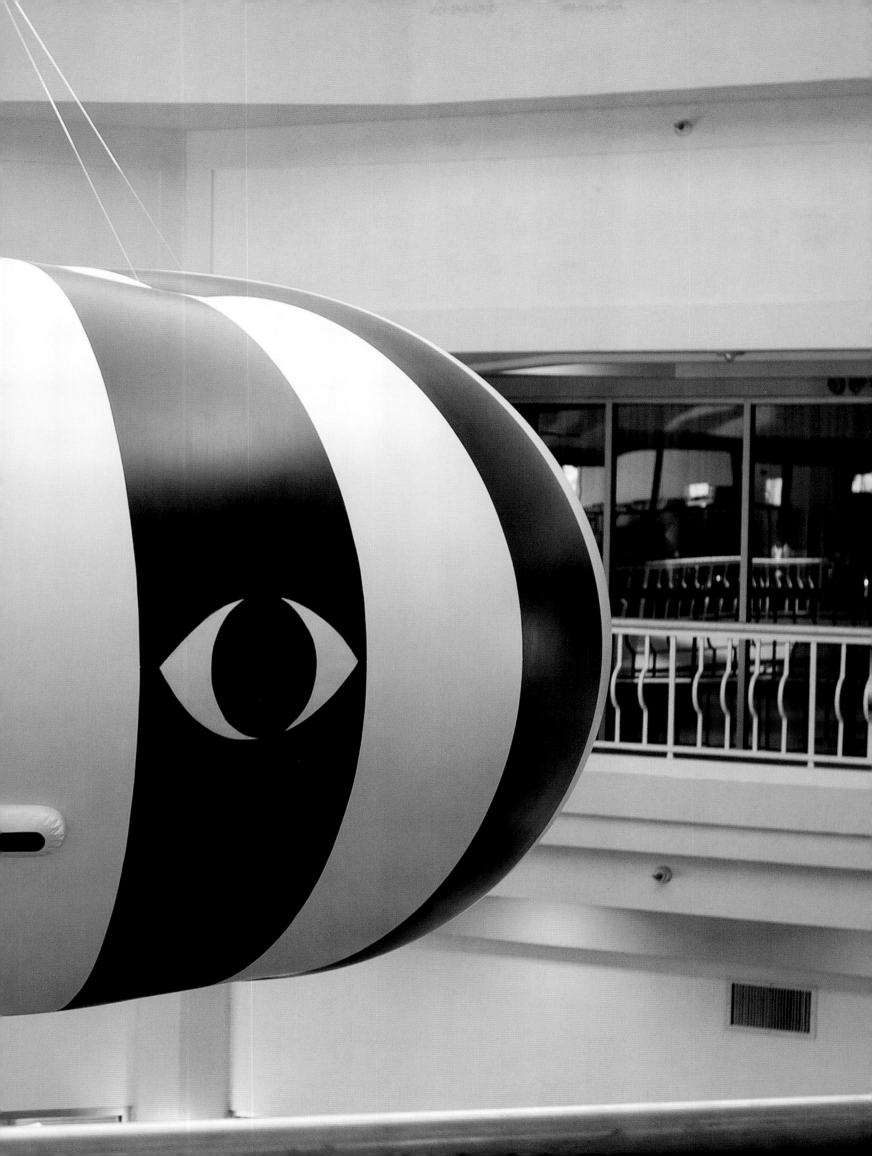

Phantom, 2009.

"Phantom" comes in several forms—an
inflatable hung high above an exhibition,
dual sculptures—but the constant remains
that he is a kinetic being. Tightly striped,
when "Phantom" enters his state of move-
ment, he spins, becoming invisible through
an optical illusion.

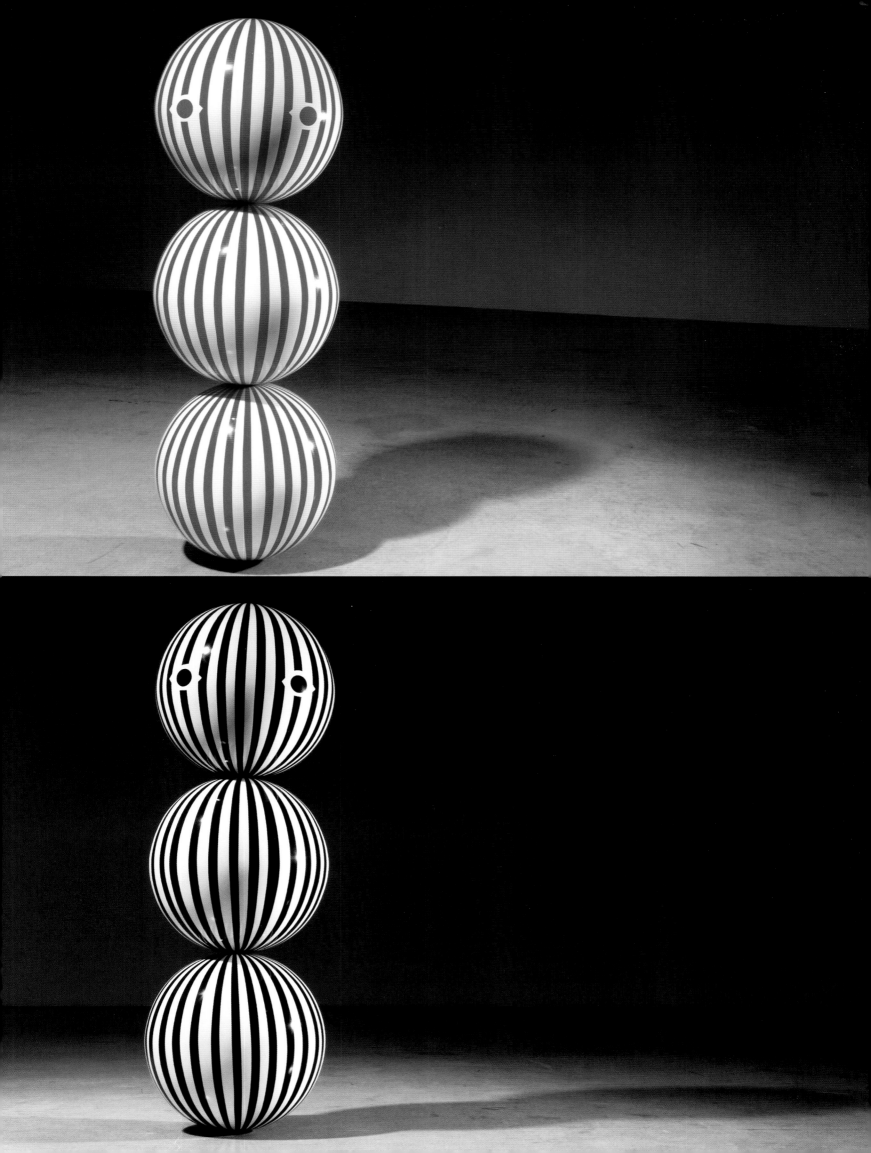

The Oracle, 2012.
Clear coat paint on fiberglass base.
72 x 62 x 73 inches.
This spread: Front
Following spread: Back

"The Oracle" is part of a series of characters
that also includes "Starburst." At its core,
"The Oracle" is a minimal sphere, but he
bubbles with emotions and colors that are
empowering, like amulets of healing power.
"The Oracle" is meant to be a configuration
of a character that reflects the individuality
inside the viewer.

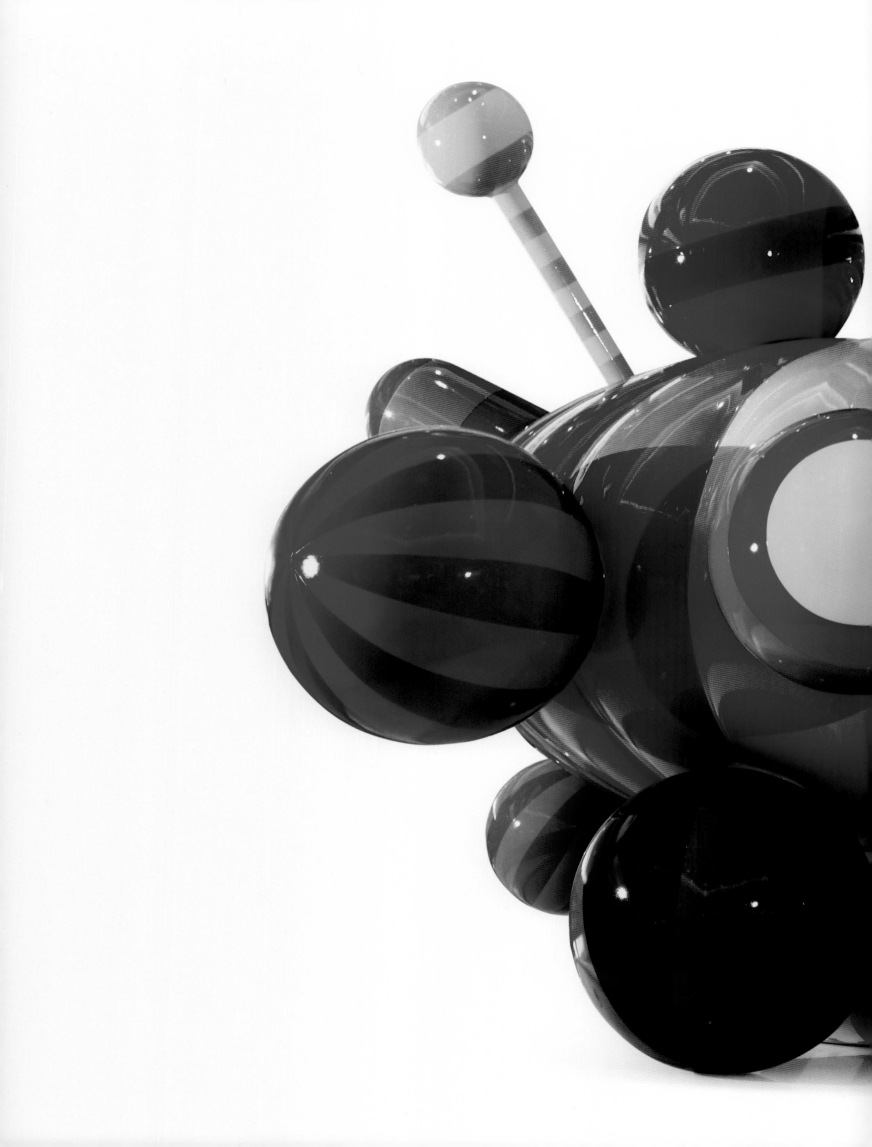

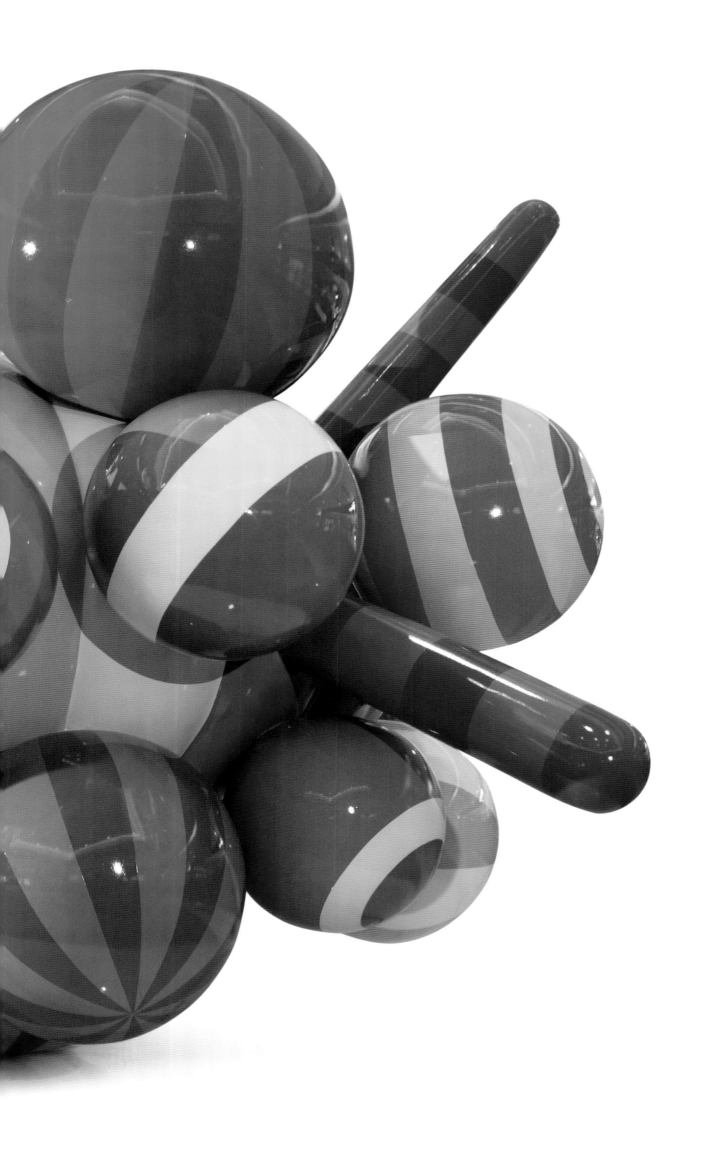

All the Wishes, 2012.
Clear coat paint on fiberglass base.
87 x 87 x 57 inches.
This spread: Front
Following spread: Back

"All the Wishes" plays the same role as
"The Oracle" and "The Starburst," existing
within the same phylum of bubbling emo-
tional spherical sculptures. However,
"All the Wishes" exists as a fetish object,
without an anthropomorphic quality—an
embodiment without direct representation.
Nonetheless, "All the Wishes" feels alive
even in its abstractness.

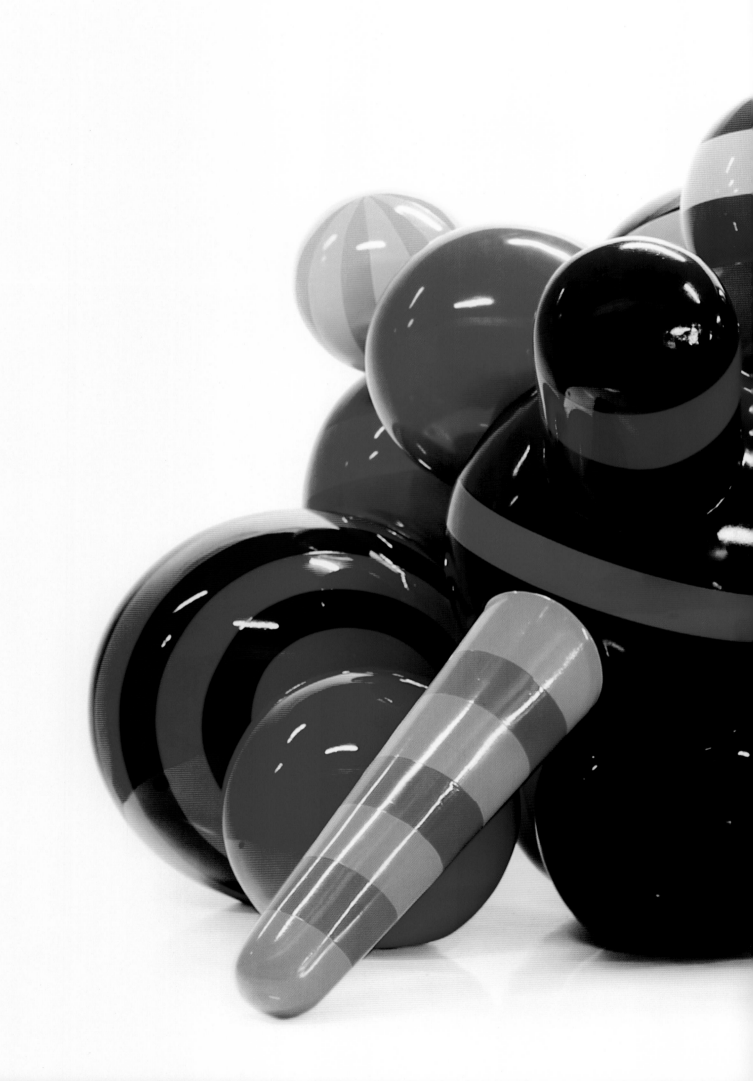

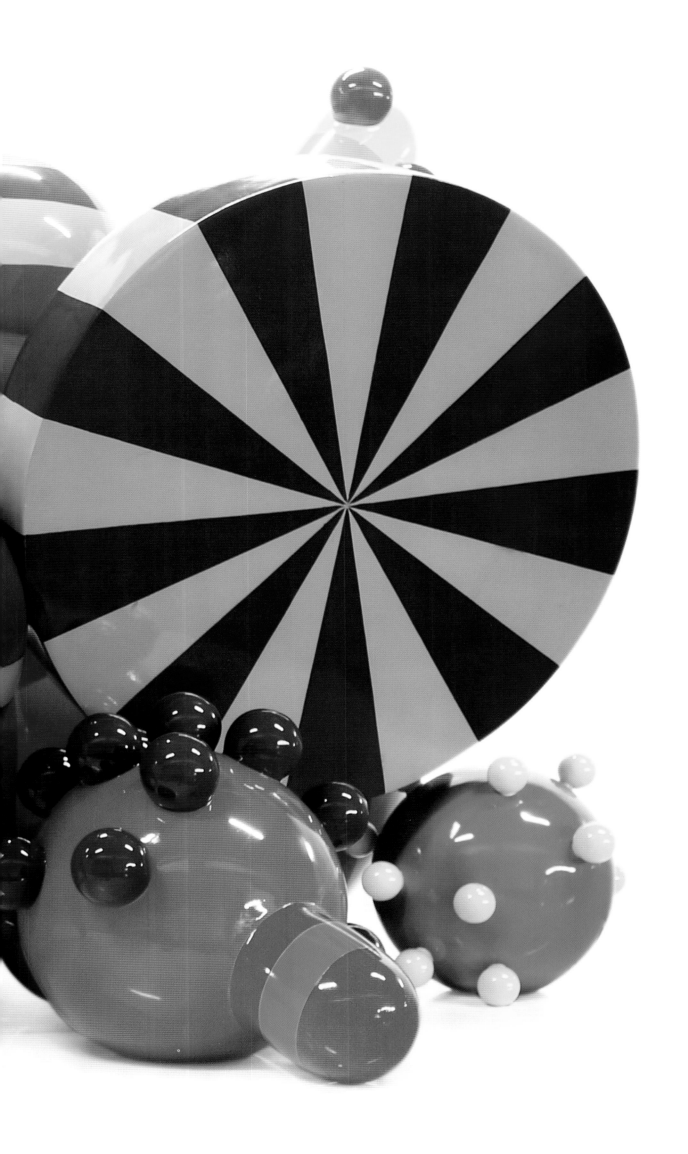

Rainbow TTT Bench, 2010.
Clear coat paint on fiberglass base.
34 x 15 x 15 inches.

After FriendsWithYou split all the colors into
each of their own archetype, they brought
them back together in the form of Mr. TTT.
The lore of Mr. TTT is that he is a warp-hole,
a traveler that the viewer can "ride" from one
place to the next. Mr. TTT is also a happy-
go-lucky shapeshifter that is excited to do his
job in the universe. "Rainbow TTT Bench" is
34 inches long, acting as both a functional
bench and a sculptural art object.

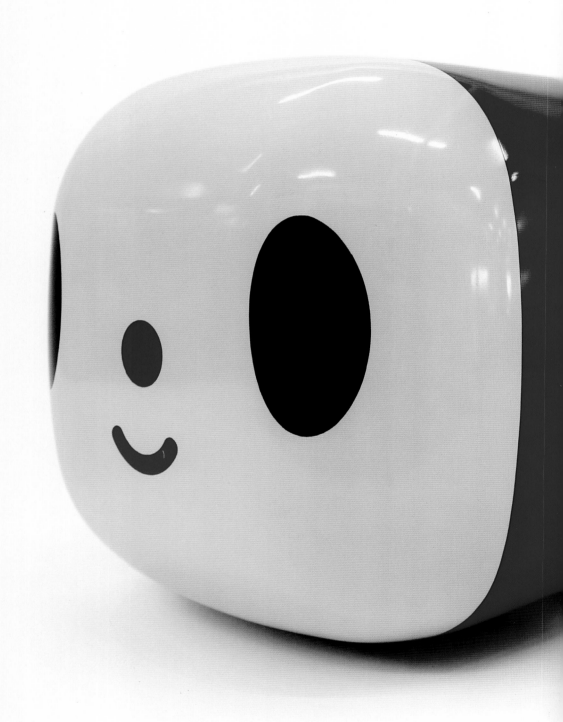

A CONVER-SATION WITH PHARRELL WILLIAMS

Pharrell Williams is one of the most prominent names in the music business, as a member of the band N.E.R.D. and the Grammy Award–winning production duo The Neptunes, with Chad Hugo. But he's also nurtured his design and contemporary art practice, collaborating on a sculpture with Takashi Murakami, as well as producing a chair for blue chip French gallery Galerie Perrotin and jewelry and glasses for Louis Vuitton. Launched in 2012, Williams' multi-media brand "i am OTHER" focuses on music, culture, fashion, and art. Through the "i am OTHER" YouTube portal, Williams and FriendsWithYou collaborated to release "Cloudy," a short animated film exploring the imaginary lives of clouds. Through this, Williams and FriendsWithYou have become comrades in the fight to bring color to the world, whether through music or art.

MAXWELL WILLIAMS What drew you to FriendsWithYou, and how does their work affect you emotionally on a visceral level?

PHARRELL WILLIAMS I like the playful nature—the way that they unlock the inner child within their work.

MW And why did you choose to include FriendsWithYou amongst a small group of artists on your curated 'i am OTHER' website?

PW Because they're people who utilize their gut instincts and imagination and try and turn it into reality. I'm really into that community of people who realize that all great things come from imagination first.

MW How did you guys come across each other? How did you guys meet?

ARTURO SANDOVAL III We were introduced through [the French gallerist] Emmanuel Perrotin.

SAMUEL BORKSON We had spoken previously on the phone. I saw Pharrell at Emmanuel's gallery, and I just went straight up to him, and started talking to him. It was really cool, because I had been following what he had done musically and culturally, and I felt that we had some kind of connective tissue between our work.

MW Pharrell, what parallels do you see between your work and FriendsWithYou's work?

188

PW I would say it's two different worlds, but I'd say what we have in common: I think we have those same chromosomes, and the willingness to bring imagination to fruition and manifestation. They're good at that.

MW And you do a similar thing with your music?

PW Well, I attempt to. That's the difference, I suppose.

SB I think you definitely do, man.

MW I think another thing that you guys share is that you both really attempt to speak to a large audience on multiple platforms. Why is the idea of talking to a large audience important for you, and what internal qualities have helped you tap into the pulse of the world?

PW I can't answer those questions. All I can say is that at the end of the day, across all disciplines of artists: we make something. We make what we perceive as some sort of stimuli, and it's up to the audience and the viewer to walk up, and be affected, and then have a reaction to it. And then from there, the process of art is complete. I just interviewed Jeff Koons on an artist talk show, and one of the things that he was saying was that the art pieces were only the beginning; the real art is when people react or respond, whether good or bad. It's the visceral reaction.

MW It feels like one through line of your work as a performer, producer, entertainer, and artist is to have people make that reaction, and one of the reactions is a certain joy or happiness. I feel that FriendsWithYou share this goal with you. Why do you think it's interesting to make people happy, and can you describe the happiness that can be achieved through a piece of art or a piece of music?

PW I don't think about things with such an equation. I set out to make things that feel good, but at the end of the day, I can't tell you whether I've achieved my goal until someone's responded or reacted to it. I think the guys are a little bit more focused in the way that they do things, and even if they don't think so, there's definitely a signature and a method in the way that they do things, because it's always organized in a very interesting way. It's always colorful, and it's always meant to lift your day.

SB Pharrell, what are your feelings about color in general? I noticed that you're a very colorful person, and you put it into your style and everything that you collect. What does color mean to you?

PW Well, [in] the electromagnetic spectrum—from gamma rays all the way to X-rays—there is a very small portion that human beings perceive, and that ranges from color to sound. All that's saying is: color and music are literally the same thing. There's an equation for a frequency in color, and there's the equivalent in sound, so, to me, there are primary colors and there are primary chords, and there are secondary colors and there are secondary chords, and there are tertiary colors and tertiary chords. They're all the same, even on a scientific level.

SB You work on this sound piece until it evokes something from you. You're like, 'Yeah. I hit it. This is feeling good to me. I know this is a good thing.' We do a very similar thing in our studio. We're working on pieces between Tury and myself until we're like, 'Whoa, this is going to really affect something. We feel the power of this.' When we did the 'Cloudy' video, and you were like, 'Please, let me just put this out,' you knew how much of a great effect that that would have. I feel that's been an overarching thing in our relationship: I feel like you've

always known something about our work that maybe we can't see ourselves, because we work in such similar ways. Do you agree?

PW I agree with most of it. The pedestal that people will put me on, I don't acknowledge it, but I purposefully do not acknowledge it. I don't know the greatness that I'm capable of, but you guys do it all the time. All you've got to do is just go in your studio. Mine has to be remembered, because mine cannot be touched. It's something that's only felt, perceived, adhered to, and remembered. Once it goes away, it dissipates in the air. Whereas yours is disseminated in the room, and there's always these physical reminders. You may not choose to acknowledge it, but you know your great work. Which is why we're affiliated.

MW In a way, FriendsWithYou operate outside of the strictures of the art world, and it's a little bit closer to the openness of the musical realm. Their artwork has a little more to do with the populism of music.

PW That's exactly right.

MW One of the things that the guys wanted to talk to you about is: religion and spirituality play a large role in their work. How important is religion to you? Do you think of yourself as a spiritual person, and does that affect your music in the way it affects FriendsWithYou's art?

PW We're all spirits. Sometimes existence is so seamless that one forgets that time and space are gridded by the moment. Everything is gridded by mathematics. You have a certain amount of heartbeats—a pulse—per minute, there are 24 hours in a day, there's inches in feet, there's distance,

there's recorded time, and there's the time we have not experienced yet. So, sometimes trapped in this flesh, we forget that we're spirits. And our sense of awareness is brought on by the five senses working in concert together. As they do, an entity has perceived awareness. Sometimes you forget that all these things are working together, and you think that the world is just a seamless place. We're all very spiritual, at the end of the day, on some level or another. Even the most hardcore atheist of all scientists—and that's not to say all scientists are atheists, but I'm just using the furthest extreme as an example—it is still amazing to them, and a huge conundrum, that once the flesh dies, they can't really tell you where the spirit goes. Einstein says that energy cannot be created nor destroyed, it can only be conjured, and that to me is definitely proof of spirit. But at the same time, yeah, there is a spiritual connotation to the guys' work, and a spiritual method in the madness of their creativity, but I always say to each his own. I commend them for having a spiritual basis in what it is that they do, and a spiritual intention to what it is that they do, because at the end of the day, what is happiness [but spirituality]?

MW I think it's important to remember that they also similarly keep things really open. They're not putting ideas in your head—it's just a basis.

PW It's never forced. It's never forced. It's always come as you are, and be who you want to be. I'm not immersed in the physical part of their world as much as I am the creative part of their world, but they're some of the most free-spirited dudes ever. Like I said, it's a completely different world from my own, but I admire the fact that they really live their art. They really live their creativity. And that is why, of all the great things that they've already done, this is simply the genesis of a long-lasting, world-changing experience for the world. These guys

These guys are more than just paintings and sculptures, they are two really large proponents for experience, which is the ultimate wealth as a human being on this planet. Experience is the only thing that you can take with you when you die.

are more than just paintings and sculptures, they are two really large proponents for experience, which is the ultimate wealth as a human being on this planet. Experience is the only thing that you can take with you when you die.

AS That was always our original intention: we always wanted to create impactful, long-lasting experiences. Do you feel that overall, with the amount of media that's consumed these days, the next level of art has to be a four-dimensional, multimedia art experience?

PW I just think that you've got to really treat the world as an art installation, and treat humanity like they are participants of an art installation. You need to do what I've been told: dream big.

SB If you could imagine any art project for us in the future, what would it be?

PW Well, you've taken over the city of Toronto before, and I think at some point, it would be cool for one of these small island nations to have you come in and curate. [It would have to be] a new and young [nation], so that it's not just a thing that lasts for a month, but it's something where you guys build all the parks, and your idea of spirituality goes into some of their laws. And your idea of creativity should be held as the apex of a society's viewpoint. That to me is when I know you have risen to the beginning of your truest potential. A small island country, not anything too big.

SB Not just talking about our work, if you could predict the future, what will it be like? Do you see religions still tearing people apart and wars? Or do you think we can get to a place where we understand each other throughout the world, and we have connected information? What do you see as the most idealized future version of the world?

PW That's not for me to judge. That's for humanity to learn on its own. There's been a lot of sages [throughout history] that wished for really great things, but at the end of the day, it's within every human being that wakes up in the morning, what

they feel, what they intend on doing, that's going to change or leave the world the same.

AS Pharrell, you have a song called 'Get Lucky,' and one of our earliest installations was also called 'Get Lucky.' We wanted to ask you what the concept of luck means to you?

PW I don't really believe in luck. I believe in intention and mathematics. Sometimes it may seem that way, but are you really lucky when you win the lottery? Or is it all based on mathematics, and you were at the right place at the right time? That's what I meant by the song. If there was such a thing as luck, how come Vegas still operates? It's not luck; it's engineered that way.

SB What is your concept of consciousness, as far as having shared information, and how we're learning at accelerated rates?

PW It was destined to be. You read all of the religious texts, and they talk about this time. They talk about time when information is disseminated in real time and people would have reactions to it. All the people online, whether they like adversarial websites or not, adversarial interests or not, they're all online. The Internet itself is a voice of people. When something happens, there's a huge reaction online. That is the collective consciousness. It does a lot of good things; it does a lot of bad things.

SB Is there anything else that you feel should be inserted into this book? This is a culmination of 12 years together, and you've been an amazing catalyst to helping us build this thing in the right direction. Is there anything that you want to add?

PW I've only tried to be the exclamation mark to your sentence. This is not about me, this is about you. The exclamation mark never really gets the credit, but it does its job, which is to highlight the most important thing, and that's the sentence. That's you guys. Who wouldn't want to be friends with you?

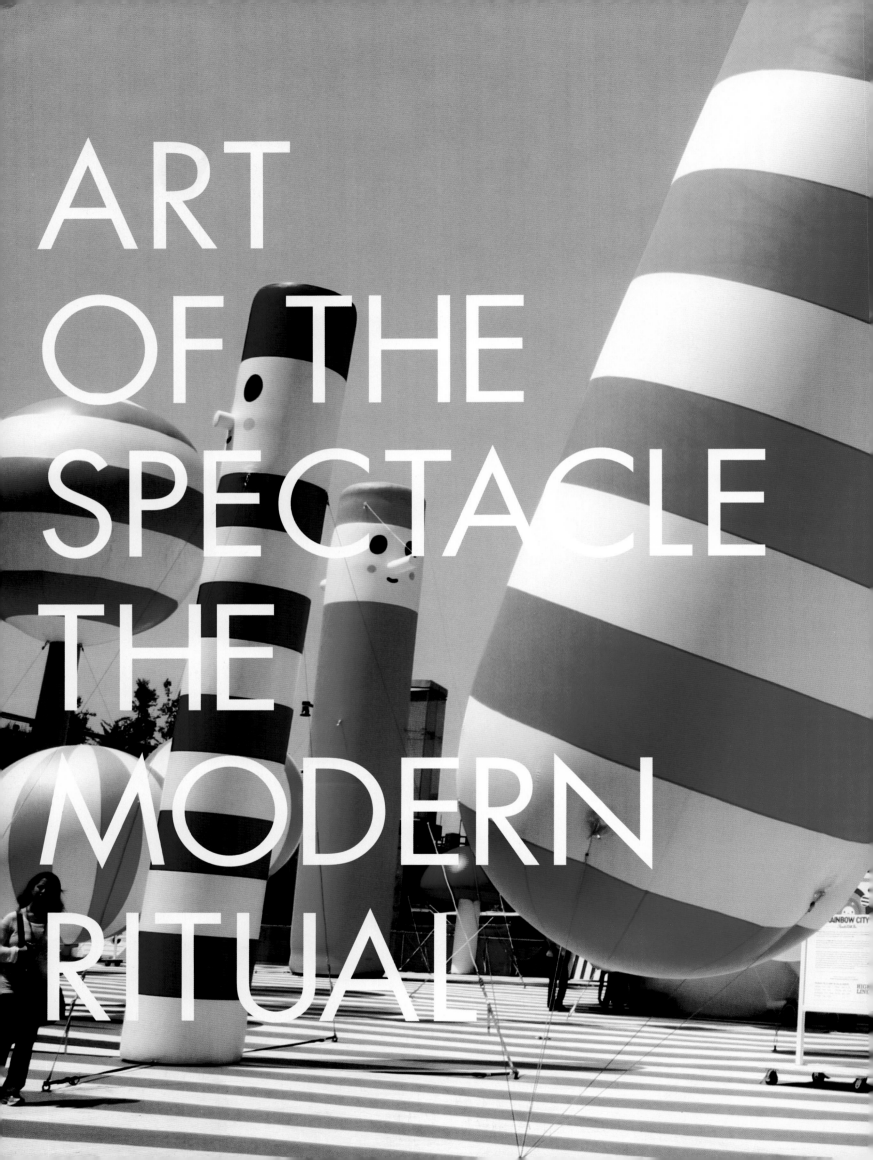

ART
OF THE
SPECTACLE
THE
MODERN
RITUAL

In "Travels in Hyperreality," a 1975 essay by Umberto Eco, the Italian writer describes Disneyland: "Within its magic enclosure, it is fantasy that is absolutely reproduced."[4] The same can be said for FriendWithYou's brand of hyperreal situations, which occur in the form of happenings, performances, and interactive sculptural installations. But where Disneyland treats its visitors as robotic creatures to be herded into consumption zones, FriendsWithYou considers their viewers as playmates.

The world that FriendsWithYou has built contains the tropes of hyperreality—fictionalized landscapes and cultures—but those tropes give way to an ebullient, naïve nostalgia. Not nostalgia in the sense of commoditized cultural signifiers, but of happy memories that are in dialogue more with the uneasy sweetness presented by Mike Kelley than Carsten Höller's clinical jungle gym slides. FriendsWithYou portray a gentle attitude towards play, something to be engaged in by both children *and* adults, not simply adults seeking out the commemorative vestiges of their juvenile memories (Kelley) or scientific reactions to thrill-riding (Höller).

The interactive hyperreal state introduced by FriendsWithYou is more of a ritualistic version of the play action. Bits and pieces of cultural, religious, and spiritual ceremonies form a root system for FriendsWithYou's gatherings, where they are conflated, dissected, and reassembled to create a new ritual. This, again, touches on the hyperreal state, giving the viewer a disconcertingly functional ceremonial space, where play is an activation.

Not to say that reliving youth isn't a part of FriendsWithYou's practice. Embedded within their work is something so deeply genuine that it can only be described as a pre-cynical position. This is a naïve hyperreality, one that leaves the viewer with positivity as a takeaway, rather than the consumer-driven hyperrealities of theme parks and online platforms.

4 Eco, Umberto. *Travels in Hyperreality*. Boston: Mariner Books, 1990. Print.

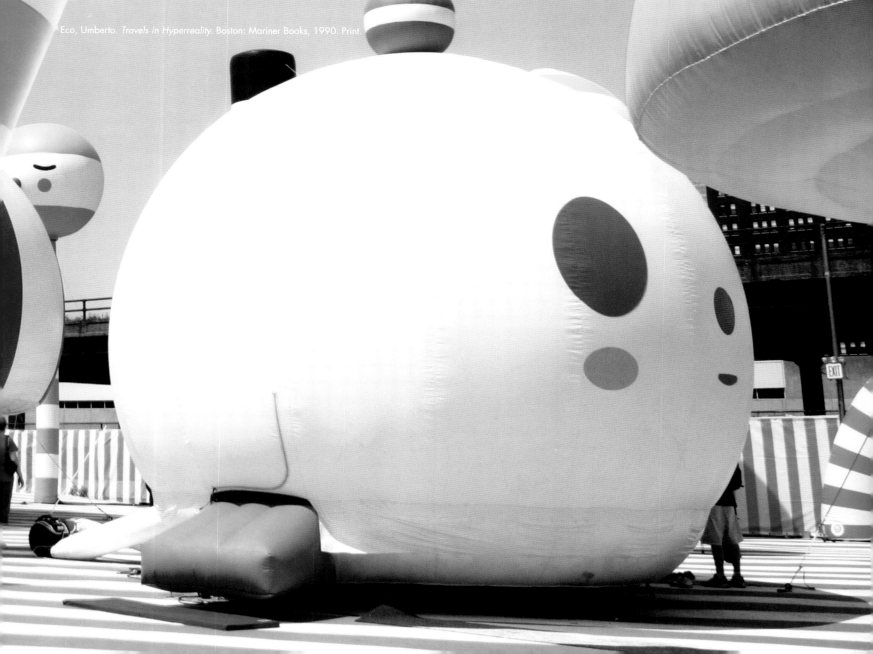

194

MAXWELL WILLIAMS What was the first thing that you did that you consider a spectacle, and how did that develop?

SAMUEL BORKSON 'See This and Die' was our very first installation. From the onset of us making art, we said, 'We're going to beat people over the head with this. We have to. We're going to make something impactful that's not as easily dismissible as a wall piece or a sculpture.' That was our first mission.

ARTURO SANDOVAL III From the get-go, even with the plush toys, we weren't letting traditional forms dictate our work. I think that's super important to our work.

SB We don't want to be trapped by any medium.

AS We both gravitated towards installation work, because we felt affected by installation work when we experienced it in our own exploration of art. We both said, 'That's powerful. That's what art should be.' Also, in seeing Alejandro Jodorowsky's films, we realized that's how these spectacles could look. So, we mixed that with the art and philosophy that we were turned onto. Then, naturally, we said, 'Okay, the way that we make art, it has to involve all the senses, and it has to involve immersive experiences that aren't two-dimensional.'

SB You have to be transported.

AS Even that first show we ever did ['See This and Die' (2003)], we were commissioned to do something at a hotel, so we just went bananas. We did this crazy chandelier made of 'spirits' that the viewer could take the spirits with them. It was an interactive, collective experience from the beginning.

SB The purpose of that was to make you face death, something that is so prevalent in all religions. It was called 'See This and Die,' as in, if you see this installation, you're going to die, and the viewer's spirit will go with the other spirits. It was morbid, but it was done in a beautifully sweet way with these spirits going into the sky. We were already putting a positive spin on such a heavy idea as death. It was the pinnacle of what man thought as a primate: 'Me alive; me die.' That's the first thing man confronted, and it was around that time that our understanding of spirituality was being fostered. So, it's interesting we started there. From there, we fine-tuned each spectacle in terms of our effect on the participant or the visitor. We analyzed what we wanted to experience, and what we know people like to get as an experience, and manifested those ideas.

AS Since they are such big gestures, when you get something right, it manifests itself to the 10th

degree, but when something is a little bit off, you see those faults. We learned quickly. We progressed very quickly from exhibition to exhibition. You can almost see, tangibly, the decisions being made. You can see what works and what doesn't. It's all a process, and I love that part—I can see what's happened on this cycle of exhibitions that you could call spectacles.

MW How did people react to the early work?

AS Very few people saw it.

SB But our second installation, 'Get Lucky,' when we did that, all of Miami came. It was like an explosion. I remember the feeling of that night. We put our friends in costumes, and Tury and I were in costumes, and we performed. We'd built this installation, and all these people came through. You could feel the spirit and the energy. The room was really hot—it was like a sauna in my costume, so it was almost a religious experience. From that installation, the Museum of Contemporary Art North Miami noticed us, and they supported our next exhibition.

AS Our third piece was at a museum. We didn't receive any conventional support at that time, but we recognized the power of happenings and installation work and the spectacle as a whole.

When we did 'Get Lucky' all of Miami came. It was like an explosion. I remember the feeling of that night. [...] The room was really hot—it was like a sauna in my costume, so it was almost a religious experience.

MW Can you comment on the assimilation of religious ceremony into art?

AS We took these religious experiences and blended them with highly symbolic, meaningful moments under very carefully crafted circumstances as a spectacle. We crafted a synchronicity of sensory preparation with our agenda. To some extent, we're still in the early stages of what we could do with that.

SB The leap from 'Get Lucky' to 'Cloud City,' the museum show, was another crazy leap. It was powerful and crazy, but also approachable. It felt like we were onto some neo-tribal universe.

AS 'Get Lucky' was the beginning of our exploration into archetypes, such as god-like figures. 'Cloud City' was eight months later, not even a year. We said, '"Get Lucky" was awesome. We're going to make another ritual, but we're not going to be so heavy about the literal stuff.'

SB 'Cloud City' tuned into the primary colors of all spirituality. There were two souls—Tury and myself in these costumes—with 'The Boy' spirit, which is the manifestation of this ancient idea of an innocent soul. The show became the interaction of 'The Boy' with a sphere, a cone, some cylinders, and this color-filled room. We were playing in this environment with this ritual soundtrack that moved the story along at a timed increment. So, we've now added time, and audio, and action, and this slide that we had made—the major deity in the room. It was ritualistic play that we engineered for two extremes. It started off like a baby, sounding like the sweetest melody you ever heard, and it turned into this dark, twisting thing, which would activate us to swirl around a slide, which was a dome that had its own spirit that the viewer could get up on and slide down. Aside from that, it was freeform playing, and visitors getting up on the installation, and interacting with it, and playing on it. And we were playing with the visitors. 'Skywalkers' and 'Rainbow City' followed in the footsteps: we made it open for the participants to create their own narrative.

MW Is the interactivity born out of this generosity of the work? You wanted to give the viewer a playful experience?

SB It is completely genuine. We want visitors to play and interact, because we wanted to be able to play. It goes back to the healing—we offer to everybody to be able to play with these godly instruments.

AS It also came from our early shows being done outside of the art circuit: 'See This and Die' was at a hotel, and 'Get Lucky' was at an independent, experimental art space with no real rules. We had that punk rock disposition—we really wanted the viewer to be on our level, democratically able to interact with the work in the same way we were able to. At one point, art was not manifestations of concepts; it was the making of pretty things. The making of pretty things became what we know as 'art,' and it carried all that etiquette with it. But it doesn't mean that art really has to have that etiquette.

SB Art went from this tribal craftsmanship—making bowls and spoons and forks. Then it went to the holiest of places—religious art was way above you in churches, and you couldn't touch it. It was so far from you.

AS That's the period right before it became classical. It took with it that this thing was precious. That kind of kept going into the modern. We didn't break any new ground. That was done way before. The Russians played with new forms of modern definitions of art. There were a lot of people that said, 'This is stupid. Art is me pissing in my own mouth and then you looking at it.' We're just following in the grand tradition of people like Carsten Höller who allow the viewer to really experience the art. We are making places of modern spiritual communion, and working with architecture and color to create spaces that lubricate interaction and immersion.

The question was, 'What would we, as cynical humans in our 30-somethings, find as being an uplifting, powerful, awe-striking moment?

MW I wonder if there's something to coming up in Miami. As two artists in Miami, you have an openness to decide what you want to do for yourself, but do you also have to make work that is going to resonate outside of Miami? Is that what inspired you to think bigger?

SB We had to do that. That was why we made inflatables like that. It's like when you're on an island and you need to relay a message, you can send a bottle with a little note inside it or you can do a flare. We were shooting off flares.

AS 'Skywalkers,' 'Cloud City,' 'Fun House,' 'Rainbow City,'—every one of those exhibitions was us screaming.

SB Soon, people knew that we could deliver a show, and we were about the theatrics of it. We were about really making a grand statement as big as we could think. By whatever means necessary, we were going to make our visions come true and once we started seeing that, it became almost addictive. We're getting more opportunities, and as it's growing, we feel we are making such impactful spectacles. By spectacle, I mean the complete breaking of your daily routine. The complete 'be here now' moment is what those kinds of confrontations, in a positive way, open you up for, leaving a resonating

impact memory. We include sound and melodies to help that along. But more and more, we want to infuse those things to make lasting healing moments on these large-scale things.

AS A crucial tool that we use in these spectacles is a sense of awe. When we talk about the early development of religion, animism isn't really even the first manifestation of real religious inclination. There is a term called 'aweism.' Before we could even conceive of the idea of spirit or anima or anything like that, we were *impacted* by spectacles. It's crucial for us to have some element of that happen in our work. If you combine that with the whole set of other circumstances, then you can't help but to feel impacted. When you walk into a church, it's not just the symbols that are there, it's the inner working of everything together: it's the setting, the angles of the walls, the light coming through the stained glass. It is thousands of years of engineering to carefully craft that experience, and it works for sure. Even if you don't believe in God, you go into a church, and you're like, 'I feel something.' And a lot of the spectacles that we're talking about here try to use some of those things. 'Skywalkers' was based on that idea. If you were on the beach, you had a different kind of experience, but thinking about the people that were *not* on the beach—because there's a mangrove, those that were seeing it from the streets couldn't see

the people holding the inflatables, so they just saw these *things* floating around. That's an awe thing.

SB Up close, too. The hugeness of a giant balloon above you is an awe moment for the people that are holding its weight. It's like a living thing. We were breathing real life into these massive things that escaped our dream realm. We were even awe-stricken ourselves. The question was, 'What would we, as cynical humans in our 30-somethings, find as being an up-lifting, powerful, awe-striking moment?' I feel that we search within ourselves for ways we'd like to be affected and how to affect others.

AS 'Rainbow City' was very much the same thing, too, but we learned a big lesson from 'Skywalkers.' The economics of it started to take a toll; that's part of making these things that happen. To finance one of those spectacles, there's a huge up-front capital investment. We started realizing that with 'Skywalkers.' Before that, we just said, 'We're going to just make it happen. We'll push forward.' Then it was like, 'Oh, man. This is a big deal.' It's like making a building. You have to think about the foundation, you have to think about the whole thing. 'Rainbow City' was our first attempt at being more mature about the spectacle. We said, 'This spectacle has to do this thing, but it also has to be portable.' We were met with similar production problems that Jeanne-Claude and Christo

came up against, in terms of scale, and then we took it a step further, because we wanted our installations to travel. We wanted to make a spectacle that we could take all over the world.

MW There's all these things that happen today that I think fit into these sorts of ideas of the modern ritual. People gather and go to Coachella or they go to Burning Man. Obviously, your work exists outside of those things, but I think there's also something that is a similar thread. I mean, there is something to people going to something to join and be a part of something and to gather. What critiques do you have of the modern spectacle?

SB A very important part of our practice is the idea of using modern times in a very clear and concise way, because we are modern people. We try to clearly delineate a road map of these impactful moments that allow for connecting points. It has to do with the overall idea of really designing and divining a series of actions and artworks that actually do act as a transcendental change in the world as a whole. We're really attempting to affect the world from a 'user' level. We're using all of the outlets. We're thinking about apps, because everybody uses their phone. How can we connect the world and make a global think-tank organization and really use all our powers of thinking and

the people around us to help generate this powerful change in us as humans? I feel at this stage in time, we're so lucky to be able to really play with this malleable illusion that we all share. We're able to really create and change and bring these ideas to the forefront in a variety of ways. We still haven't even learned how we can fully impact the world on a regular basis or make new seeds that continue to expand. This kind of thinking infects people, and I feel that it spreads. I feel that one of our main missions is to spread some good, positive things in a widespread way.

MW With the things you're talking about, with apps and the Internet, there is a lot of negativity in those areas.

AS When we first started doing spectacles and rituals, it was really also to capitalize on the vacancy of rituals that we would want to be involved in. When we first started doing those things, it was around the same time when Burning Man started. They're maybe a year our senior, but we weren't aware of it. At the time, there weren't a lot of rituals, and there weren't a lot of physical human interactions that we would do with others.

SB There was a lack of secular human interaction that wasn't sports or school. How can we generate

these things so that we can just be with each other?

AS And then, we started using the element of play to be like a facilitator for interaction. That was pivotal in our work, and we involved that in 'Cloud City.' It is a spectacle. It's a ritual in form, because it's cyclical, because it has these archetypes. It involves very reduced figurations. I think all those things are part of us, like trying to decipher these new spectacles and these new rituals. The ritual is the key here, because I think that that's something else that we also wanted to power. Okay, so awe is something that definitely gets you there. The ritual is something else that does the same thing that awe does. Especially the rituals that we try to imitate to some extent. In 'Cloud City,' it's this thing to get you away from yourself and into the group. We understood that that was necessary for everyone's health. We would say, 'Dude, I feel like I want to go to church,' because I wanted to be part of those groups. I think we all do. Everyone wants to connect to each other. The most amazing modern spectacle ever is Instagram and Twitter and Facebook. That's a spectacle.

SB It's like you're all hanging out together somehow. That's probably one of the biggest rituals.

AS It couldn't be more ritualistic.

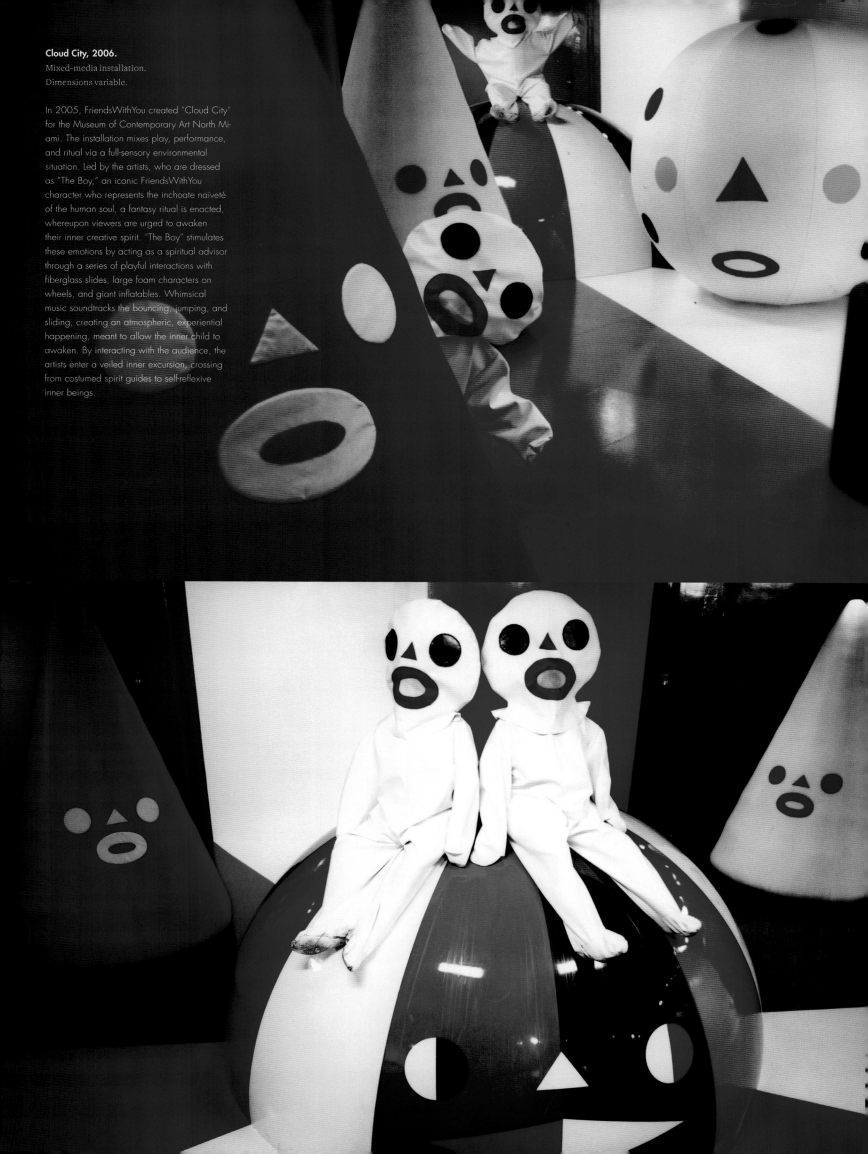

Cloud City, 2006.
Mixed-media installation.
Dimensions variable.

In 2005, FriendsWithYou created "Cloud City" for the Museum of Contemporary Art North Miami. The installation mixes play, performance, and ritual via a full-sensory environmental situation. Led by the artists, who are dressed as "The Boy," an iconic FriendsWithYou character who represents the inchoate naïveté of the human soul, a fantasy ritual is enacted, whereupon viewers are urged to awaken their inner creative spirit. "The Boy" stimulates these emotions by acting as a spiritual advisor through a series of playful interactions with fiberglass slides, large foam characters on wheels, and giant inflatables. Whimsical music soundtracks the bouncing, jumping, and sliding, creating an atmospheric, experiential happening, meant to allow the inner child to awaken. By interacting with the audience, the artists enter a veiled inner excursion, crossing from costumed spirit guides to self-reflexive inner beings.

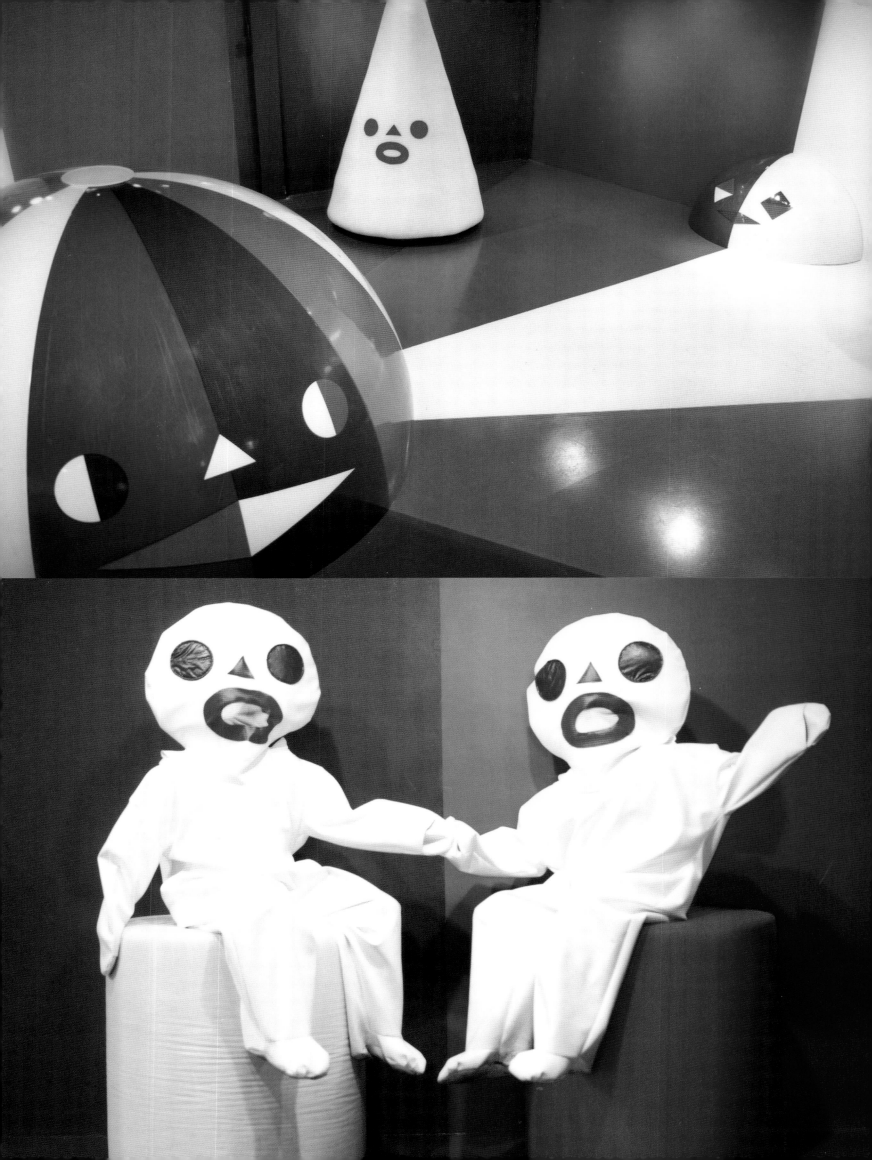

Skywalkers, 2006.
Collaboration of 18 Blimps by artists.
Vinyl inflatables.
Dimensions variable.

This page:
FriendsWithYou

Following page:
Ara Peterson

Last page (clockwise from top left):
Kinya Hanada, FriendsWithYou,
FriendsWithYou, Ben Jones.

Utilizing the procession as a means to explore
religious ritualism, FriendsWithYou fostered a
cavalcade of helium inflatables during Art Basel in
Miami in 2006. Friends from various art circles were
invited to design balloons and participate in the
happening. The balloons moved along the beach
in a flamboyant vigil. The balloons were large and
transcendently formal—not unlike a Jeff Koons balloon
dog—and invoked large-scale religious iconography
such as Buddhist effigies and statues of Hindu gods.
FriendsWithYou invited Ara Peterson, Kinya Hanada
(Mumbleboy), Ben Jones, Misaki Kawai, Devilrobots,
and David Choe to design inflatables for "Skywalkers,"
allowing for a collaborative experience that gave
credence to FriendsWithYou's accessible, public
practice. The procession was pleasing to the eye
and easily visible from afar, leading viewers to an
unexpected beacon, where they could experience
the ritual in its purest form. The procession itself was
of a positivist, communal nature, a reiteration of the
artists' intention to allow spiritual connection through a
shared affirmative experience.

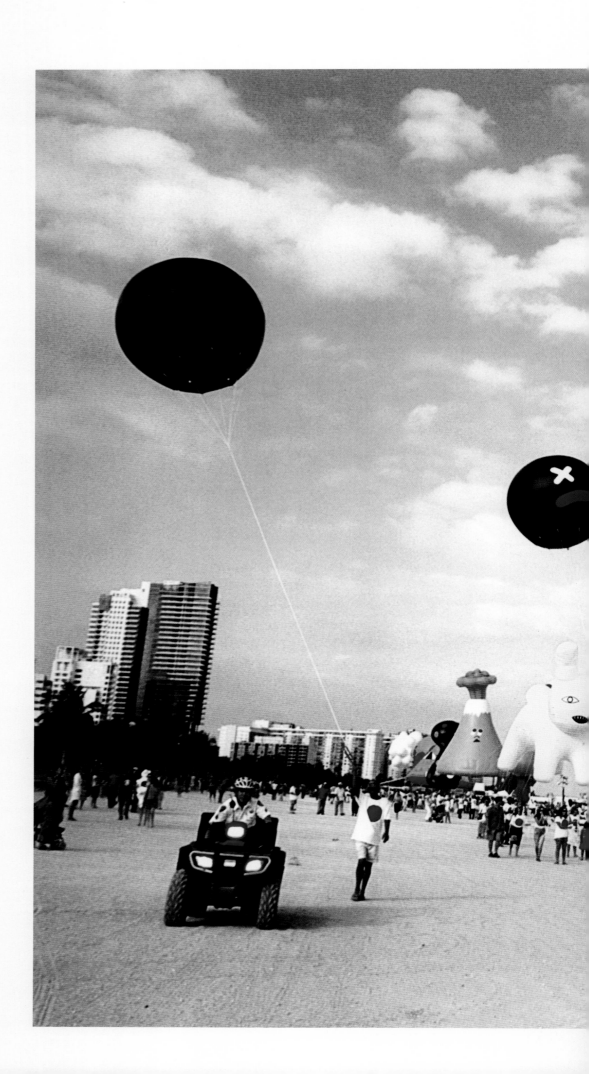

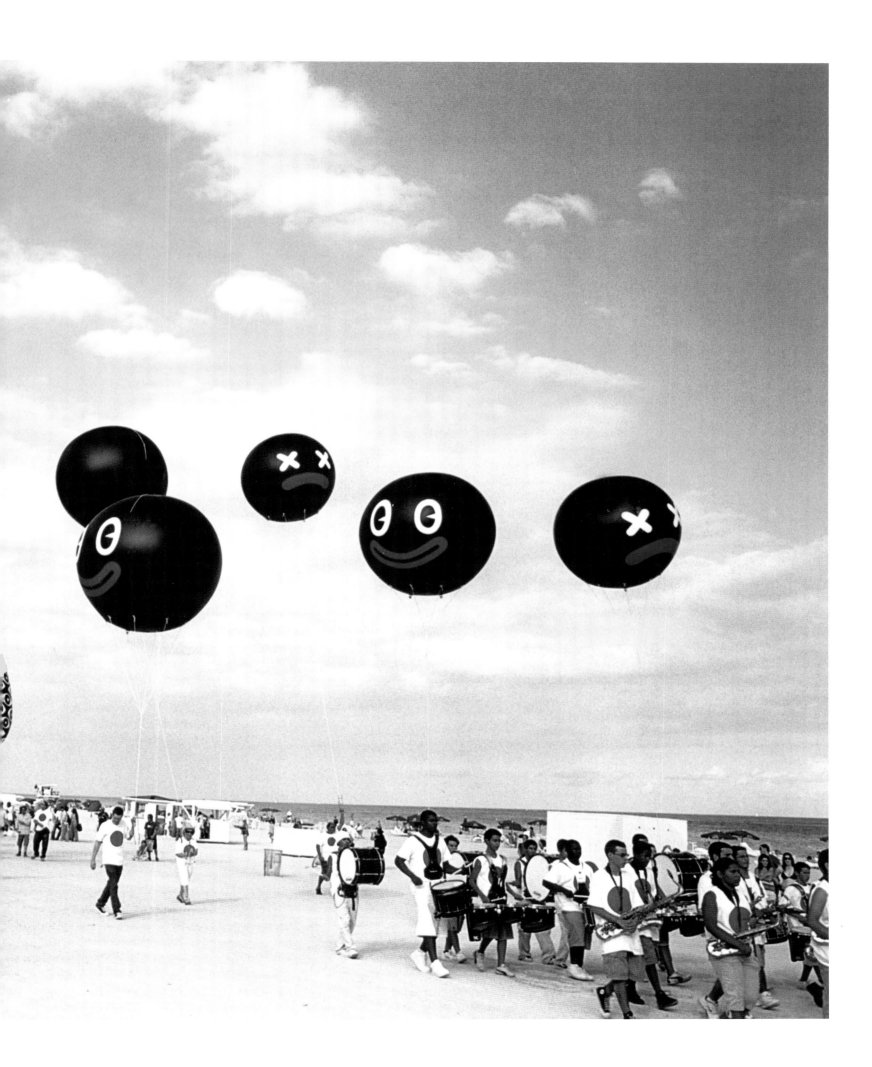

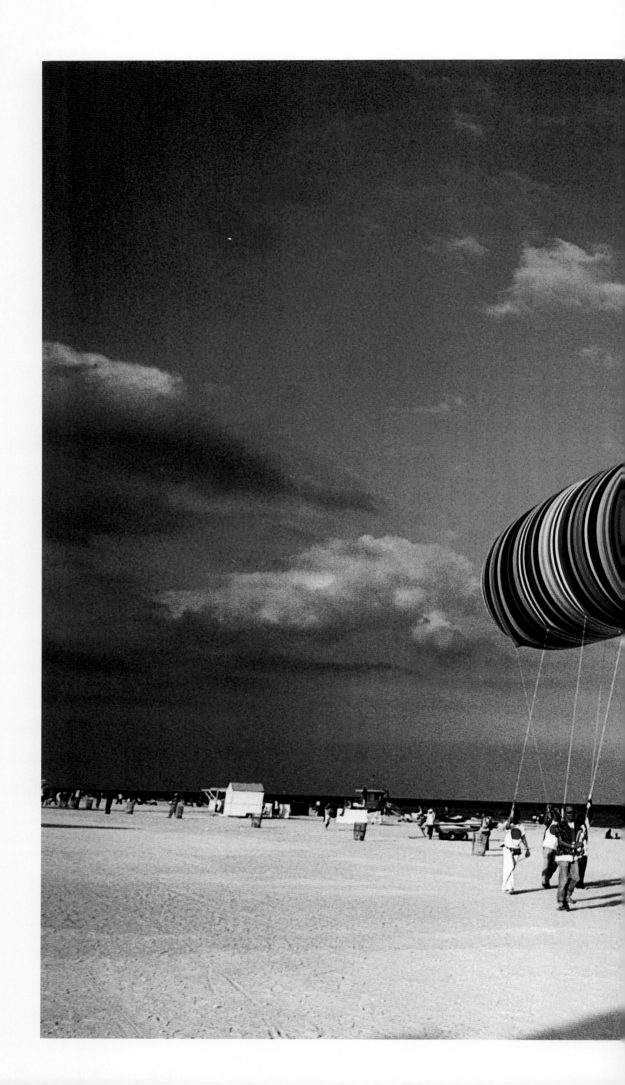

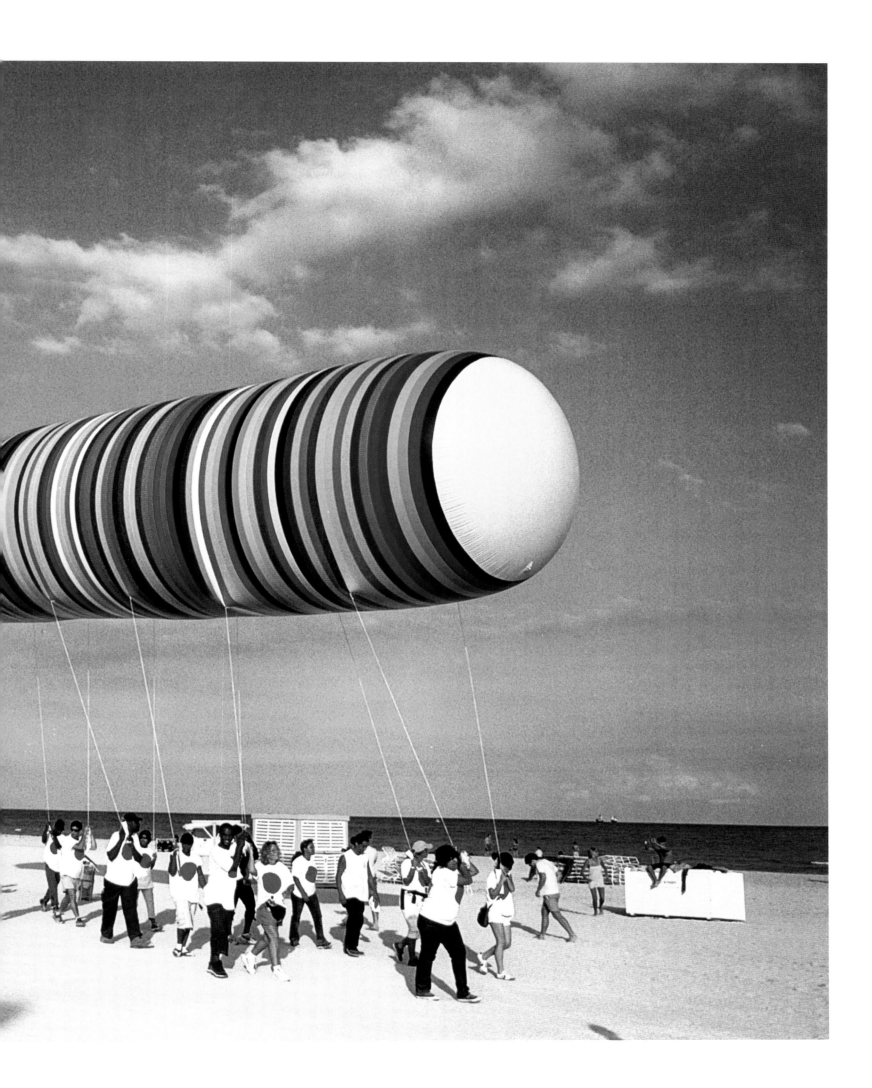

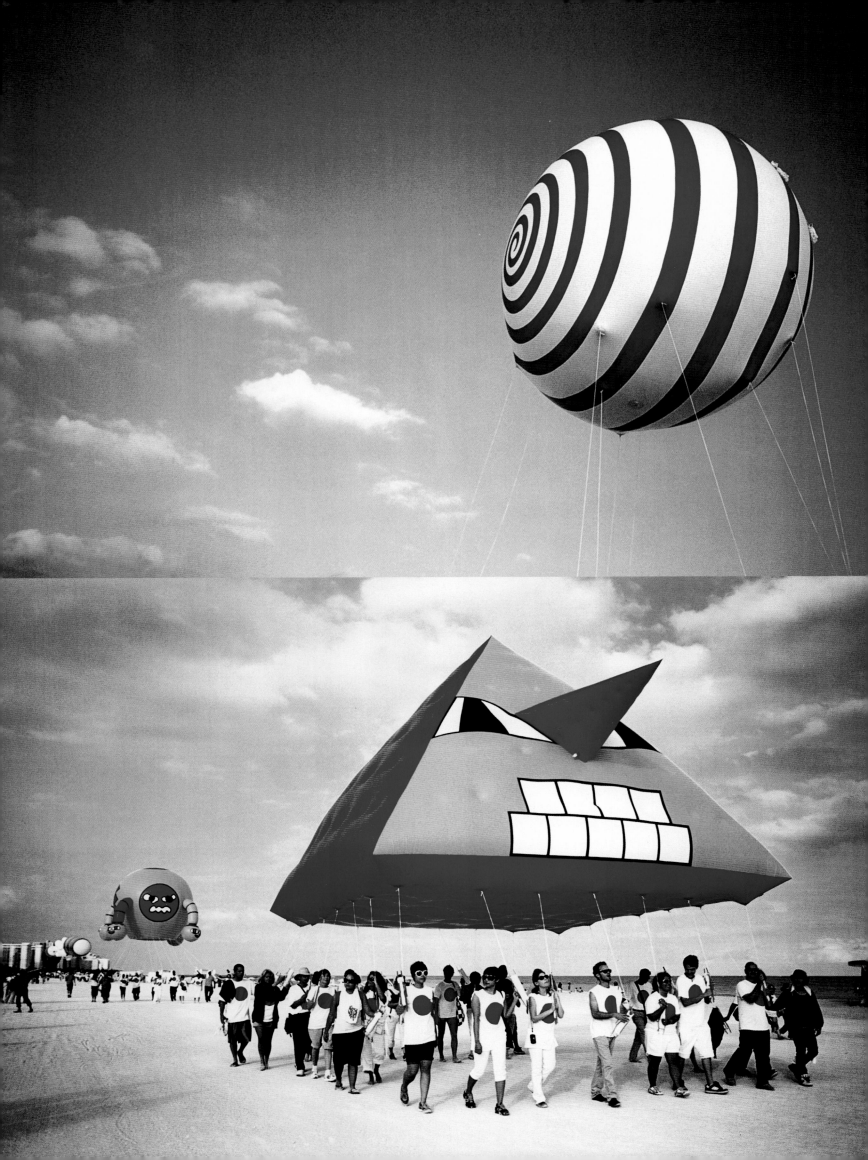

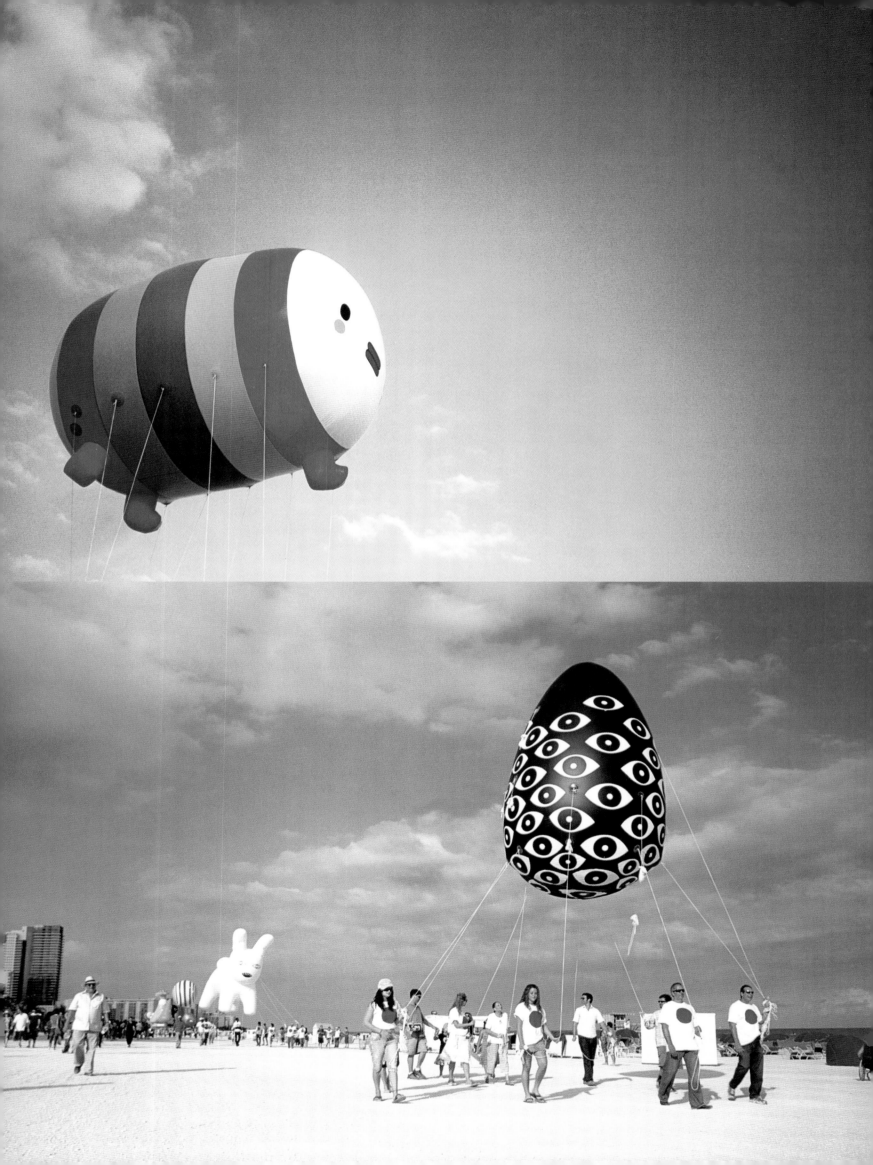

A crucial tool that we use in these spectacles is a sense of awe. [...] There is a term called 'aweism.' Before we could even conceive of the idea of spirit or anima or anything like that, we were impacted by spectacles.

Fun House, 2008.

Mixed-media installation.
Dimensions variable.

Interactivity is a large part of FriendsWithYou's spectacle-based work, allowing the viewer to become an integral part of the piece both visually and spiritually. The perfect enunciation of this is "Fun House," a large bounce house—the kind you find at block parties and small street fairs. Where Mungo Thomson's "Skyspace Bouncehouse" was a minimal version of a child's game, stripped of its childish signifiers, FriendsWithYou embrace the inherently gleeful nature of the form. The bounce house is itself a cheery character, and the entrances are through the sides of the head (earholes). Originally a private commission, "Fun House" is a signature FriendsWithYou piece, revealing coded biographical information within its animated character. Parallels to FriendsWithYou's lives exist in the bounce house's biography: for instance, Arturo Sandoval III left his homeland at the age of 14, which is the same age Samuel Borkson was kicked out of his own home in Florida. "Fun House" is a retreat from that reality, the representation of a comfort space meant to promote the healing activity of play. Since it's original incarnation in 2008, "Fun House" has grown into an environmental installation that resembles a lighthearted, optimistic park.

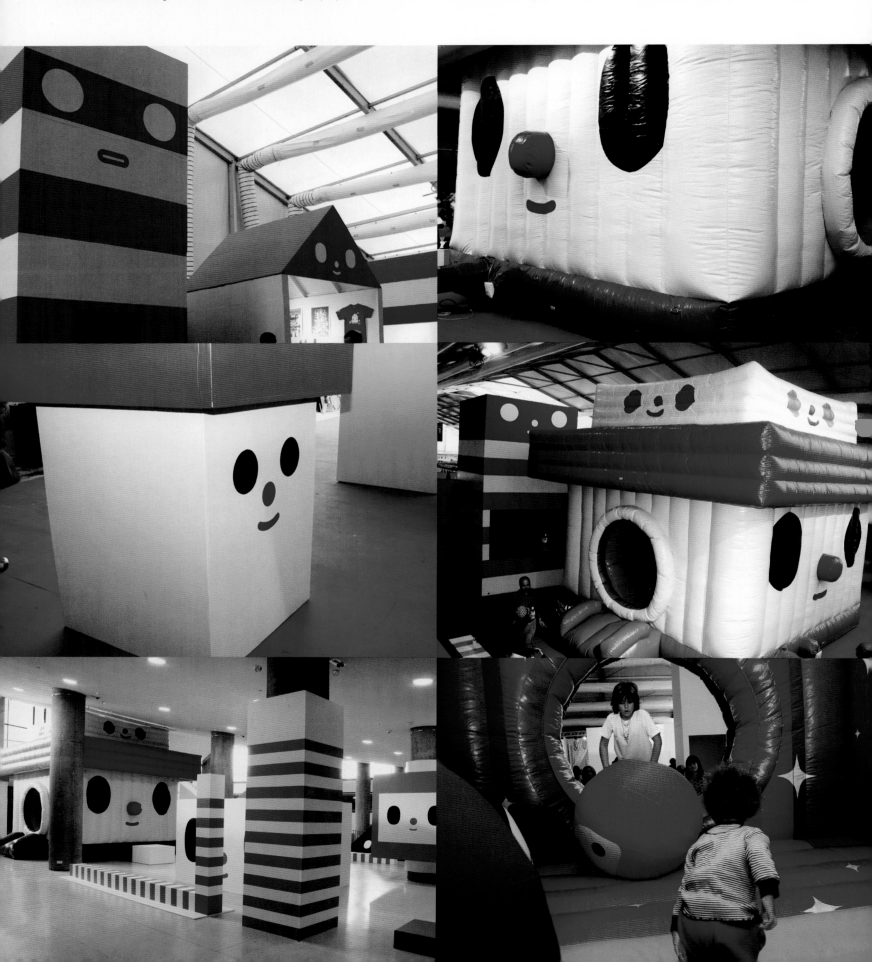

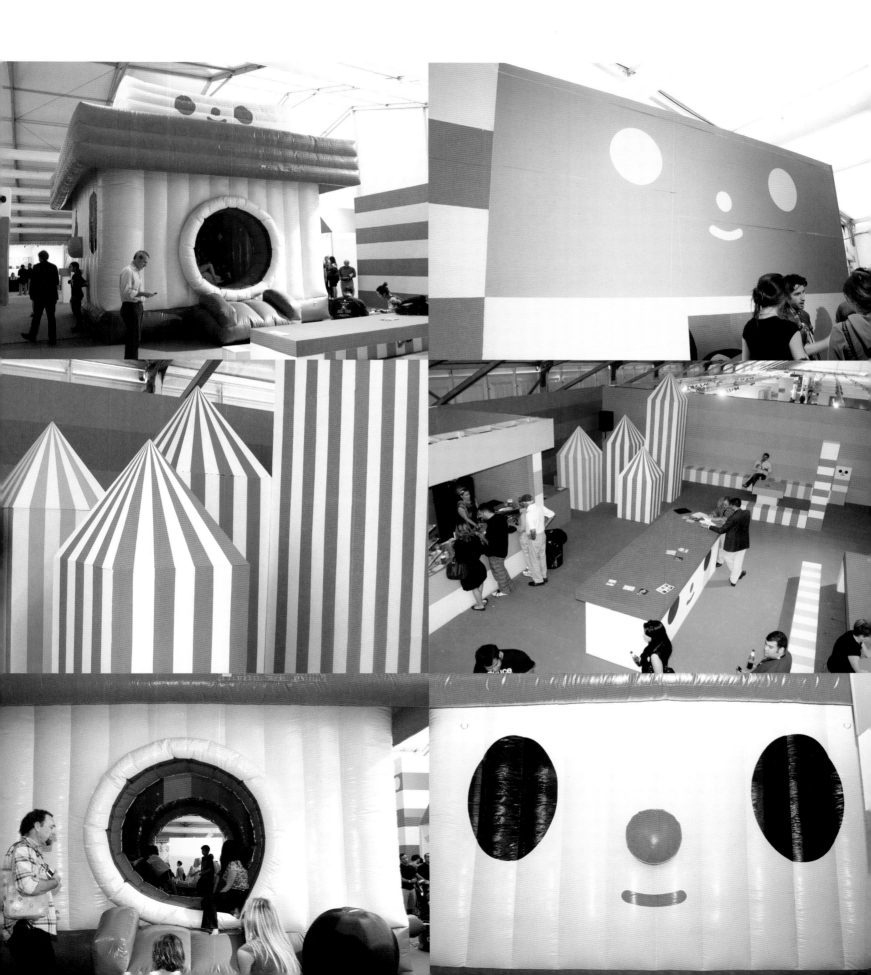

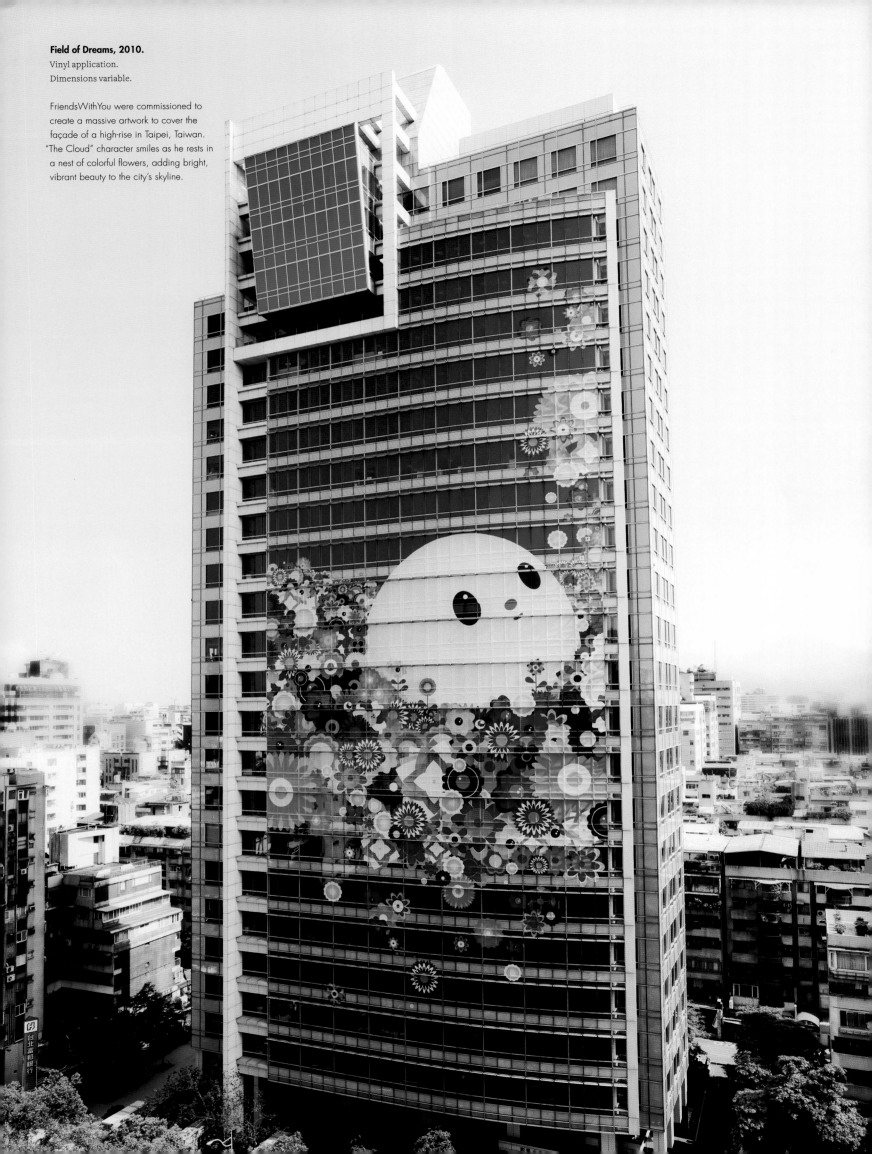

Field of Dreams, 2010.
Vinyl application.
Dimensions variable.

FriendsWithYou were commissioned to create a massive artwork to cover the façade of a high-rise in Taipei, Taiwan. "The Cloud" character smiles as he rests in a nest of colorful flowers, adding bright, vibrant beauty to the city's skyline.

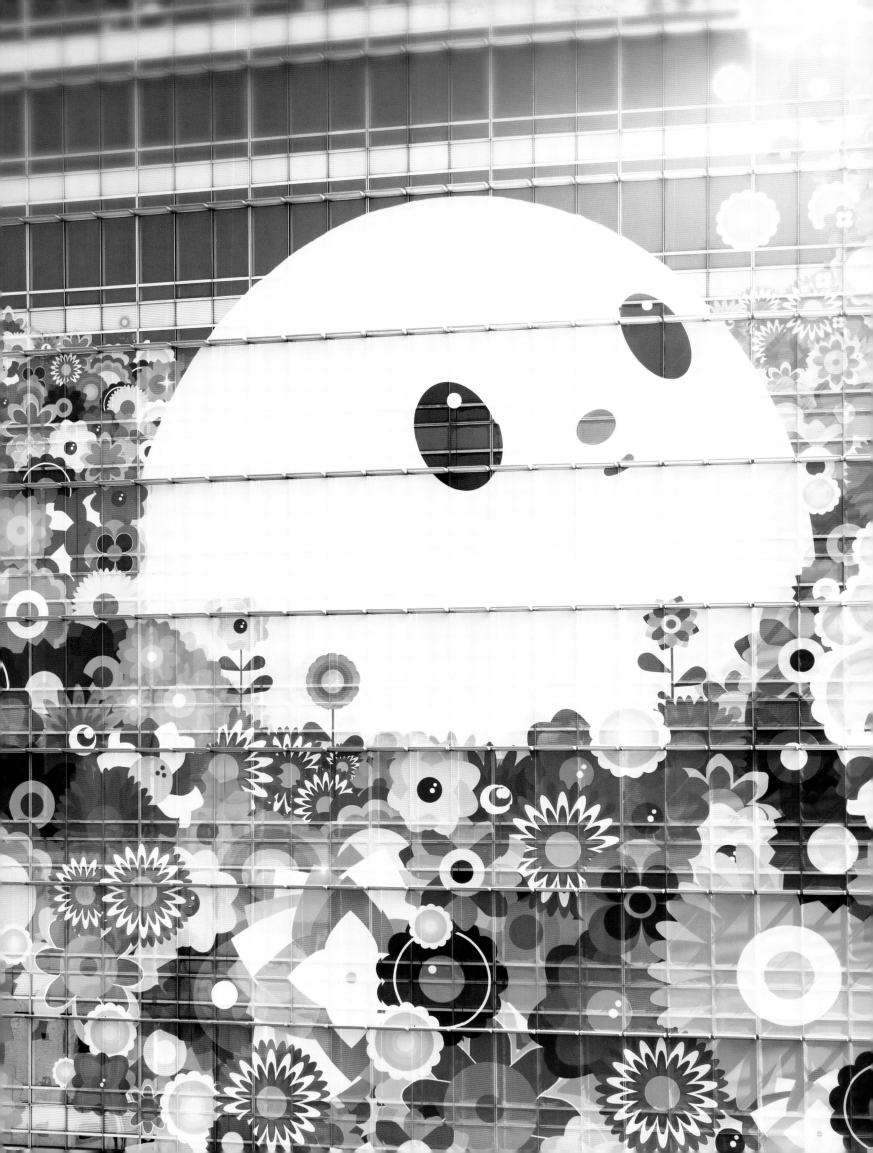

Happy Rainbow, 2012.
Commissioned installation. Vinyl inflatables.
Dimensions variable.

This 16-piece installation consists of a
40-foot interactive bounce house, fiberglass
sculptures, oversized plush sculptures, and
see-through resin sculptures, all unified to
make an exhibit that is sensual and complex.
Entering the installation is a brightly colored,
impactful experience designed to envelop
the visitors and help them transcend into a
higher state of self-awareness through the
simple act of "play." Originally exhibited
as a public artwork in Hong Kong, the
installation acts as a conduit into a colorful,
joyful world.

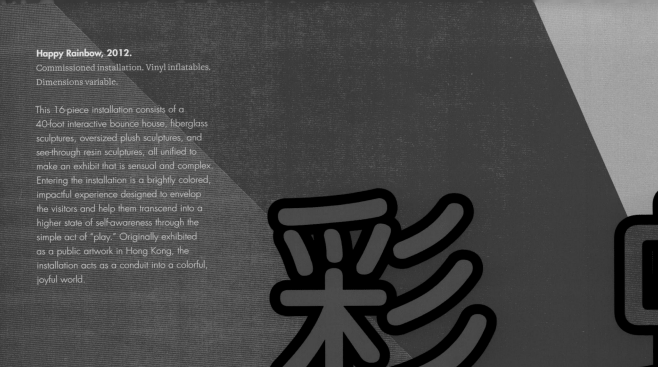

彩 虹

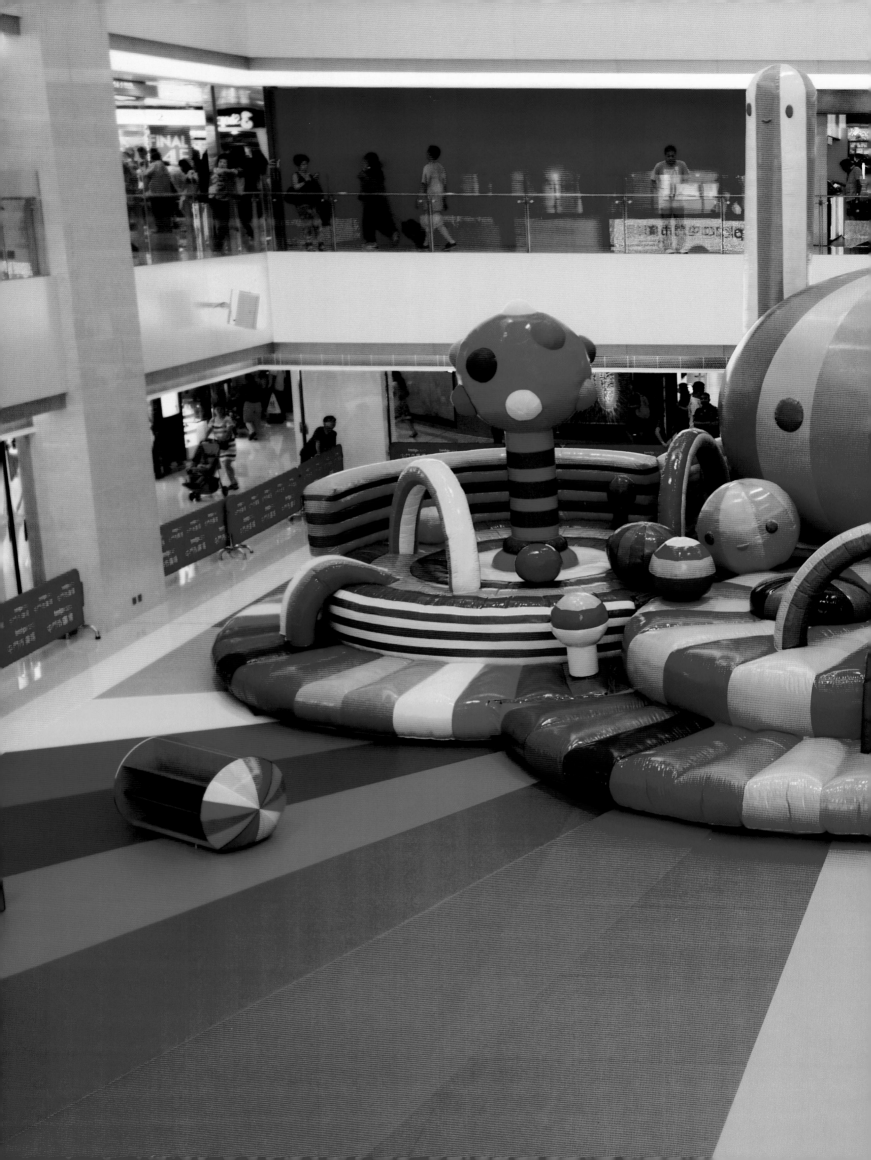

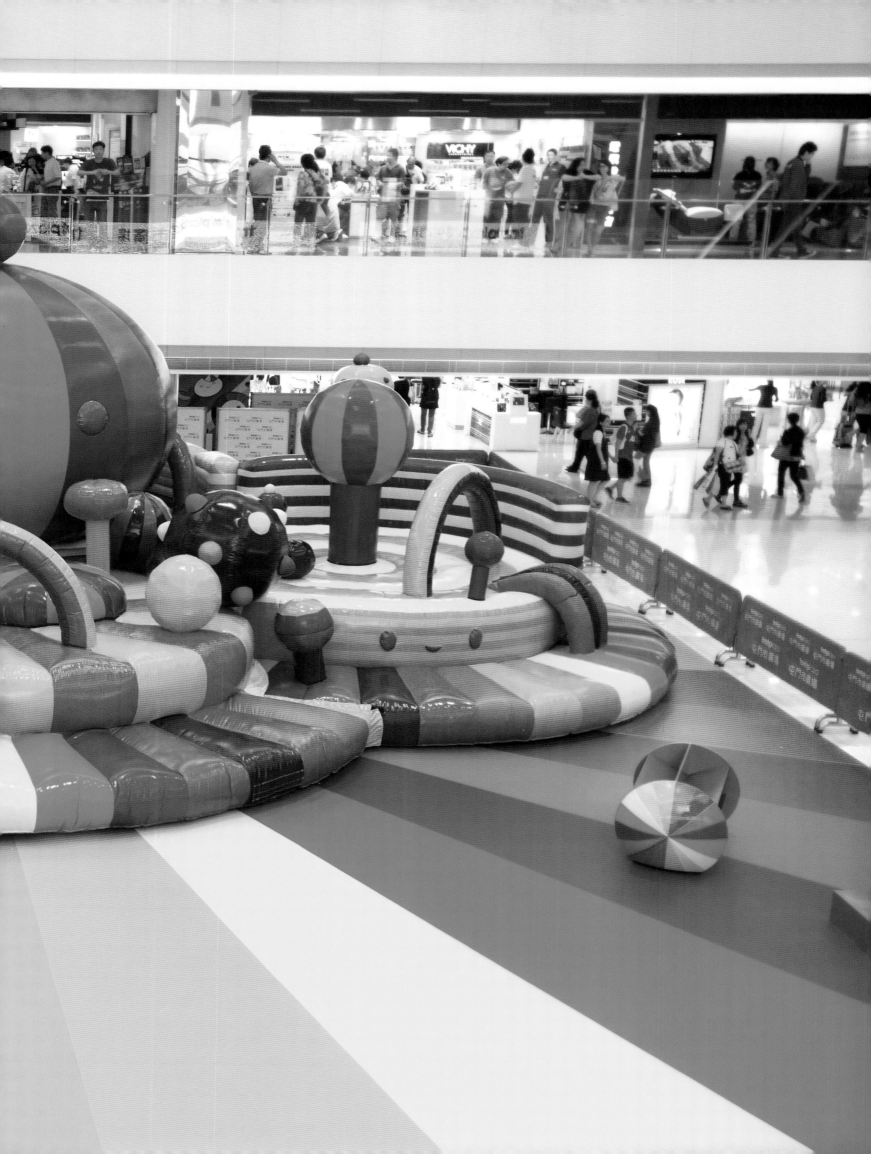

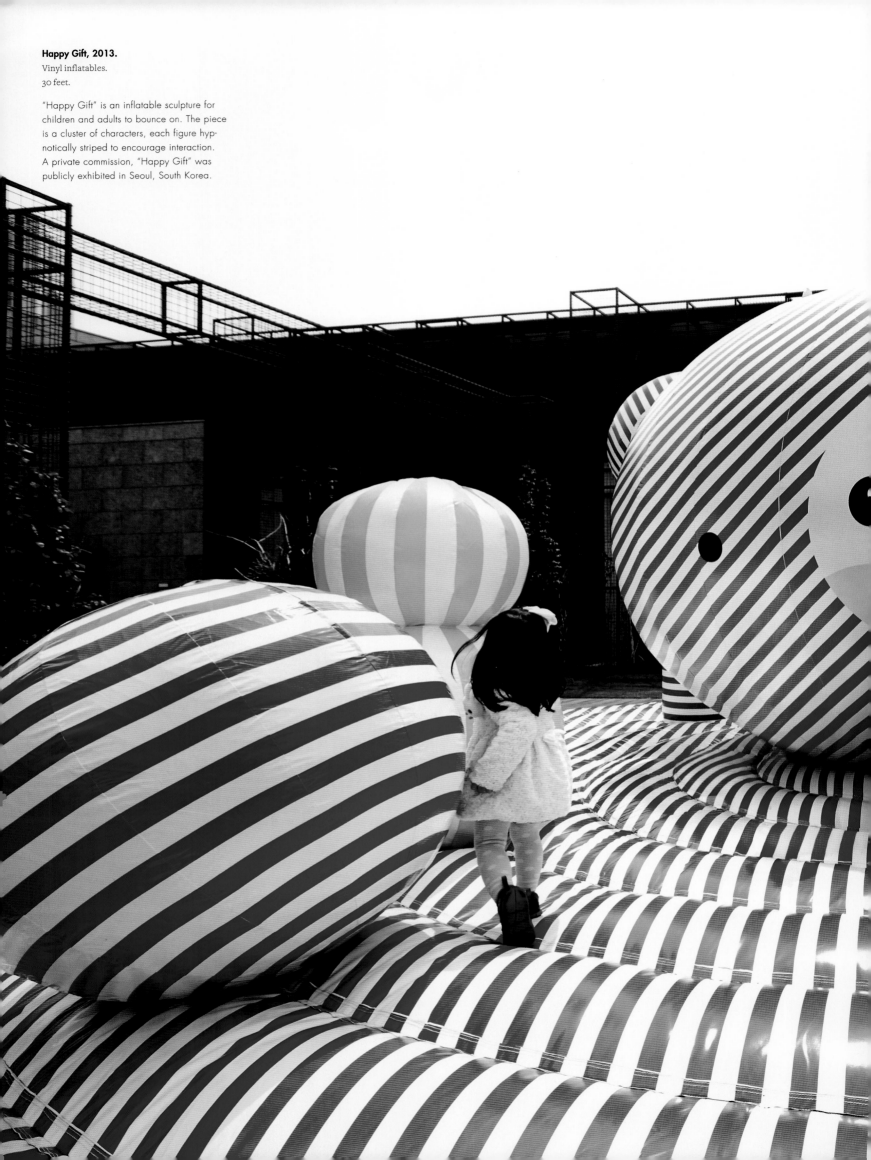

Happy Gift, 2013.
Vinyl inflatables.
30 feet.

"Happy Gift" is an inflatable sculpture for
children and adults to bounce on. The piece
is a cluster of characters, each figure hyp-
notically striped to encourage interaction.
A private commission, "Happy Gift" was
publicly exhibited in Seoul, South Korea.

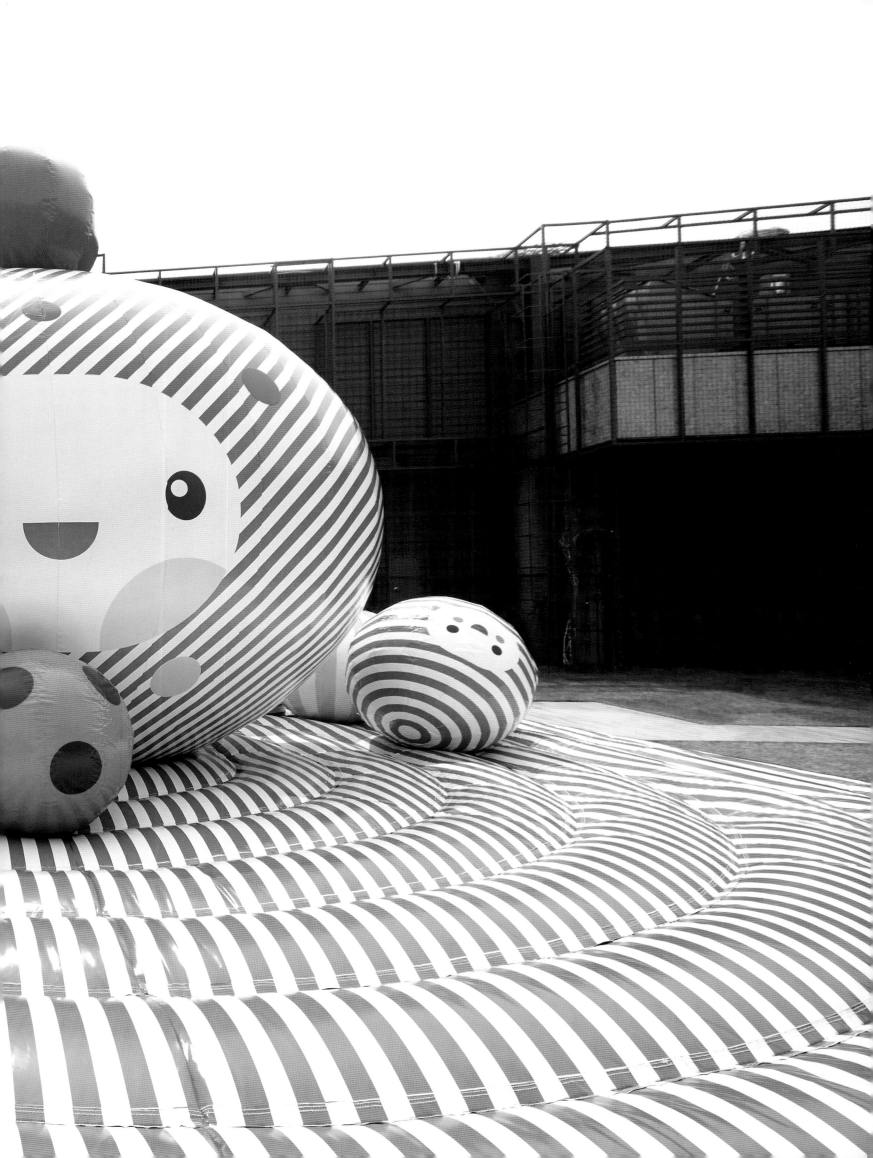

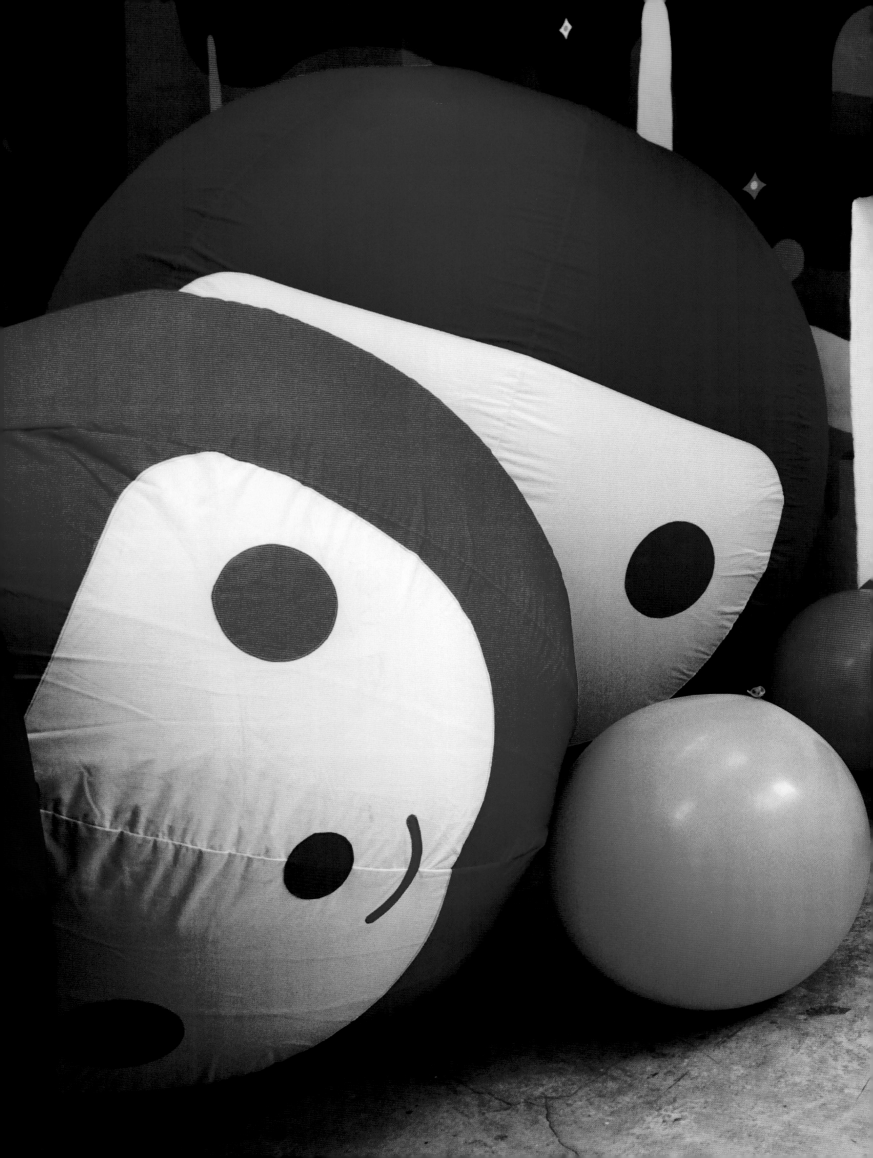

Wish Come True Large Inflatables, 2008.
Vinyl inflatables.
Dimensions variable.

The "Wish Come True" inflatables were an
interactive experience. Utilizing reduced
tonal archetypes, FriendsWithYou created
an interactive playground of balloons. Cov-
ered in veneer and with a bladder inside
that held air, the balloons were light, giving
them an easily actionable composition. The
interactions between the audience and the
inflatables became a highly charged and
vigorous free-for-all. The exhibition was
realized with artist Bhakti Baxter, who col-
laborated with FriendsWithYou to create the
murals that can be seen in the background.

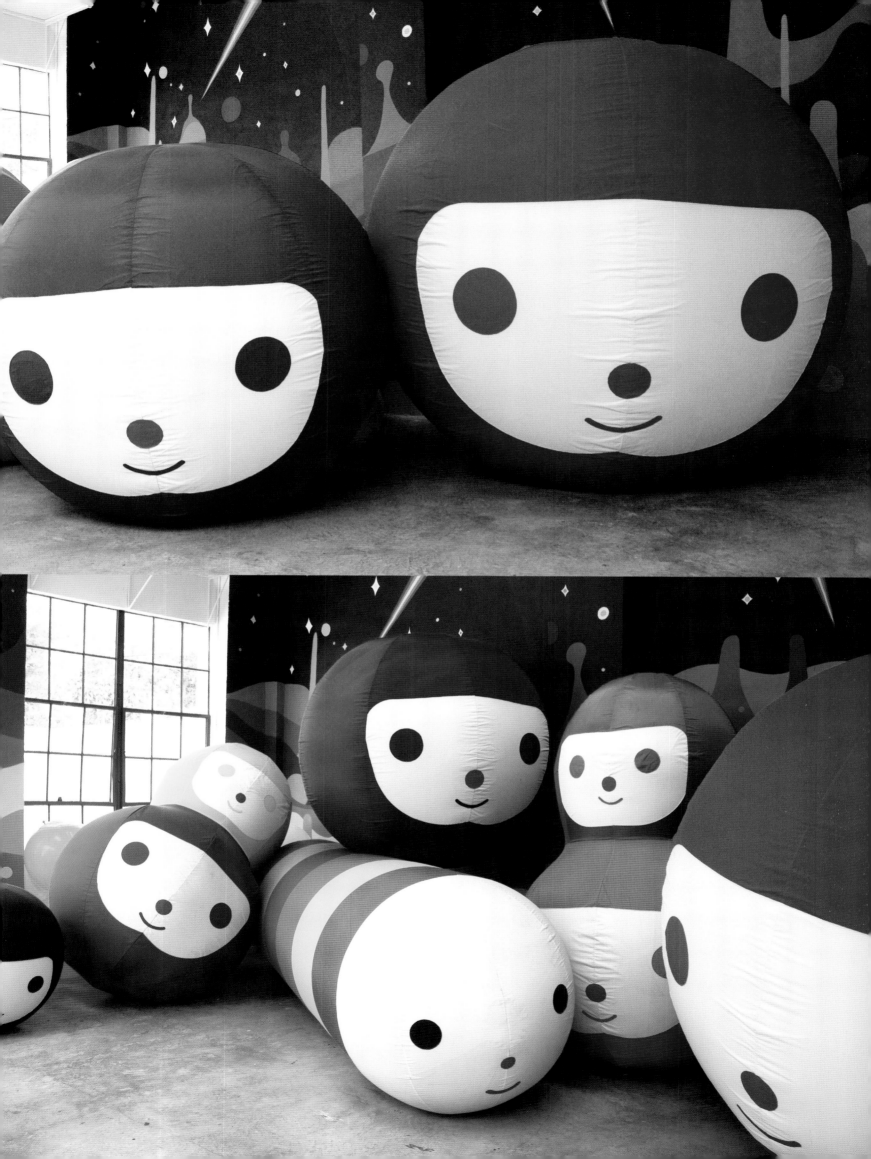

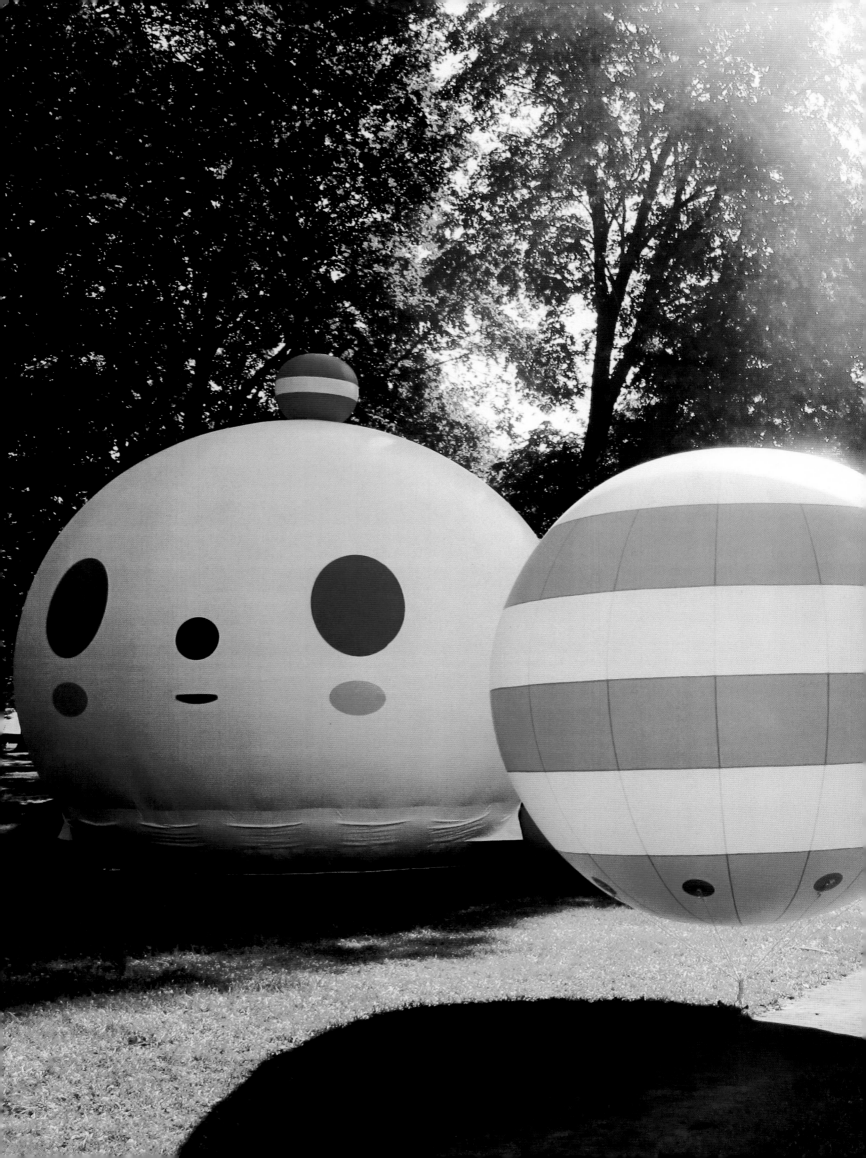

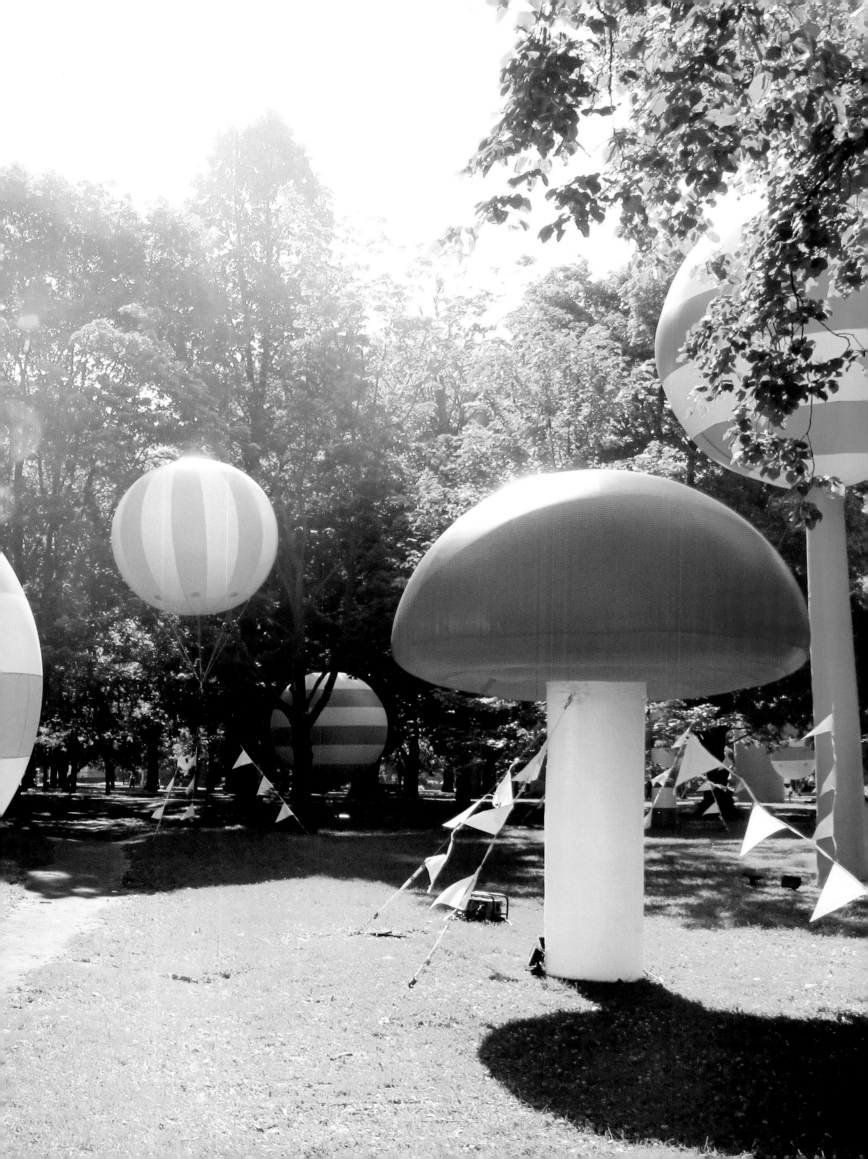

We were breathing real life into these massive things that escaped our dream realm. We were even awestricken ourselves.

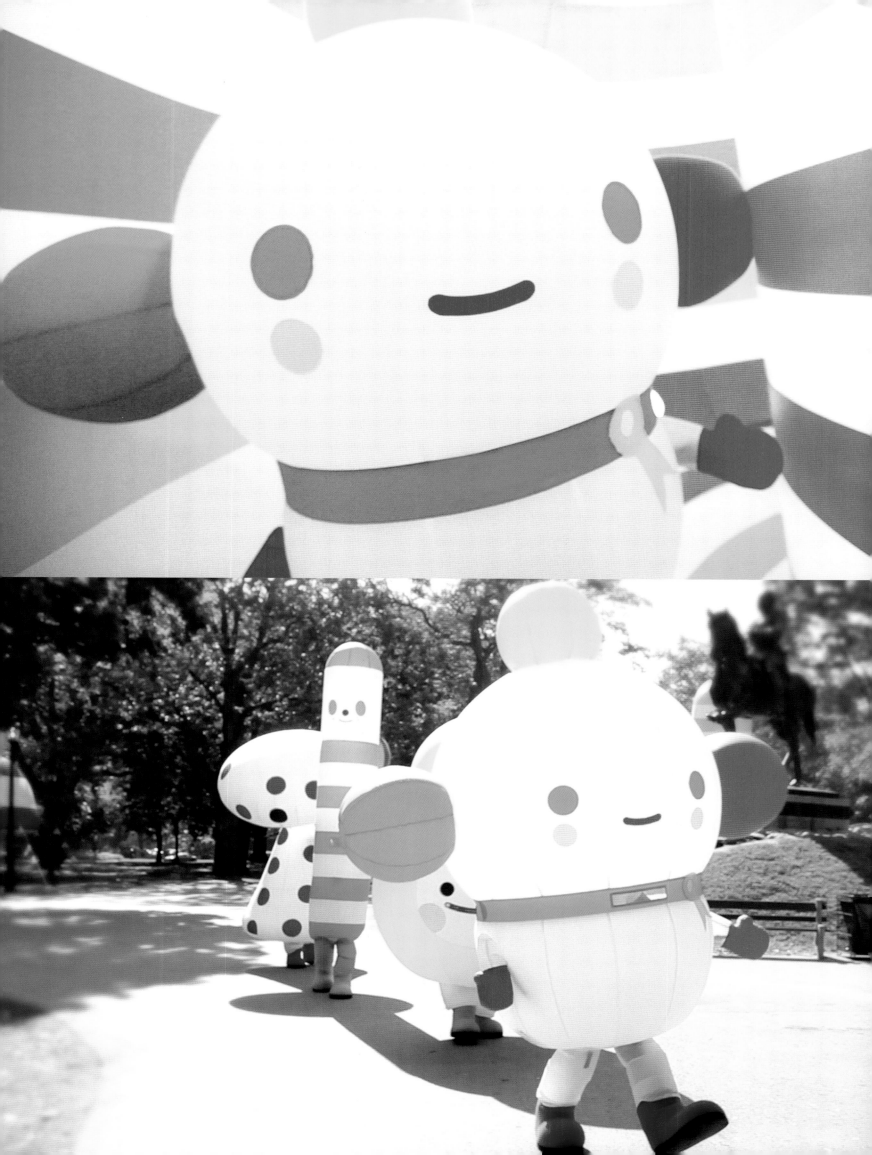

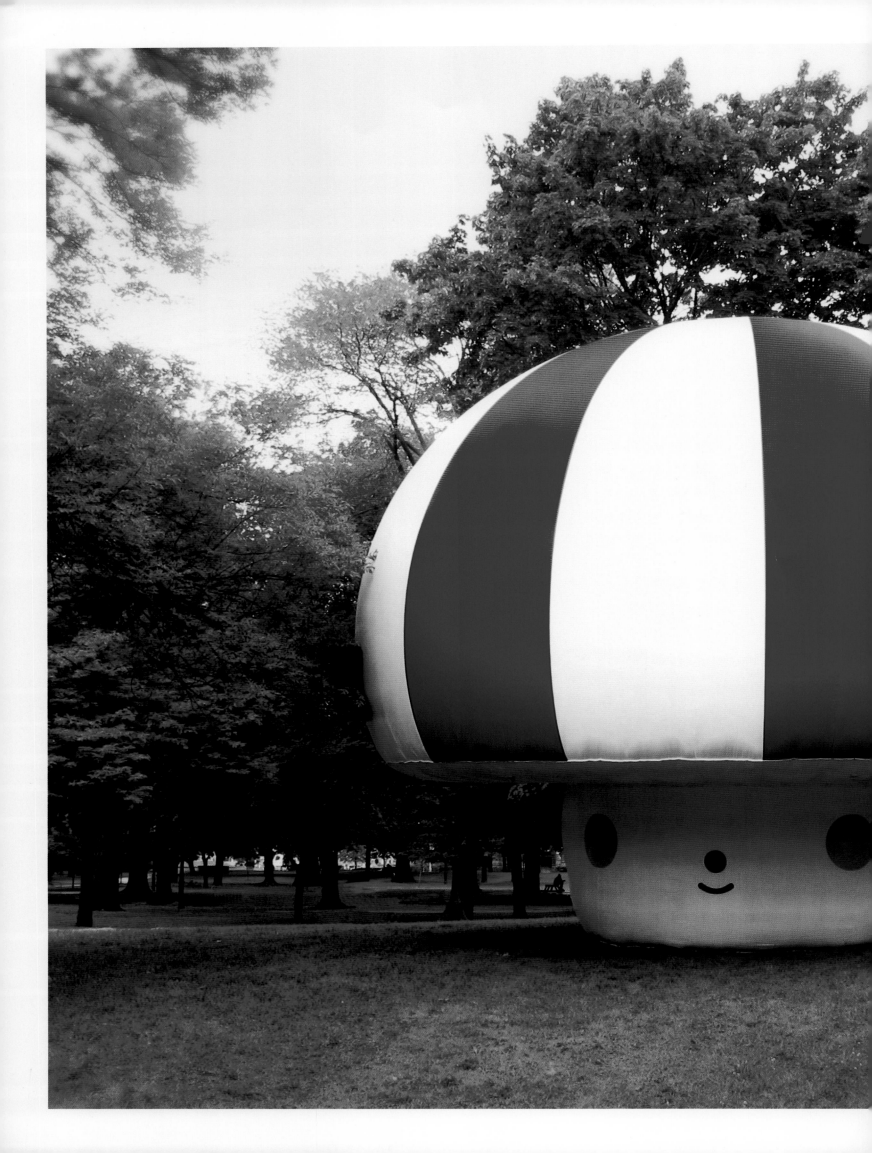

Rainbow City, 2010.
Vinyl inflatables.
Dimensions variable.

Shown in Toronto, Miami, and New York,
"Rainbow City" was first commissioned by
the Luminato Arts Festival in Toronto, and
subsequently shown in New York in the
High Line park, and during Art Basel Miami
Beach in the Design District featuring a
performance by N.E.R.D. The work is a 40-
piece environmental installation addressing
the potency of interaction, ritual, and play.
Holi, a festival effectuated by Hindu followers
throwing brightly colored water and powder
at each other, inspires the vibrant collection
of mutable, air-filled sculptures. Fabricated
from intensely colored and receptive materi-
als, the installation encourages visitors to be
active and explore, subsequently inventing
their own ritual. The individual structures are
simple, minimal forms that borrow aesthetics
from toy-like geometry and design and
tower over guests, as each element's height
ranges from 10 to 40 feet. By dwarfing
the audience, the totemic pieces trigger a
sense of reverence, similar to the visual of a
monolithic monument. During interaction, the
inflated sculptures "embrace" visitors, while
repetitive sound elements further enhance the
sensory experience. The overall installation
creates a surreal landscape of psychedelic
scenery intended to simultaneously provoke a
religious and childlike awareness. "Rainbow
City" invites spectators to participate in a re-
sponsive environment, offering an opportunity
to connect physically and psychologically
with an energetic yet ephemeral setting.

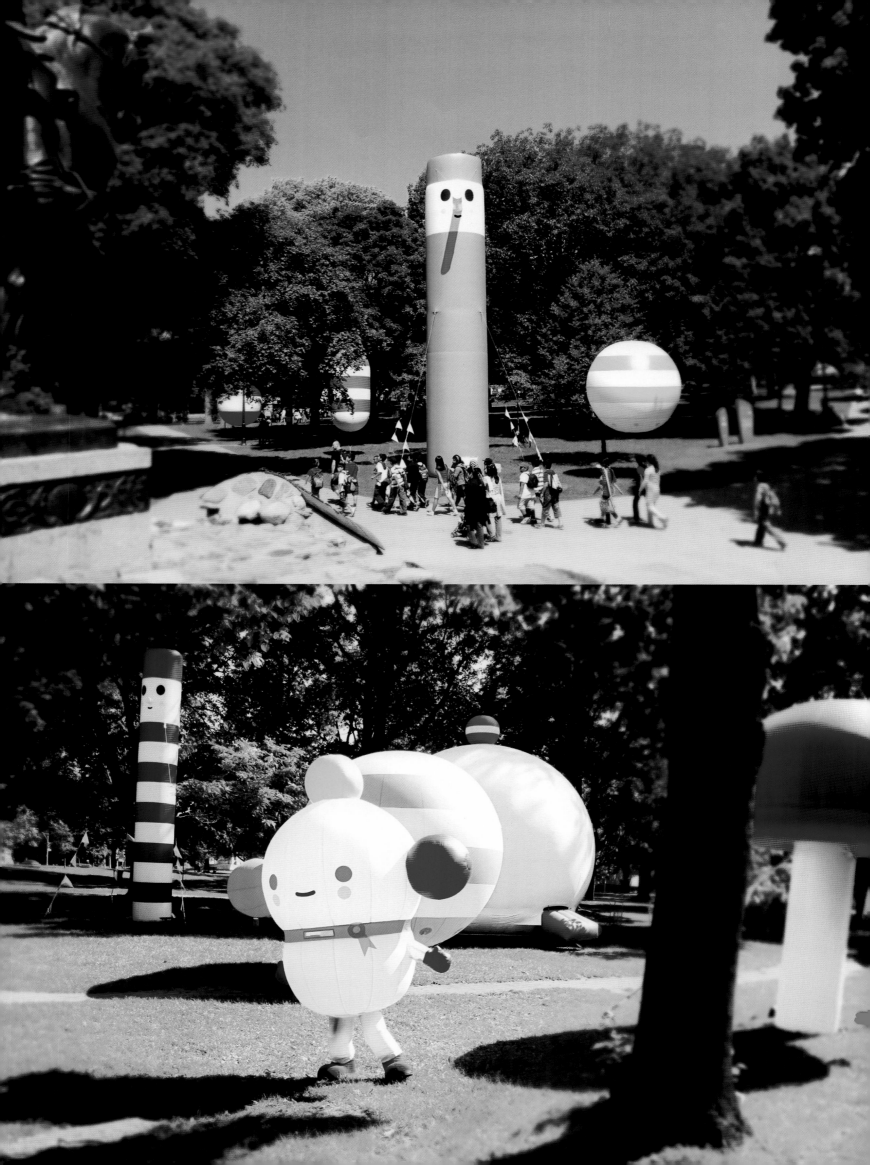

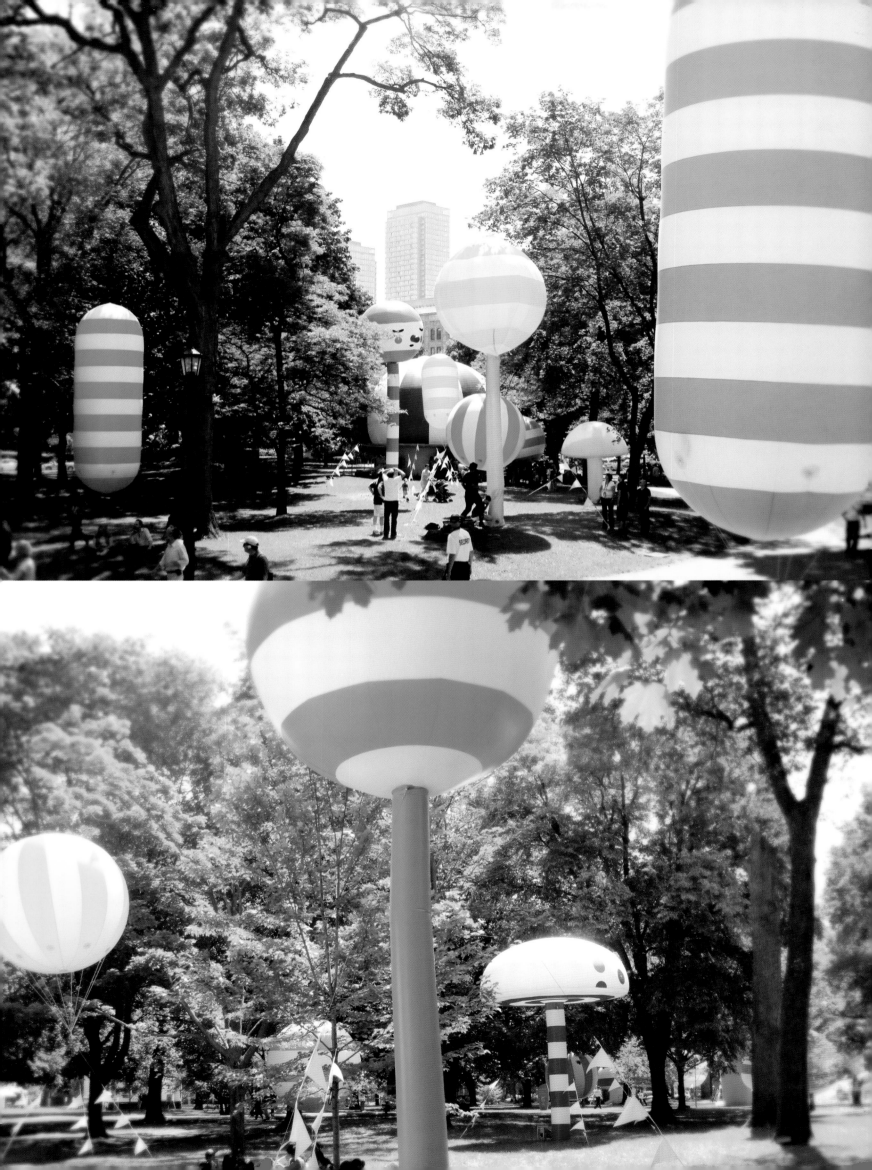

Rainbow City (New York), 2010.
Vinyl inflatables.
Dimensions variable.

This iteration of "Rainbow City" was installed
for the opening of Section 2 of the High Line
park in the Chelsea neighborhood of Man-
hattan. Supported by Friends of the High Line,
the piece gave New Yorkers a month-long
play place within the city's celebrated new
public space.

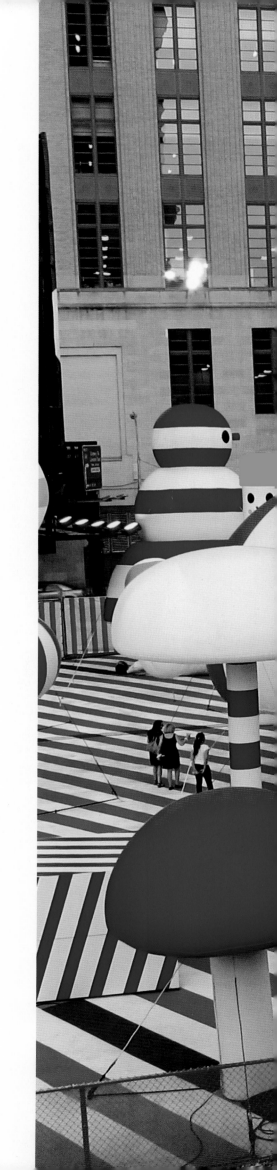

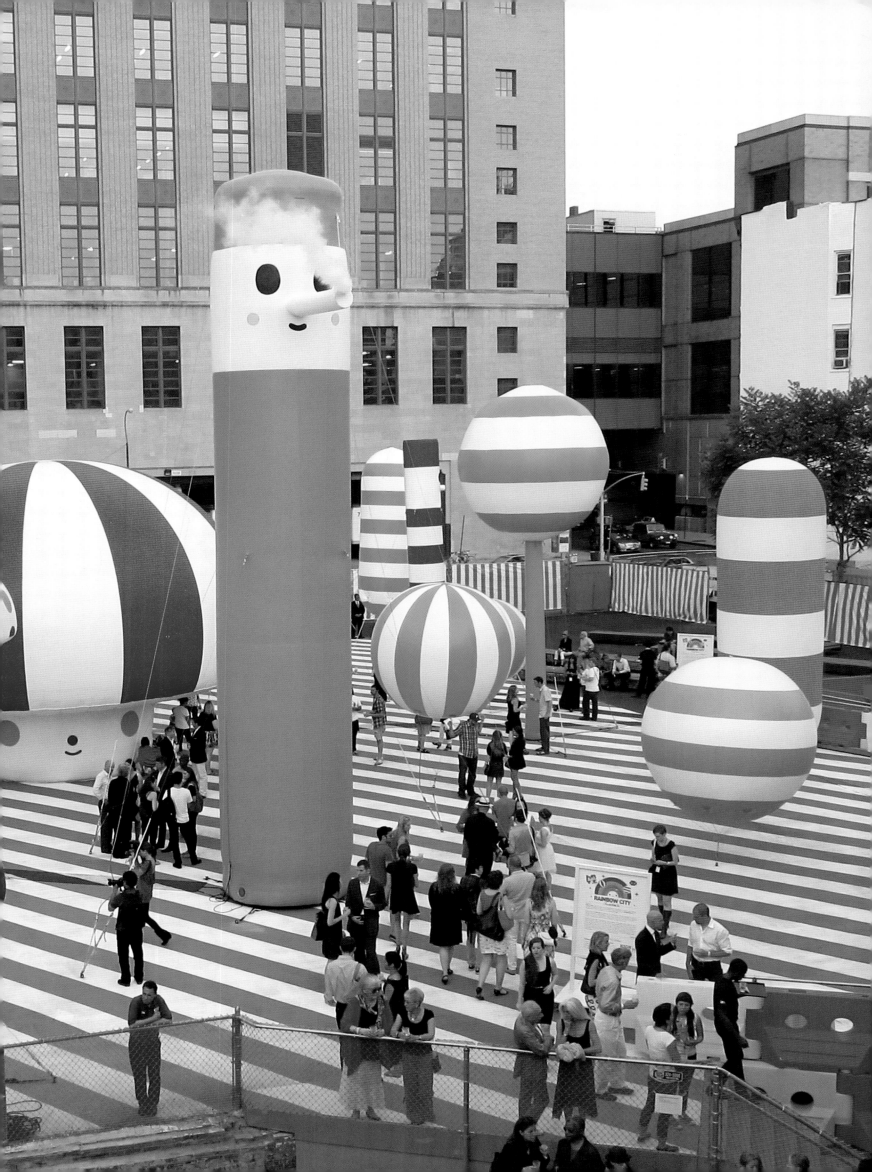

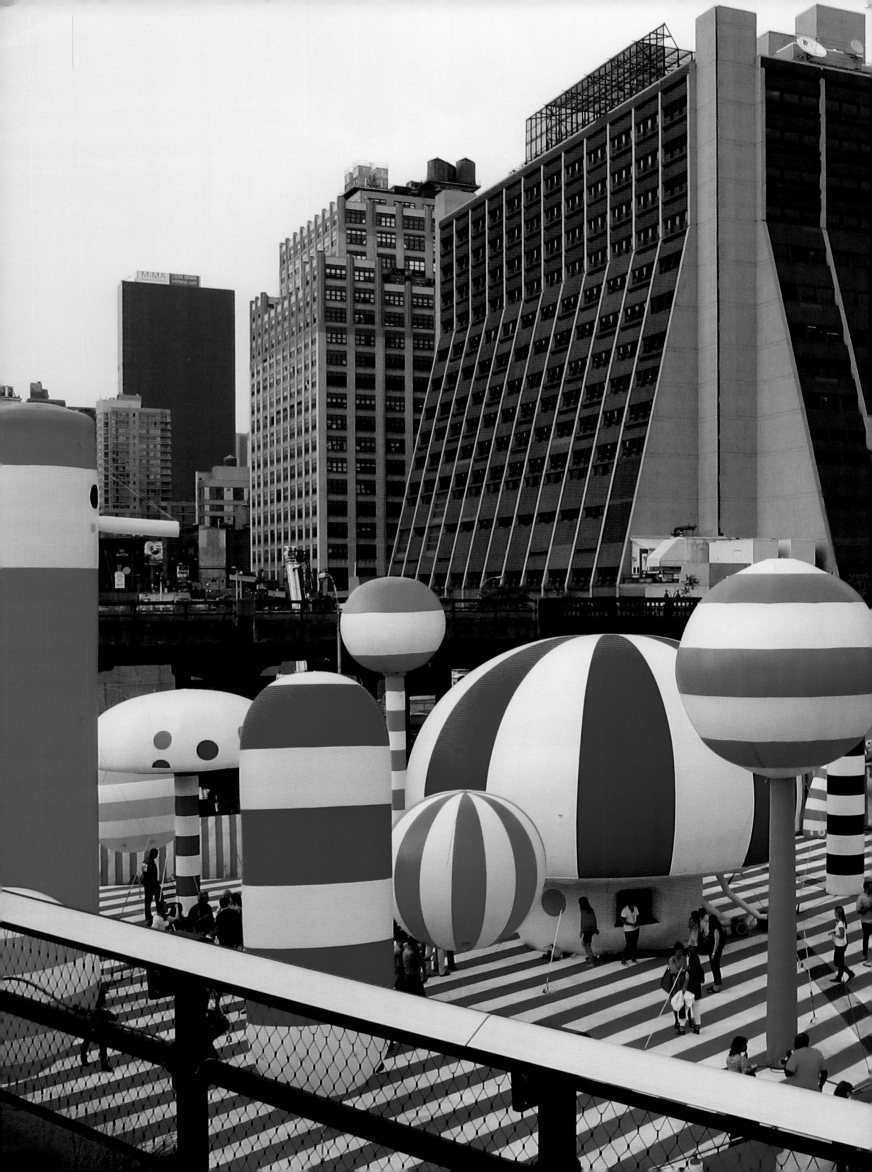

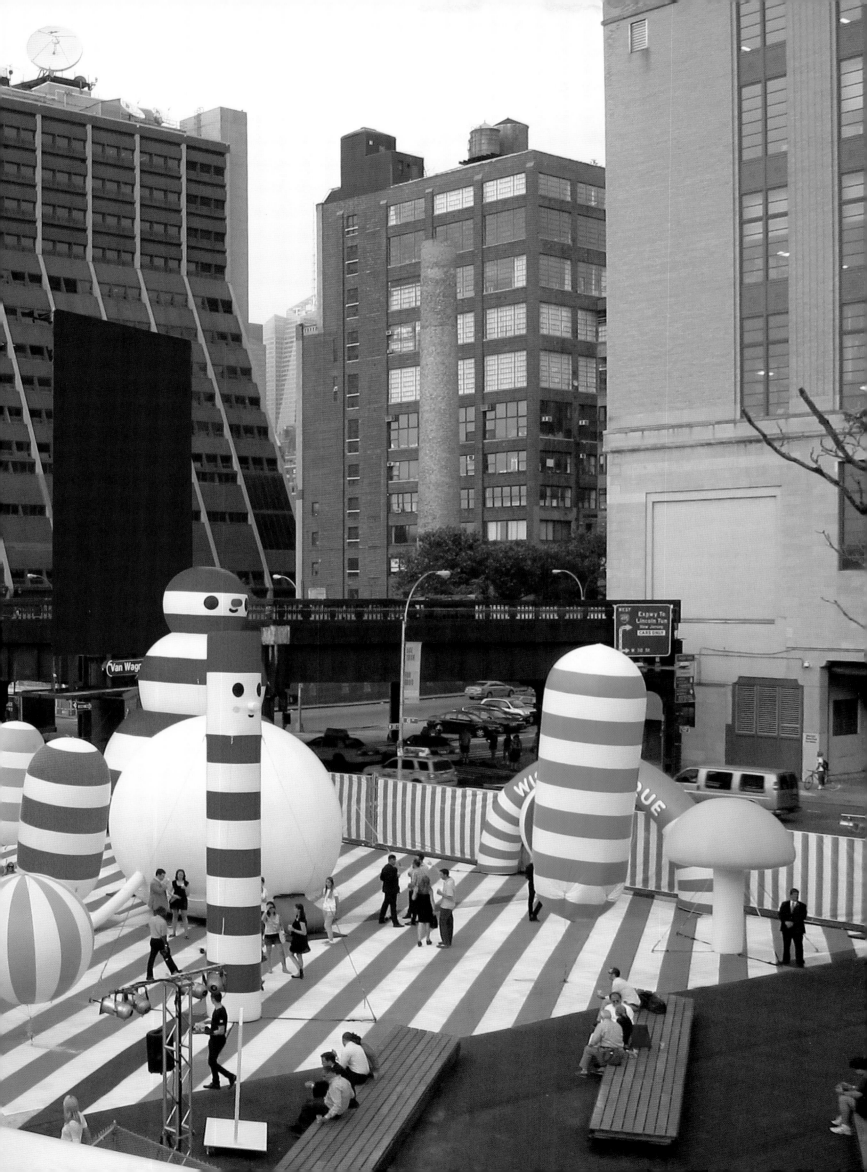

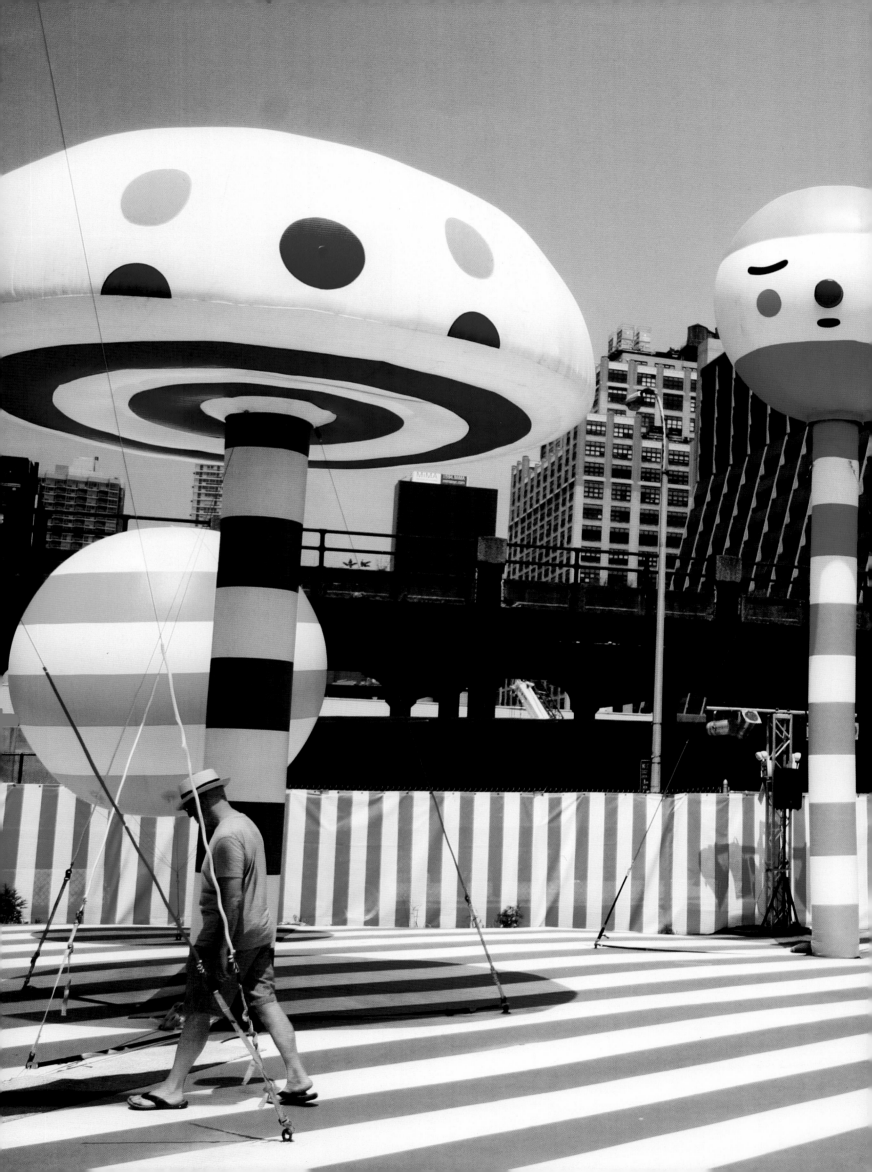

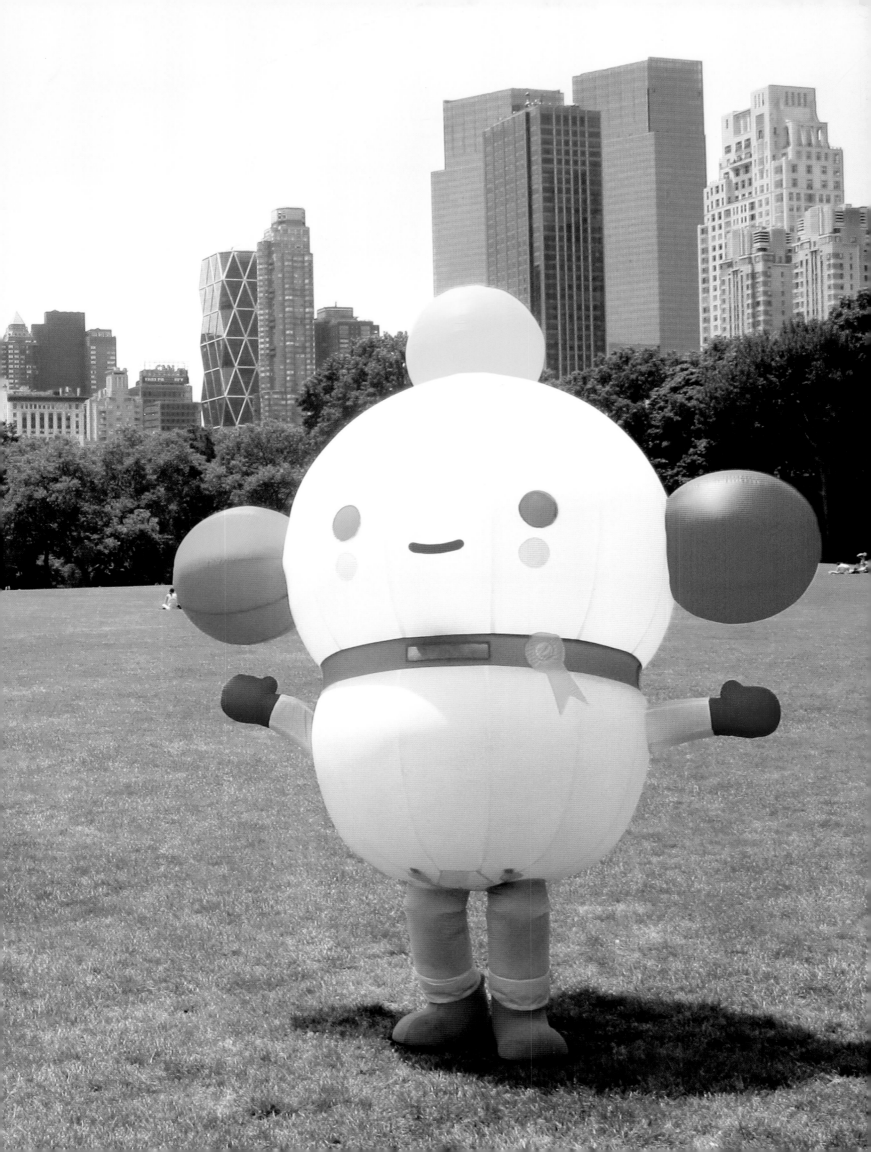

ACKNOWLEDGEMENTS

We have been so blessed and honored to do what we do. We can barely begin to thank all the people involved in making this happen. We have had so much support from our friends, family, and all the amazing people that have inspired us and believe in our mission. And to all of you reading this right now: we are all FriendsWithYou. We are all together. Thanks to our families: the lovelies Eva Seta & Melody Lisman, Lola, Elliot, Mindy, Marla, and Lacy Borkson, Arturo and Marianela Sandoval, Emmy, Ryan, Cami, Fifi, and Simone Stark, Ray, Jane, Adam and Ryan Caragher and fams, my hermano Leonel, Paloma and Palomita Matheu, Sweet Grammy Rozzy Baby, and all the fam, cuzzies, and cuties that have been with us on this journey. This book would not be possible without Ian Luna, Charles Miers, Monica Davis, and the Rizzoli team. We are most honored to include the intro by Peter Doroshenko of Dallas Contemporary and the amazing conversations with our teacher and inspiration Alejandro Jodorowsky and our big brother and greatest supporter Pharrell Williams. Our magical book team led by the genius Emma Reeves, the unconquerable Roxane Zargham, and the great Maxwell Williams. Our internal team, Steve "Little Bear" Saiz, Julie Machado, and the Wizards: Mike "Gator" Feinberg, Tim Smith, Paddy Scace, and "Prince Charming" Nat Pastor, "the General" Maureen Esposito, Alex Hoffman, our magic elves Erica and Eve, and all the incredible interns who have lent a hand. Thanks to our best friends who have supported us: Azul, Jen, Alvie, JJ 'n' Jenny, Ben Jones and Christina, Norby, Pressy, Dave Choe, Denzolo, Uncle, Jimmy, Rhode and Sylvia, Kitao, Tim B, Saelee, Manny Prieres, BOX Space Miami, Daniel Arsham, Bhakti Baxter, Tao, Jason, Randy & Inah, Nick & Muriel, Matt & Breeda, Phi, Helen, Rocket!, Seb, Josh Paulin, Drew Stoddard, Natalie Kates, da Ruths, Sven, Feefee, Ceci, Pooper, Del Marmols, the Aramis 3, Harlan, Eggy Weggy, Rasco, Alex Caso, Gonz, Chris Schafer, Ollie Sanchez, Julian Consuegra, Sweet Little Jeffy, Mario, Tpot, Dzzaa, Andy Milonakis, Dan Goldman, Rolan, Typoe & Books, Jacuzzi Boys, X, Yago, Ryan Induce, Kevin Hayes, Luis Guava, Boris, Eric Wareheim and Liz Lee, Dougpound, LuLu, Jason and Renee, YAYA, God, Buddha, Jesus, Muhammad, and all the celestial beings, Gordo and Frookie the OG, Bonnie Clearwater, Miki Garcia, Jackie Fletcher, Ozzie Torres, Friends of the HighLine, Luminato Toronto Festival of Arts and Creativity, Aventura Mall Ventures, Hanna GRP, MOCANOMI, Museum of Contemporary Art North Miami at Goldman Warehouse, Indianapolis Museum of Art, iAmOther, N*E*R*D, Loic Villepontoux, Kim Hastreiter, David Hershkovits, Carlo McCormick, Robin Cembalest, *Paper* Magazine, KAWS, Die Antwood, Al Moran and Aaron Bondaroff of OHWOW, Kathy Grayson of the Hole Gallery, Jeffrey Deitch, Silvia Karman Cubiñá, Ruba Katrib, Jim Crawford, Gregory Blum, Lorenzo Ragionieri and Evan Gruzis, Hugo, Zeke, Steve Berra, Weidenfelds, Meatball & Justin, Steve Thompson, Rosa de la Cruz, Ibett Yanez, Stephen Colbert, Kristin Weckworth, Nikki Macaluso, Friends Night crew, Dunte, Mathieu Van Damme, KidRobot, Chad Philips, Case Studyo, Chris Lorway, Sarah Lerfel, Matias Fernandez, Santi, Fernan, Otto von Schirach, Sonni, Wes Pentz, Raul Sanchez, Jake, Fabio, Jeremy Larner, Bill Schultz, Kenny Scharf, David Morgan, Mark Ryden, Christina Kang and Director Minjin Chae, Joe, Reginito "Chico," Chu, Peter & Lars, Francesca Gavin, SOHO, the Goldmans, Robert Klanten, Jim Drain, Barry McGee, Shepard Fairey, Ara Peterson, Misaki Kawai, Devilrobots, Kinya Hanada, Dearraindrop, Naomi Fisher, Norman Bambi, Golden Eyes, Keith from China, Clyde Wagner and Robert VanderBerg, Gwen Stefani, Alia Shawkat, Tarina Tarantino, Gary B, Jaime Hayon and the Lladró team, Yosi Sergant, Louisa, Julie B, Scope Art Fair, Jeri Yoshizu, Polina Berlin and the Paul Kasmin Gallery, Emmanuel Perrotin, Andres E. Sanchez, Kristia Moises and Sara Leonardi of MCLEMOI GALLERY, Craig Robins and Dacra, Dr. Darren Romanelli, Best Buddies, and Sanrio. Thanks to our inspirations: Alejandro Jodorowsky, Takashi Murakami, Paul McCarthy, Isamu Noguchi, Alexander Calder, Ellsworth Kelly, John McCracken, Steve Jobs, Moebius, Jean Arp, Osamu Tezuka, Hayao Miyazaki, Disney, Mickey Mouse, Pinocchio, Anpanman, Totoro, and Malfi. And thank you to everybody who bought this book: may your love shine bright eternal and may all your wishes come true.